Art, Creativity and Imagination in Social Work Practice

In this book practitioners and researchers depict and evaluate some of the new experimentation with personal story-telling, creative writing, song, art and photography that now abounds in health and social care. Authors demonstrate how personal, artistic expression can strengthen a sense of self, mobilise energy and passion, and foster intercultural dialogue and appreciation. They draw out affinities between art and social work - how imagination and creativity enable experiences of trauma, mental illness and everyday confusion to be opened up, recognised, explored and communicated. The book portrays work across age groups, with children, youth, young and older adults, and in diverse cultural settings, in Canada and the Netherlands as well as the UK. It includes work by social workers facing threats and accusations, therapeutic work with children, and restorative youth justice

Art, creativity and imagination in social work practice describes creative work, while helping to understand and explain what makes it effective as social work practice. The book moves from accounts of more intimate and personal experience towards evaluations of more specialised professional work, and then examples of community-based and public uses of art. The more theoretical middle section shows how psychodynamic concepts, allied with various clinical and research procedures, bring to light unconscious processes. This highlights the rootedness of artistic process and inspiration in the unconscious and in intra- and inter-subjectivity. Several chapters explore art in different facets of research - data collection, participant engagement, and processes of representation and dissemination. The value of art as a tool for collaborative inquiry, and as a lively means of expression and representation is well portrayed.

This book was published as a special issue of the *Journal of Social Work Practice*.

Prue Chamberlayne has until recently been Visiting Senior Research Fellow in the Faculty of Health and Social Care at the Open University. She has used biographical methods in a range of research and policy settings, and enjoys creative activities such as poetry and drawing.

Martin Smith is the Practitioner-Manager of the Buckinghamshire Social Services Out of Hours Emergency Team. He is particularly interested in researching and writing about social workers' experiences of stress and fear.

Art, Creativity and Imagination in Social Work Practice

Edited by Prue Chamberlayne and Martin Smith

Routledge
Taylor & Francis Group

LONDON AND NEW YORK

Transferred to digital printing 2010

First published 2009 by Routledge
2 Park Square, Milton Park, Abingdon, Oxon, OX14 4RN

Simultaneously published in the USA and Canada
by Routledge
270 Madison Avenue, New York, NY 10016

Routledge is an imprint of the Taylor & Francis Group, an informa business

© 2009 Edited by Prue Chamberlayne and Martin Smith

Typeset in Times by Value Chain, India

British Library Cataloguing in Publication Data
A catalogue record for this book is available from the British Library

ISBN10: 0-415-46508-7 (hbk)
ISBN13: 978-0-415-46508-3 (hbk)

ISBN10: 0-415-59081-7 (pbk)
ISBN13: 978-0-415-59081-5 (pbk)

Contents

Part 3 - The wider community

List of Contributors

Donovan Chamberlayne lives and works in London and is currently based in a Youth Offending Team as a Looked After Child social worker.

Frida van Doorn is a health psychologist at the Erasmus Medical Centre, Department of Child Psychiatry in Rotterdam.

Victoria Foster is currently a Lecturer in Social Policy in the Department of Social Work at the University of Central Lancashire.

Lynn Froggett is Reader in Psychosocial Welfare and Director of the UCLAN Psychosocial Research Unit. Her work is strongly interdisciplinary. She has a social work background and draws on perspectives from the humanities and creative arts, social sciences, psychoanalytic theory and gender studies. Her wider project is to develop the theoretical and conceptual terrain on which to link social policy and social provision with day-to-day experiences of care. This is supported by an empirical research programme with a particular focus on arts-based community settings and the development of innovative research strategies which include narrative, biographical, visual and performative methods. She recently completed a three-year study of integrated approaches to adult health and social care in an arts-based community setting and is currently developing research and evaluation in a range of locations which use creative and arts-based interventions. These include a children's centre and restorative youth justice and regeneration contexts.

Yasmin Gunaratnam is a Senior Research Fellow in the Centre for Ethnicity and Health at the University of Central Lancashire.

Karen V. Lee is a Faculty Advisor and co-founder of the Teaching Initiative for Music Educators cohort (TIME) at the Faculty of Education, University of British Columbia, Vancouver, B.C., Canada. Her research interests include issues of musician/ teacher identity, music/teacher education, performance ethnography, women's life histories, auto-ethnography, writing practices, and arts-based approaches to qualitative research. Her doctoral dissertation, a book of short stories titled *Riffs of Change: Musicians Becoming Music Educators*, was about musicians becoming music

educators in a classroom context. She is a musician, writer, music educator, and researcher. Currently, she teaches undergraduate and graduate students at the university.

Carolus van Nijnatten is a professor of social studies of child welfare and social work at the University of Utrecht/Radboud University Nijmegen.

Paula Pope is a Principal Lecturer at Liverpool John Moores University.

Olivia Sagan is Senior Research Fellow for Pedagogy at the University of the Arts, London.

Claire Smith is a PhD candidate at the University of Ottawa, Canada. The focus of both her MA and her PhD research is head injury. She used multiple literacies to present her MA findings and intends to do the same in her PhD work.

Martin Smith is the practitioner-manager of Buckinghamshire Social Services out of Hours Emergency Duty Team. He is particularly interested in how those in the caring professions respond to experiences of stress and fear.

Hannele Weir is a Lecturer in Applied Sociology, City University, Institute of Health Sciences and Module Leader to Historical, Cultural and Social Perspectives of Violence on Society, Violence and Practice MSc course.

Prue Chamberlayne and Martin Smith

ART, CREATIVITY AND IMAGINATION IN SOCIAL WORK: INTRODUCTION

Whether a work of art provides a useful 'third thing' that helps people think about issues in a way that they would not be able to do without it, or whether the arts essentially provide a diversion from such engagement has been, and will continue to be, a question much debated.

Commenting on T. S. Eliot's sprawling modernist master-piece poem, *The Waste Land*, first published in 1922, some critics enthusiastically claimed that Eliot had expressed and encapsulated the sense of spiritual devastation and uncertainty experienced by many in the aftermath of the Great War. Some went as far as to claim that he had expressed 'the disillusion of a generation'.

Reflecting on these comments in 1932 Eliot was disparaging:

> When I wrote a poem called *The Waste Land* some of the more approving critics said I had expressed 'the disillusion of a generation', which is nonsense. I may have expressed for them their own illusion of being disillusioned, but that did not form part of my intention.

Far from accepting that *The Waste Land* spoke to crucial issues on a national and international scale he dismissed it as, 'a wholly insignificant grouse against life; . . . a piece of rhythmical grumbling'. Here Eliot appears to support the contention that art is fundamentally unhelpful in making sense of the human condition as it is essentially illusory and therefore not of real substance or value. (Typically) Eliot comments quite differently in 1951:

> A poet may believe that he is expressing only his private experience; his lines may be for him only a means of talking about himself without giving himself away; yet for his readers what he has written may come to be the expression both of their own secret feelings and of the exultation or despair of a generation.
> (All quotations from Macrae, 1980, p. 58).

These brief quotations highlight some dilemmas of art. Is it 'merely' personal? Can it be universal? Can it portray meaning in an *unlocking* way to someone who hears, reads or sees it in such a way that makes a genuine difference in their life? Is art 'merely' a special instance of creativity or something more (greater) than this that carries meanings and implications far beyond the art work itself?

The writers of the chapters in this collection claim that getting to know, gaining understanding of and applying the arts to social work practice make a difference for the better. Several spring from highly personalised, individual creativity, some use individual examples of arts-based work to discuss a method or policy approach, and some point to applications of art as a tool of engagement in community work activism or postgraduate teaching. Our arrangement of the contributions moves along this spectrum, starting from more intimate accounts and moving to wider public arenas. The chapters portray work across age groups–with children, youth, young and older adults. Several explore the use of art in different facets of research, such as data collection, involving participant engagement, or in processes of representation and dissemination. Several are drawing on MA or PhD theses which have engaged with art as a vehicle of both exploration and presentation.

Our call for contributions hoped to draw out depiction and evaluation of some of the new experimentation with dance, drama, story-telling, creative writing, art, photography and film that now abounds in health and social care. We asserted that psychodynamic concepts, together with clinical and research procedures that take account of and bring to light unconscious processes, are well placed to describe creative work, and to understand and explain what makes it effective as social practice. Both social work and art often work at the borders of the sayable, the thinkable, the knowable. Affinities between art and social work abound: imagination and creativity enable experiences of trauma, mental illness and everyday confusion to be opened up, recognised, explored and communicated; because it is so very personal, artistic expression can strengthen a sense of self and of self-esteem; it mobilises energy and passion; it can act as an effective means of intercultural dialogue and appreciation. Our call invited attention to the difficulty of describing and evaluating arts-based work, given the silence on 'imagination' in social science.

The new synergy between the humanities, social science and the performing arts makes an exciting setting for this collection. Even as we launched our call in September 2006 a conference at Swansea was taking place: *Circles within Circles – Qualitative Methodology and the Arts: the Researcher as Artist* (Wainwright & Rapport, 2007). Throughout that year the Performative Social Science jiscmail group (performsocsci), run by Kip Jones at Bournemouth, took off and flourished. In June 2007 the Creative Methods Network held an event on *Performing Data* at Dartington Hall in Devon. In July 2007 the Bristol Arts Based Educational Research Conference addressed arts-based research both as an inclusive and participatory form of enquiry and as a new way of disseminating research. In May 2008 the on-line journal FQS (Forum for Qualitative Social Science) brings out an issue on *Performative Social Science*. In December 2008 Research Network 3 of the European Sociological Society holds a conference in Crakow, Poland, on *Performing Biographies: Memory and the Art of Interpretation.*

Such an explosion suggests a conjuncture of multiple factors. In her chapter, Victoria Foster points to the inadequacy of language in capturing the flux of a postmodern world, leading to a 'crisis of representation'. Developments in IT and digitalisation prompt multimedia experimentation with new ways of

conveying meaning and experience, linking the visual and the verbal, movement and sound. Perhaps these developments are fuelled by a rebellion against excesses of bureaucratic regulation, a turn to pleasure and fun.

The value of art as a tool for engagement and collaborative inquiry, and as a new, more lively means of expression and representation is well portrayed in the chapters of this book (see also Jones, 2006; Wainwright & Rapport, 2007). But there are other dimensions to questions of art, imagination and creativity for social scientists and practitioners. One is how to insert the artistic into social science, how to bring about a dialogue between the humanities and social science, how to achieve common understanding in terms of philosophy and epistemology. For this a strong resource lies in German hermeneutics, where there has been long standing advocacy of aligning human sciences with the arts, for an understanding of culture, aesthetic experience, 'play', the uniqueness of being, for different criteria of methodological rigour and truth (Gadamer, 2003; Crotty, 1998).

Another dimension, especially for those concerned with psychodynamic thinking, lies in the rootedness of artistic process and inspiration in the unconscious and in intra- and inter-subjectivity (Bollas, 1987; Gosso, 2004). It is commonplace to say that it is hard to imagine twentieth-century art without Freud. Ninjatten and Doorn, Sagan and Smith in this collection give accounts of using art to give expression to and understanding of unconscious process. All the contributors speak of art bringing 'deeper' understanding and 'different' ways of thinking. Gunaratnam searches for sources of creativity and reasons for responses to it in corporeal and inner experience, drawing on psychoanalytically informed literature. Froggett, focusing on inter- and intra-subjectivity, and tracing how and why creative writing 'recognises' deep destructiveness, violence and eroticism in ways which can achieve moral learning, draws on the thinking of Winnicot, Klein, Bollas and Milner.

Themes

In exploring what art, imagination and creativity offer to social practitioners, five dualities or contrasting emphases stand out. The first concerns *art as solace* as opposed to *art as energiser*. In several chapters we see the help of art in painfully finding a new self, following traumatic loss as in brain injury, or after years of constriction in social and emotional deprivation. Approaching unconscious blockages through art therapy or gaining new self-esteem and recognition through creative writing demonstrate the 'reach' of art. Notable in all these cases, however, is the importance of a supportive social and interpersonal environment – since, as all the writers emphasise, the process is intrapersonal, interpersonal and contextual. Yet paradoxically, given the role of art as a slow healer and comfort in boosting resilience, art can also jolt and energise. In *Art Therapy and Social Action*, Kaplan demonstrates how drama acts as a powerful antidote to political numbness, rekindling the old protesting flame.[1] Weir and Pope, in this collection, show the social power of civic and museum art to mobilise community imagination,[2] and to cross class and

cultural divisions. What is common, though, is the power of art to promote the imagining of how things might be different – personally, socially, and in research.

The second duality concerns the value of *openness* as against the need for *containment*. Most of the chapters argue the value of reaching further into imagination and the unknown. Yasmin Gunaratnam concludes her chapter on the dangers of sentimentality in art, of 'aestheticising suffering', drawing on the poet William Carlos Williams' refusal to baulk at the existential terror and physical shame of old age and dying. Having long explored the emotional complexities of intercultural care and challenged the simplicities of anti-discrimination policies, she concludes: 'I believe that it is through our very awareness of its risks, omissions and limits, that art . . . can expose us to a fuller relationship to otherness and to what is unknown and unfathomable'. Art can help us confront our evasions, denials, detachments. Margot Waddell (1989) likewise argues the need to set aside the frenzied activity of daily life, which all too often impedes capacities for emotional thinking. From a different tack, Martin Smith argues the need to rein in certain kinds of uncontained imagination, such as paranoia and 'catastrophic thinking', which can be thoroughly destructive. It is of course not that he is advocating non-recognition or suppression. As Froggett discusses in her chapter, human development right from infancy demands the holding in tension of the erotic and destructive – the terrifying and the beautiful.

The third duality concerns *process* as opposed to *product*: the personal vulnerability and risk of engaging with and 'going there' in art as against the mystery of 'where it comes from' and the power of the image to capture so much. The sense of risk and vulnerability is common to both clients and researchers – and to any of us in taking 'creative steps' in life and at work. It is already there in bridging aesthetic and academic domains, treating research as an aesthetic process, introducing flux, beauty, death (as several of our writers put it), engaging in multidimensional rather than linear learning, as Hannele Weir explains. Several of our writers are crossing this divide for the first time. Hannele Weir is also mindful of the class barriers being stepped over by nurses and policemen viewing and writing about gallery art. Conveying and analysing the more personal aspects of vulnerability in using art and imagination involves the author in writing him or herself into the account, in a way which is personally and emotionally exposing. Several of our authors have done this, while Karen Lee and Claire Smith have treated their own experience as case studies. In writing a journal article people often feel 'on their own', though hopefully in the trust that there is an appreciative and sympathetic audience – even reviewers and editors!

Several contributors write of social support as an essential container of the terrors of 'going there'. In Martin Smith's discussion of social workers' fears brimming over into paranoia, containment is vital to prevent the irrational getting out of hand. The problem with services today is that such containment is so often missing.

For Ogden, in *This Art of Psychoanalysis*, conveying the process of creativity is more feasible than 'representing' it – perhaps in words.[3] Several of the contributors have found that artistic devices such as wall posters, photos, poems capture

complexity and depth of experience in an accessible way that elicits deep and engaged responses from audiences. Gunaratnam gives a particularly eloquent account of where such images emerge from, and how you recognise them. As writers, several have drawn on poems as bearers of complexity – often in simple language, through images and metaphors which go beyond language. In many cases the process is the product. As Schweitzer in *Reminiscence Theatre – Making Theatre from Memories* (2007), so graphically relates, the life-affirming nature of memory-based theatre work with older people strengthened self-esteem and dispelled age-related prejudices in lasting ways.[4]

The fourth duality marks the tension between *the accessible* and *the elusive*. Accessibility emphasises the way art readily strikes a chord, more easily than words, and especially more easily than academic or official writing, facilitates participation in information-gathering and discussion on findings, is empowering, activates citizenship. For Kip Jones art is convivial and playful, rooted in the local, the quotidian. He draws on Bourriaud's 'relational aesthetics', which emphasise cooperation, commonality and equal status – art as social exchange (Jones, 2006, p. 72; Bourriaud, 2002). Pam Schweitzer reports on a Turkish elder in Germany remarking on a play: 'I didn't understand a word, but I understood everything' (p. 405 of review – see note 4). Both Sagan and Smith describe contexts in which art defies severe restrictions to build communication and identity.

Art brings in the audience in a way that social science has rarely done. Indeed, without spectators the performance is nothing – it is they who appreciate the 'whole structure' of work. The writer and even the actors may become preoccupied with technicalities, while the audience responds to and continues to interpret the overall meaning, so that 'genius' and sense of mystery shift to the observer (Gadamer, 2003, p. 93). 'Reader response theory' addresses the same relationship in literature (Iser, 2000). As Wainwright and Rapport say, artistry offers means to bring social science audiences in to participate both in the experience being demonstrated, and in its interpretation (2007, p. 7).

On the other hand exploring deeper meanings of art, as is the case with the unconscious, can be elusive and challenging. Explaining why and how art moves us and stimulates spontaneity and energy already invokes complex understandings of the mind and the senses. Bollas argues that our aesthetic sense comes from our precognitive transformational experiences (1987, p. 32). Ogden speaks of the art of therapy as maintaining active reciprocity to all one doesn't know, a scary and demanding exercise, as poets know (quoted in Wengraf, p. 409 – see note 3). Many writers in this book are writing about the 'elusive' nature of the creative, whether as a source of inspiration or as an object of inquiry. We 'wrestle' with meaning, as Donovan Chamberlayne's chapter poignantly conveys. His account exemplifies the 'distillation' that Foster finds at the heart of self-discovery.

The fifth duality embodies a tension between *the age-old and the blindingly new*. While it is true that 'there is nothing new under the sun' it is also true that the sun is new (and therefore different) every day. The same things can therefore be

seen in different lights and these shifts in perspective are among the greatest gifts that the arts, creativity and imagination have to offer us.

Psychodynamic theory holds that what appear to be new things are, in fact, old things re-discovered. The practices of psychoanalysis and social work create genuinely new and energising modes of relating. Winnicott (1965) wrote that the infant's joy in creation is actually a re-creation – a finding of something that existed before it was discovered and was believed to be lost. Freud (1908/1988, p. 139) also wrote along these lines, 'A strong experience in the present awakens in the creative writer a memory of an earlier experience (usually belonging to his childhood) from which there now proceeds a wish which finds its fulfilment in the creative work.' Segal (1974/1988, p. 256) employs this thinking in contemporary literary criticism:

> The artist is concerned primarily with the restoration of his objects. Proust, for instance, says that a book, like a memory, is 'a vast graveyard where on most of the tombstones one can read no more the faded names'. To him, writing a book is bringing this lost world of loved objects back to life.

An example of a famous writer combining the age-old and the blindingly new within the same time period is provided by the late Poet-Laureate Ted Hughes. In 1998 he published a collection of poems entitled *Birthday Letters* that were primarily about his relationship with his first wife, Sylvia Plath. The collection was heralded with critical acclaim and Hughes's breath-taking innovative use of a familiar genre particularly praised. The year before *Birthday Letters* in 1997 Hughes published his *Tales from Ovid* which retold Ovid's tales of metamorphosis that were written around the time of the birth of Christ. Examples of such 'blindingly new' creations in this publication include Yasmin Gunaratnam's use of a topical popular song as a springboard into deeper reflections, Hannele Weir's getting out of the classroom and into public spaces as an arena for learning, Paula Pope's analysis of 'text communication', that most modern form of relating, and the way in which Donovan Chamberlayne combines his personal experience, Buddhist beliefs and professional role in his attempts to understand and move on from painful life-experiences. Each of these contributions use the 'blindingly new' as a starting point to reach back into the age-old.

It is particularly difficult for busy social work practitioners to find the time to attempt to create 'new' writing. First, they need to register that something they have done or thought or encountered might merit mention and consideration. They then need to clear a thinking space in which they can 'turn over' what they have noticed and look at it from different perspectives in their mind's eye. If wanting to continue to attempt to incubate and hatch this idea into publication, they need to order material, leave it alone, make connections with previous work on the subject and return to it again with new eyes and ideas. Running through this process needs to be the belief that what one has to say might be sufficiently worthwhile for someone else to take the time to read it and, maybe even be influenced by it. Small wonder

so many brilliant papers do not get written but perish shortly after conception or during the tortuous process of trying to be born.

Contributors to this collection are therefore to be congratulated on nurturing their ideas through to the life form they take in this book. At the time of publication all chapters are 'new' work and, like all new work, they are re-writings of what has gone before. Indeed, the best new work is that in which the old work can be heard most volubly. As T. S. Eliot (1920/1997, p. 40) puts it in *Tradition and the Individual Talent*:

> we shall often find that not only the best, but the most individual parts of a [new poet's] work may be those in which the dead poets, his ancestors, assert their immortality most vigorously.

Overall the literature base is excitingly wide, giving readers access to literature in public art, for example, and to practitioner literature in other countries. Several of our authors are from North America, one from Holland. Hannele Weir quotes a collaborator in India at some length, and Karen Lee is writing of the death of her Chinese father. Indeed, Yasmin Gunaratnam suggests that her affinity with art comes significantly from her feeling of difference and marginality (in Britain) – a familiarity with borderlands. Victoria Foster finds feminist thinking particularly relevant to her work with *Sure Start* mothers. Both these writers further theoretical thinking between psychoanalysis, post-modernism and post-structuralism on questions of imagination and creativity.

Summaries

The book starts with a wide-ranging and evocative chapter from Yasmin Gunaratnam, who has worked a great deal on the complexity of emotions in intercultural care. Beginning with reference to a 'pop' song by 'The Black Eyed Peas' she shows how the right form of words expressed in the right way at the right time can help express something of importance for a group of people as they struggle to adjust to a social trauma – in this case the bombings in London on 7 July. She also shows how such a form of words can come to the mind of an individual 'seemingly from nowhere' as they manifest something of importance for the person at the time. Gunaratnam argues that art connects with people she presents research findings to in a meaningful way and seems to feed a hunger that more academic papers leave unsatisfied. She writes of the comfort inherent in healing stories that affirm 'the poetics of human experience' and of how one's thoughts and judgement can be 'high-jacked' by bubbling images, music and phrases. Gunaratnam draws on a wide range of poets and literary criticism as well as case-work examples to illustrate how the 'shaping spirit' of the arts can aid us in our work.

Starting from her own journal entries around the time of her father's death, Karen Lee undertakes an auto-ethnographical study of a father–daughter relationship, delicately and evocatively reconstructing her conversations with her father at that

time, and tracing shifts in her inner dialogue with him since, as her own life and career have moved on in leaps and bounds in a way which would give him great pleasure. Attributing her own development to the way she has overcome many of the conflicts she had with him earlier, not least as a second-generation immigrant who herself had to learn to appreciate his culture, she argues the importance of recognising the long-term nature of bereavement – for people in any field of life. Claire Smith's research also starts from her own experience, of a brain injury which stopped her athletic career in its tracks and obliged her to develop a new identity. Using her own example as one case story alongside two others, she argues the advantages of art over social work as a means of people recovering a sense of self through creativity and non-judgemental interaction with others.

Olivia Sagan also provides a detailed study of subjective change as she describes how a creative literacy course was used to help an 'unlikely-looking' subject – a 65-year-old Yorkshireman who had never written creatively previously. Sagan shows how the writing functioned as a 'third thing' which enabled Bertie to feel sufficiently relaxed and comfortable so that he could think about his experience of poverty. The arts are shown here as helping the 'defended subject' become less defended and more able to express him/herself. Bertie's feeling that, 'If I could say it, get it down on paper, it would be out there' articulates the value of the arts in helping to find 'the words to say it'. This recalls Walt Whitman's 'Song of Myself', 'I celebrate myself and I sing myself', and when this happens the world rarely remains the same. Sagan also refers to Winnicott's 'squiggle technique' and, perhaps unsurprisingly, Winnicott's shade smiles over and through much of what is written here on creativity, imagination and the willingness to play.

The next three chapters focus more specifically on social work and clinical work. Martin Smith explores social workers' fears of being threatened and accused – often real enough – but which can also get destructively and infectiously out of hand, leading to demoralisation and suicide. He gives a fascinating round-up of ambiguous and unambiguous cases and of complaints procedures, from his research interviews and from the press, as a prelude to discussing the unconscious world of threats and fears, primitive anxieties and the 'inner courtroom of the mind', which can be taken over by 'a pure culture of the death instinct' (Freud). He draws on delightfully wide cultural and literary references, including Kafka, King Lear, Chicken Licken and voodoo. He also gives some heartening accounts of the containing, calming effects of sharing fears with a trusted person in a team.

Both Nijnatten and Froggett, like many others in the issue, are writing about the transformative effects of creative processes, drawing on different clinical traditions and literatures. Both chapters centre on a case study. Carolus Nijnatten describes the 'self confrontation method', newly adapted for work with children, in this case a very aggressive, bright young boy. Using cards which name, categorise and picture emotions, and drawings, the method leads Paul to recognise and enter into dialogue about his hidden emotions. Thus art gives expression to the unsayable, in interaction with an adult who understands the symbols and helps to initiate discussion of different possible strategies. This calls to mind the forum theatre techniques of

Augusto Boal (1979) in which members of the audience interrupt a scenario to act out a particular part in a different way, trying to move a situation on. Internal and external conflict is vital to personal development and self-structuring, as Ninjatten says. Through art children can be helped to end their self-renunciation. In contrast to cognitive behavioural approaches, which are in some ways similar, the self-confrontation method proceeds through the individual's own creativity and development of a self-narrative.

Lynn Froggett focuses on subjective dimensions in restorative justice among young offenders, comparing the withdrawal and avoidance which may well result from supposedly re-integrative shaming, with the moral learning and sense of interdependence which can be achieved in interactive creative work such as poetry writing. Beginning with an evocative portrayal of the 'false self' of the hooded Stella preening her hands, Froggett traces developments in the interactive constellation, in Stella's body language, in her speech and in her poetry. The role of Bob as 'trickster' facilitator is crucial, allowing a non-judgemental symbolised space where the erotic and the destructive (drawing in Winnicott and Bollas) can be held in tension. Here Stella can for once feel real, her child-like fury against her violent primal objects given crude but authentic expression in the container of the rhythmical discipline of the form. 'The perverse side of the self . . . needs to be brought into view, worked with and recognised as the source of embodied vitality if moral learning is to be achieved'.

Victoria Foster's chapter is the first of three which considers the use of creativity and the arts in a community setting. Drawing on feminist sociological inquiry and using a participatory model of social research she describes an arts-based research project evaluating a *Sure Start* programme with children under five and their families in a run-down ex-mining community in North West England. Visual art, creative writing and short-film-making are employed throughout the research process and drama is used as a means of disseminating findings. Foster draws on the metaphor of the crystal in post-modern texts as it reflects externalities and refracts within itself, sending scattered shards of colour in several different directions simultaneously. What the viewer sees depends on where they stand, moving their position will gain a different view. Foster draws attention to the dangers of voyeurism when conducting research and warns against 'tidy, cleansed accounts of the research process'. She promotes a participatory, emancipatory approach to social inquiry, based on a model of collaboration with research participants. Her chapter describes how women in the local community were included as co-workers in the research process. Foster claims that the resulting data that emerged was much richer and more intimate than that which would have been achieved by 'an outsider'. She concludes by stressing the value of using visual and oral elements in research methods, as well as written materials, in communities where education and literacy levels are not high. In so doing she reminds us of the origins of artistic expression and communication.

Hannele Weir also stresses the value of learning through the visual arts in her description of how viewing art at the Tate Modern art gallery in London was used to further the learning of police officers and nurses studying for an inter-professional sociology module. Weir describes how the art gallery was used in place of the classroom in such a way that aided most participants' understandings of representations of violence. Ratna Golaknath, one of the participants, provides a rich and reflective commentary on how viewing relevant pictures affected her and subsequently informed her work as a practitioner. Weir illustrates the tension between *art as solace as opposed to an energiser* described above as she highlights the power (and function) of art to disturb and provoke as well as to provide a pleasing, aesthetic experience. She evocatively conveys how art can be used as 'a learning tool' with the capacity to 'speak' to those with ears to hear. Whereas Foster advocates a contributory approach to research drawing on the resources of the local community, Weir claims that the use of a specialist expert is useful to promote a learning experience. The role of the 'artist educator' as described in the chapter is therefore an important part of the process. Weir's reference to the juxtaposition of the pleasure of beauty and the challenge of the disturbing picks up on a theme which resonates throughout this edition.

Paula Pope considers the social and artistic 'capital' of a community – in this case, Liverpool. Pope describes work with thirty-six students on a youth and community studies programme involved in culturally based projects in the local community. 'Culture' is defined broadly as 'everything I do when I'm not working'. A resume of key points in the history of Liverpool introduces the case material which follows. Pope describes how a group of young people thought to be at risk of offending created a banner displaying images representing aspects of their lives and heritage. 'Art isn't as bad as I first thought it was', comments one. Tai chi, a drumming workshop, photography, poetry and visit to the City's museum slave trade exhibition are all employed to help young people develop relationships and learn about culture from one another. Performance poetry is shown to inspire members of the group to write creatively about their experiences and text messaging is shown to possess a high level of emotional content despite being a 'short-hand style of communication'.

Donovan Chamberlayne calls his Buddhist perspective, 'dancing shoes' a case study. While this provides an accurate description, what he has written is much more than just a case study. Using a carefully woven and intricate narrative he blends together personal experience of loss, challenge presented in a professional role, concern for a drug user friend in crisis and experience of spirituality and Buddhist writings. This chapter shows how the personal, professional, political, social and spiritual are inextricably and inevitably linked. It is a refreshing breath of life experience gained from painful lessons as Chamberlayne brings to life the struggles encountered by social workers attempting to grapple with shifting, painful and difficult issues. Belief, creativity and imagination are brought together in a reflection on the social work task that is both affirming and non-dogmatic – a warm and welcome change from performance indicators, eligibility criteria and

budget-driven-thinking. And, a fitting end (and hopefully simultaneous new beginning) to this book.

Notes

1 For a review by Martin Smith of Kaplan (2007), see *Journal of Social Work Practice*, vol. 21, no. 3, pp. 411–413.

2 Strengthening community imagination is one of the explicit aims of the Bromley-By-Bow Centre, an arts based community centre evaluated by Froggett et al. (2005). This centre is notable for recognising and working with vulnerability as a basis of gaining creative strength – see Froggett & Chamberlayne (2004).

3 For a review by Tom Wengraf of two books by Ogden, *This Art of Psychoanalysis: Dreaming Undreamt Dreams and Interrupted Cries* (2005), and *Reverie and Interpretation: Sensing Something Human* (1999), see *Journal of Social Work Practice*, vol. 21, no. 3, pp. 408–411.

4 For a review by Dee Ohanlon of Pam Schweitzer, *Reminiscence Theatre – Making Theatre from Memories*, (2007), see *Journal of Social Work Practice*, vol. 21, no. 3, pp. 404–407.

References

Boal, A. (1979) *Theatre of the Oppressed*, Pluto Press, London.

Bollas, C. (1987) *The Shadow of the Object. Psychoanalysis of the Unknown Thought*, Free Association Books, London.

Crotty, M. (1998) *The Foundations of Social Research: Meaning and Perspective in the Research Process*, Sage, London.

Eliot T. S. (1920/1997) 'Tradition and the individual talent', in *The Sacred Wood. Essays on Poetry and Criticism*, Faber and Faber, London.

Freud, S. (1908/1988) 'Creative writers and day-dreaming', in *The Pelican Freud Library Vol. 14 Art and Literature*, Penguin, London.

Froggett, L. & Chamberlayne, P. (2004) 'From biography to practice and policy critique: a case study of community innovation', *Qualitative Social Work*, Vol. 3, no. 1, pp. 55–70.

Froggett, L., Chamberlayne, P., Wengraf, T. & Buckner, S. (2005) *Integrated practice – focus on older people*, Report of the Bromley by Bow Centre research and evaluation project, University of Central Lancashire and Open University, funded by the Dunhill Medical Trust 2002–5, 146 pp.

Gadamer, H-G. (2003) *Truth and Method,* (Second Revised Edition), Continuum, London.

Gosso, S. (2004) *Psychoanalysis and Art: Kleinian Perspectives,* Karnac Books, London.

Iser, Wolfgang (2000) *The Range of Interpretation,* Columbia University Press, New York.

Jones, K. (2006) 'A biographic researcher in pursuit of an aesthetic: the use of arts-based (re)presentations in "performative" dissemination of life stories', *Qualitative Sociology Review,* vol. 11, no. 1, pp. 66–85.

Hughes, T. (1997) *Tales from Ovid,* Faber and Faber, London.

Hughes, T. (1998) *Birthday Letters,* Faber and Faber, London.

Macrae, A. (1980) *York Notes on The Waste Land,* Longman, Essex.

Segal, H. (1974/1988) 'Delusion and artistic creativity: some reflections on reading *The Spire* by William Golding', in *Melanie Klein Today. Developments in Theory and Practice. Volume 2: Mainly Practice,* ed. E. Bott Spillius, Routledge, London.

Waddell, M. (1989). 'Living in two worlds: pyschodynamic theory and social work practice', *Free Associations* no. 15, pp. 11–35.

Wainwright, P. & Rapport, F. (2007) 'Conference Report. Circles within circles – qualitative methodology and the arts; the researcher as artist', *Forum Qualitative Social Research,* vol. 8, no. 3.

Winnicott, D. W. (1965) 'Communicating and not communicating leading to a study of certain opposites', in *The Maturational Processes and the Facilitating Environment,* Karnac Books, London.

Yasmin Gunaratnam

WHERE IS THE LOVE? ART, AESTHETICS AND RESEARCH

Almost three years ago, I was invited to speak at a multi-disciplinary conference on end of life care. The event coincided with my birthday and I had been ambivalent about the prospect of working that day. At the conference, I was confronted with a steady stream of Power-Point slides of statistics, charts and diagrams, many concerned with demonstrating the robustness and 'evidence' of different projects and initiatives. Undoubtedly nervous, but also defensive about my own forthcoming narrative-centred presentation, my mind started to wander. The sun was streaming through the high windows of the Victorian town hall, illuminating dust motes swimming in pools of light above the heads of participants. The room was warm and airless and I had begun thinking about whether I should adapt my presentation. In the midst of my distraction and seemingly from nowhere, the song 'Where is the Love?' from the hip-hop band Black Eyed Peas came into my mind. In the song, key social issues — terrorism, war, racism, greed and intolerance — are lamented. The opening lyrics ask: 'What's wrong with the world, mama?/ People livin' like they ain't got no mamas ...'. The chorus raises questions of integrity and forgiveness and appeals to a father figure: 'People killin', people dyin'/ children hurt and you hear them cryin'/ Can you practice what you preach/ and would you turn the other cheek/ Father,

Father, Father help us/ send some guidance from above/ 'cause people got me, got me questioning/ where is the love?' The power and urgency of this simple plea is amplified in childlike repetition at the end of the chorus 'Where is the love?/ Where is the love/ the love/ the love?'. At lunch time, after my presentation, I left the conference. I had a craving for Sri Lankan food and I went to eat in a local Sri Lankan restaurant by myself. The smells in the restaurant, the sounds and the tastes mingled with my birthday heightened feelings of loss for my own parents who had died a decade earlier and whose deaths had precipitated my research into palliative care. A year after this experience, 'Where is the Love?' became a frequently requested song on London radio stations, as Londoners struggled to make sense of the 7 July suicide bombings on the Underground. Soon afterwards, I began using the song in my teaching and training with health and social care professionals to discuss the suppression and the complexity of emotions in intercultural care.

I have begun with this personal account because it encapsulates the three main themes that this article engages with. First, I am interested in the inter-relationships and disjunctions between, on the one hand, forms of emotional thinking (Waddell, 1989) and 'sensuous knowing' (Taussig, 1993) that engage bodies, biography and emotion, and on the other, techno-rational forms of knowledge that deny incoherence and ambiguity and evade emotionality. These inter-relationships are critical in understanding the dynamics that can shape practice and creativity in welfare services. They also constitute a tension — perhaps even a paradox — that is embodied in this very act of trying to *write* about creative processes and the artistic.

Second, at a conceptual and a practical level, as a researcher working with questions of social difference in health and social care, I want to understand more about where artistic representations might come from and what art can offer us in our relationships to social difference and to otherness. My very practical concern is with what art *does* in public presentations. Why does art appear to touch and move audiences in ways that the written word and rationalist presentation doesn't even come close to? For example, since I have been using art in research presentations, I have noticed that I receive far more feedback and also post-presentation requests for poems or for extracts from short stories than I do for the academic papers on which the presentations are based.

My third area of interest lies in reclaiming presentation as a vital, though often neglected, part of the research process. It is rarely accounted for — financially, conceptually or emotionally — by researchers and funders. It can come to represent the validation of what is already known and the closure of the research process as discovery and invention. Yet, what I want to demonstrate is that research can become most alive in the field of presentation, carrying with it new understanding, ethical responsibilities and corporeal exposure.

Using experiential examples and drawing upon ideas from psychoanalytic aesthetics and post-structuralist theory, I will explore the form and content of my artistic representations as encounters and events that can 'make way' (Caputo, 1997) for what is beyond immediate recognition and realist representation. In many ways, the structure of the article itself mimics the pull, tug and unevenness of the combining of art with social theory, involving a sliding between personal experience, academic and artistic literature and analysis.

Creativity, care and social welfare

It is difficult to discuss the place and the value of creativity within the context of social welfare without also recognising how the proliferation of market and consumerist principles (Froggett, 2002) and the sheer intensity of caring work with inadequate resources (Waddell, 1989; Jones *et al.*, 2006) can suffocate and marginalise the spaces that enable creativity and the aesthetic. Drawing attention to the value of creativity and art within such organisational contexts can seem both trivial and grandiose — far removed from the realities and constraints of 'real world' practice. It can feel especially inappropriate and/or insensitive to talk about art, when so much of work across the welfare services is concerned with human pain, frailty and suffering. As Waddell (1989) has recognised with specific regard to social work, there are incessant attacks upon emotional thinking in social work that is characterised by an inherent paradox involving:

> ... the necessity of thinking in order to modulate pain, and the difficulty of doing so because pain is so hard to bear, and the forces against thinking so recalcitrant and becoming ever more so.
>
> (Waddell, 1989, p. 32)

Such relations are also present in the palliative care field where much of my research has been conducted and which involves work with people with life-limiting illnesses and those who are dying. An environment of care marked by repeated losses and grief, where trauma can be unspeakable and where bodies hurt, decompose, unravel and fade. In addition to the complex physical, emotional and socio-economic needs of patients and carers (Croft, 2004), palliative care professionals face very real constraints of time in their work with dying people. As one hospice social worker described the 'pressures' on her practice: 'it's now or never, basically' (Gunaratnam, 1997, p. 172).

Yet somewhat paradoxically, in a field of care that is socially and symbolically marginalised (Lawton, 2000) and that is emotion-rich and time-scarce, emotional thinking and creativity can be a vital part of professional practice, not only through structured activities such as art or music therapy (see Connell, 1998; Schroeder-Sheker, 1994), but also through the enfolding of the artistic into everyday practices: the researcher who 'as a last resort' spontaneously tells an agitated patient a story that comforts and calms her (Stanworth, 2003, pp. 11–12); the psychologist who plays Shubert's 'Ave Maria' sung by Jesse Norman for a patient during a painful medical procedure (De Hennezel, 1997, p. 6); the Japanese doctor who writes personalised, traditional Japanese poems (tanka) for his patients (Tamba, 2006); the social worker who after years of trying 'very hard' to acquire expertise in different areas of her work, relaxes her desire for structure and certainty, recognising: 'I am now comfortable to work with mystery, to wait for the unspoken to emerge, to work with image and metaphor' (Mason, 2002, pp. 26–27).

The divisions between care and art and between rationality and sensuality in these examples are blurred, but they also evoke a sense of extra-ordinary impulsiveness and improvisation that appears outside of structure and forethought, yet is fully situated in

the context of palliative care. Qualities that are not dissimilar to my experiences of using art in research. In focussing specifically upon my presentation of research findings through art — photography, music, poetry, literature — I want to examine how artistic representation can create opportunities for evoking and affirming some of the poetics of human experience, that is: the non-measurable; the contradictory; that which exceeds identity categories (Adorno, 1984); the 'indescribable and the undiscussible' (Bar-on, 1999); and the hopefulness of a 'not yet' (Bloch, 1986).

Taking root: creativity and presentation

> ... poems happen. They spring up like weeds, growing through cement cracks, under the most inhospitable of conditions, like leaves trapped in a fence or wall, like fungi growing in crevices.
>
> (Caputo, 1993, p. 183)

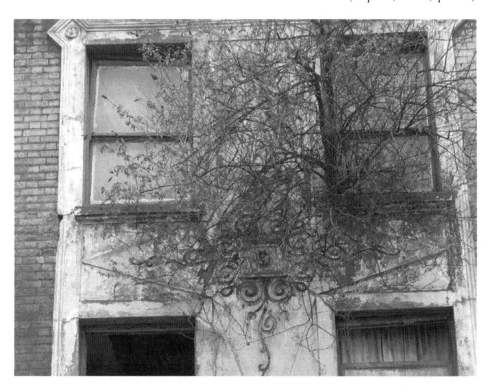

FIGURE 1 A tree growing through an abandoned house in the East End of London.

My use of art in research presentations has emerged over the past four years and was significantly enabled by a move outside of academia and into the black voluntary sector. Although my research focus has remained broadly the same, within the voluntary sector I was presenting research to more socially differentiated and non-specialist audiences. There is no doubt that I felt challenged in these new

environments to find more accessible ways of communicating research and without compromising complexity. However, I do not wish to give the impression that these changes in style were wholly rational or controlled. While I prepare materials for presentations, what actually *happens* during a presentation, both what I say/show and how this is received/responded to is unpredictable. In this regard, I see the *experience* of presenting in similar terms to Bourdieu's (1990) notion of 'practice': as involving a sensual, moment-by-moment unfolding of activity that is characterised by presence, context and improvisation. What is especially risky and jeopardising about the practice of public presentation is the role of judgement in linear time, that as Arendt (1978) has pointed out is both unpredictable and irreversible.

In preparing research presentations, I often find that my thoughts and judgement about what to include in a presentation are hijacked by a bubbling up of images, music, and words or phrases, evoked and literal, from interviews and research interactions. External and apparently unrelated events can have a similar effect and can root themselves in my analysis of individual cases or topics. I feel called, or more often whispered to and pestered, to take account of wispy and unformulated connections. I can find myself drawn to certain images or to photograph something (such as the tree growing out of the house in figure 1[1] that materialises the Caputo quotation so beautifully) and not *know* why.

It is only at a later stage of assembling a presentation that these seemingly haphazard fragments of thought and image can come together and make sense. At other times the impulse for artistic representation springs from a profound irritation at the inadequacy of my analysis, use of language or attempts to represent a fullness of lives. I have a strong sense that I have missed or forgotten something. It is not uncommon for the missing fragment to come to me in my sleep, so that in the morning before a presentation I am scrambling through books or poetry, my own writing or photographs to incorporate the missing item. Sometimes the mosaic of these different representational forms can 'work', to the extent that I feel that I am closer to what I had in mind (and heart). At other times the sense of an absent presence continues to haunt a presentation.

What can connect these very different experiences is the delay and distance between an event (such as an interview) and how artistic representations emerge or pull me towards them. Using Arendt's (1978) work on imagination to discuss reflective thinking and practice in social welfare, Lynn Froggett (2002) has suggested that it is precisely the withdrawal of the intellect and the holding of ambivalence that can free creativity:

> ... *all* thinking involves a retraction of the mind from commonsense awareness of the immediacy of the given world and is in some sense reflective in that the mind becomes the 'screen' or 'container' where images and imageless thoughts are formed and refashioned ... Perhaps what we are referring to when we speak of reflective thinking and practice is the ability to delay the return of thought to the outer world long enough to turn things around, experiment with perspective, infuse with emotion, manipulate, modify or enjoy them. This involves a tolerance of ambiguity.
>
> (Froggett, 2002, p. 179)

As Froggett suggests, creativity and 'experimentation with perspective' require a holding off of interpretation and judgement, and a pacing, backwards and forwards, between outer and inner worlds. For me, such movements are also intrinsically ethical and corporeal. They involve an emotional and sensual vulnerability, an openness to be touched by demands from the outside world and a surrendering of intellect, enabling what the poet John Keats (1958, p. 193) termed 'negative capability' — a capacity 'of being in uncertainties, mysteries, doubts, without any irritable reaching after fact and reason'. Relations expressed with great insight and power in the eighteenth century poem 'The Tables Turned' by William Wordsworth (1798):

Sweet is the lore which nature brings.
Our meddling intellect
Misshapes the beauteous forms of things: —
We murder to dissect.

Enough of science and of art;
Close up these barren leaves.
Come forth, and bring with you a heart
That watches and receives.

Art as an event: accounting for creativity

What makes me think? Something gets under my skin, something disturbs me, something elates me, excites me, bothers me, surprises me.

(Diprose, 2002, p. 132)

Ideas about how creativity can breakthrough the constraints of the intellect and commune with intangible realities in external and internal worlds can be found in pychoanalytic and post-structuralist theorising. There are strong resonances (but also differences) between what the pyschoanalyst Bollas (1987) describes as the 'unthought known' in his evocatively entitled book *The Shadow of the Object* and how the philosopher Deleuze (1994) describes the generative role of writing:

One's always writing to bring something to life, to free life from where it's trapped ... a spark can flash and break out of language itself, to make us see and think what was lying in the shadow around the words, things we were hardly aware existed.

(Deleuze, 1994, p. 141)

Several post-structuralist theorists who have written about inspiration and originality have done so through the conceptualisation of thought and writing as an 'event' (Lyotard, 1988; Deleuze & Guattari, 1987), distinguished by the singular and unpredictable thrown-togetherness of disparate, external elements (Clark, 2003). Derrida, for example, has attributed his creativity to a process whereby:

A sort of animal movement seeks to appropriate what always comes, always, from an *external* provocation.

(Derrida, 1995, p. 352, emphasis in original)

The uncompromising emphasis ('always') given to the outside world in the first stages of creativity, even when Derrida's description of 'a sort of animal movement' is suggestive of an instinctive and embodied drive, is where differences lie between post-structuralist and psychoanalytic theorists. From post-structuralist perspectives, there has been a move to decentre and disperse creativity as being located solely in the individual, thereby also challenging modernist and romantic notions of creativity and art as emanating from exceptionality and genius. Unlike psychoanalytic theory, the notion of creativity in post-structuralist scholarship is deconstructed to the extent that its origins are always precarious and cannot be sited in any universalistic terms.

For some theorists such as Deleuze and Derrida, creativity involves a responsive and responsible opening out to opportunistic connections with the outside world that together create and bring into being an 'event'. Such openings are achieved through language and carry with them the potential not simply to describe but also to transform and invent new realities. As Clark (2003) has suggested with regard to research, the flourishing of creativity is connected to openness and receptivity on the part of the researcher:

... thinkers or researchers have to not only try and comprehend what is happening but at the same time to open themselves to the transformative effects of these happenings.

(Clark, 2003, p. 34)

In relation to difference, this brings with it ethical concerns: how we might 'make way' (Caputo, 1997) for the unfamiliar and strange, whilst recognising that a 'grasping' encounter with difference and its translation into language and category — itself a process that involves imagination (Castoriadis, 1987) — can 'wipe out its originality' (Blanchot, 1971, p. 76).

From a different vantage point, psychoanalytic perspectives relocate and situate creativity in interiority. As Glover (2000) has noted in relation to art, the psychoanalytic method:

... involves an approach which is highly sensitive to the way in which meanings are metaphorised through the play of language, as well as via the actual *materials* of the visual arts.

(Glover, 2000, emphasis in original)

Despite their variations, psychoanalytic theories share a common concern with the processes whereby creativity and aesthetics evoke, either through regression or through construction, psycho-somatic and pre-verbal infantile experience. Winnicott (1971) for example, whose work has had a significant influence on psychoanalytic aesthetics, sites the origins of creativity in the infant–mother relationship: in the

mother's adaptive presentation of the outside world to the baby at a pace when the infant is ready to 'find' the external world. Central to this relationship is the mother's face — what the mother sees in the infant is reflected back, so that through her gaze the infant sees/recognises something of his/herself. Winnicott describes this as 'a two-way process in which self-enrichment alternates with the discovery of meaning in the world of seen things' (p. 132). For Winnicott, this alternating movement between subjective and objective realities is negotiated by a liminal 'potential space'. Hand (2000) has summarised the significance of this psycho-somatic and spatio-temporal relationship to creativity in the assertion that:

> When 'what we create' and 'what we find' are 'linked up' we are of course in the realm of the transitional object, that 'third area' or 'potential space' in which play and symbol-making begin, and continue throughout life.

My own experience of (re)creating art from research lies somewhere between an awareness of the interplaying and partnerships between these external and internal worlds. I have a sense that my use of art is a response to something that has a life in the external world, that has meaning, histories and 'truth/s'. It constitutes an 'event' as theorised by those such as Deleuze and Derrida. Nevertheless, the impulse to create poems and short stories from my interviews (but also to do more 'dry' policy oriented work), is related to complicated complicities and ambivalence in my position as a minoritised woman in academia.

I am painfully aware of the inaccessibility of most academic writing (and as I am writing this article) and of the elitism of academia, yet I also believe in the transformative potential and power of ideas and social theory. In common with many researchers, I have a sense of ethical responsibility as a witness to the testimony of others (Frank, 1995). However, this concern accompanies a more ambiguous and open-ended sense of obligation described by Bourdieu in his reflections on his own class migration, from being the son of a farmer to an intellectual (Bourdieu & Waquant, 1992, pp. 208–209):

> I feel I have to be answerable — to whom, I do not know — for what appears to me to be an unjustifiable privilege.

The artistic representations that I have been impelled to create are thus also the result of intrapsychic processes. These processes are beyond my conscious rationalisation, but at some level are caught up with an exploratory 'drive towards self-knowledge' (Williams & Waddell, 1991) that is inseparable from the singularity of biography and the patterning of social difference. So, while I use artistic representations to communicate about others and external realities that I have stumbled into, they are always also about me and offer uncertainties of embodiment, judgement and relationship. This is why I believe that so many researchers can feel uniquely vulnerable and exposed when using art (particularly their own art) in presentations and why art can be marginalised in favour of more 'objective' and rationalist approaches that deny practitioner subjectivity, social location and emotional involvement.

Rationality, art and a 'crisis of representation'

Debates about the tensions and relationships between art and rational knowledge have a long history, dating back to the Greek philosophers Plato and Aristotle. Drawing upon these ideas, Adorno (1984), the social theorist and philosopher, has argued that art offers neither a rational duplicate of the objective world, nor an inscription of the 'psychic content' and intents of the artist, rather it is a part of an interactive and somewhat mysterious relation between objectivity and subjectivity that is conveyed through 'mimesis':

> Mimesis is the ideal of art, not some practical method or subjective attitude aimed at expressive values. What the artist contributes to expression is his ability to mimic, which sets free in him the expressed substance.
>
> (Adorno, 1984, p. 164)

The acute contradictions of these relationships are animated through Adorno's dense theorising and use of language. His use of the word 'mimesis' for instance, as an artistic ideal, combines imitation and repetition with otherness and singularity. It is this slippery, paradoxical quality of art and its relationship to an unruly, autonomous other, defying categorisation, identification and incorporation that is so relevant not only to research and to professional practice but also to all human relationships.

We can get to know people (or to think that we know and understand others), but there is always something unfathomable that exceeds and escapes categorisation, knowing and representation. Something that can surprise and/or devastate, particularly in times of late modernity, marked by the contingency of the social and material worlds (Giddens, 1991; Thrift, 2004). In the social sciences this predicament lies at the heart of what has been referred to as a 'crisis of representation' (Denzin, 1997) and has precipitated the exploration of new and experimental forms of representing research, such as 'messy texts' (Marcus, 1994); multi-voiced textual practices (Gunaratnam, 2001; Lather & Smithies, 1995); and performance art (O'Neil, 2002). For some researchers this has meant a move away from 'realist practices of representation' (Marcus, 1997, p. 410) in favour of the generation of 'doubled practices' where research:

> … becomes a site of the failures of representation, and textual experiments are not so much about solving the crisis of representation as about troubling the very claims to represent.
>
> (Lather, 2001, p. 201)

Aesthetics and 'others'

Engendered in the move towards more artistic and experimental forms of doing and representing research is a concern with difference, strangeness and otherness. In relation to social inequalities and difference, it has been claimed that artistic

representation can subvert dominant ideologies (Benjamin, 1992) and convey hidden or denied processes and subjugated experiences:

> Works of art are ciphers of the social world — in art works we are able to access the 'sedimented stuff' of society — what is normally unseen/hidden/overlooked. The function of aesthetics is to reveal the unintentional truths about the social world and to preserve independent thinking.
>
> (O'Neil, 2002, pp. 78–79)

If art is capable of revealing 'unintentional truths' about others (both to audiences and to researchers themselves), I have also found that art can simultaneously reflect and engage audiences with the difficulties, confusions and responsibilities of representing and encountering difference. Within the time constraints of a research presentation, I have little doubt that a poem or an image is highly economic in conveying some of the intricacies of difference and in enabling complex and ambivalent interpretations. At the same time, art can maintain an 'inaccessible alterity' (Lather, 2001, p. 214) and does not offer up otherness on a plate that can be consumed through empathy or easy/lazy categorisation. In this sense, art and creativity can also be constitutive of a hopefulness: the possibility of bringing about new and uncertain ways of encountering difference and 'what has never been' (Bloch, 1986, p. 6).

An example is useful here. In one of my poems entitled 'The Bed' (Gunaratnam, 2005), the reader is invited to consider different and co-present representations of 'race', masculinity, bodies and emotions through the experience of illness:

> Intent concern accompanied the glinting blade
> that sliced from hip to hip.
> A tributary
> meandering down into dry recesses of manliness.
> A cut so deep, so low
> folds of distinction reopen.
> Hard layers. Moist untouched spaces.
> Shiny black skin. Striated muscle.
> Prowess
> flow into tired, needy sinews of a pure new
> softness

In the poem, my commentary about 'Edwin' an African Caribbean man with prostate cancer ('He has a story to tell/ he doesn't know/ how'), interweaves with unmediated extracts from his interview account, culminating in an imagined scene away from the research gaze. During our interview, Edwin had resisted my suggestion that his move from the marital bed to sleeping on a settee since his wife's admission into a nursing home was due to feelings of loss ('Do I miss her?/ He laughs'). Instead, he emphasised that the settee was more convenient for his need for more frequent urination during the night ('I just roll off/ pee in the bucket/ it's easier'). Whilst grounded in the realities of an interview and a life, the poem contains elements of

fantasy through which intersubjective relations in the interview are brought into play and interfere with both my commentary and Edwin's.

By using the poem in presentations I have been able to convey something of the 'body-person' of Edwin and a tussling of perspectives and interpretations which maintains alterity through the insecurities of meaning surrounding the bed that were a central part of the interview [see Gunaratnam (2003), Chapter 6 for an in-depth analysis of the interview]. The poem also connects the subjective and intersubjective with wider structural and historical processes by initiating a move towards restoring an interiority to black masculinity (a 'not yet') in a social context where dominant representations of black men are characterised by the hyper-physical and hyper-sexual (St Louis, 2000; Gunaratnam, 2003):

> In the shadows of nightfall,
> he again feels the knife.
> This time in his heart.
> Quivering. Shimmering.
> In this place of dislocation,
> contorted emasculation
> he marks his loss. Silently
> with truth.
> Rolling the saltiness around his mouth.
> he leans forward slowly
> pisses into the bucket.
>
> Relieved.
>
> (Gunaratnam, 2005, p. 121)

The capacity to feel and to live 'in the question' (Keats, 1958) of difference, rather than to categorise and quantify its weight is challenging, particularly in social welfare agencies where anti-discriminatory practice can be underwritten by complicated emotions of anxiety, guilt, fear and shame (Gunaratnam & Lewis, 2001). Art does not necessarily by-pass these difficult emotional dynamics, but, it can on occasions enable a responsiveness that is capable of modulating uncomfortable psychic experiences whilst receiving uncertainty and ambivalence.

At one hospice based event at which I had used the poem 'The Bed' in my presentation, an Indian woman bi-lingual advocate admonished me playfully in the tea-break: 'I can't believe you said "pisses" in public'. By coincidence, this was also the same person who I had interviewed some months before as a part of her palliative care team. In returning to the transcript of that group interview in writing this article, I was struck by a passage in the discussion that had turned to the advantages and disadvantages of shared ethnicity. To the surprise of her team, the advocate had given the following example as a disadvantage of commonalities in ethnicity:

> … going to see an elderly Asian patient with prostate cancer, if you had a particular list of questions you're supposed to ask, I could not ask the question about his sex life … I'm just about getting my head around questions like toilets and things like that … and even that is a bit embarrassing sometimes.

By articulating these very 'toilet' experiences in public, I could see how the poem triggered a defensive response of anxiety and embarrassment (no doubt further intensified by me as an Asian woman) that did not allow for metaphorical meaning, closing down an opening to the emotional pain that the poem traces. In contrast, soon after the same presentation, I received an email from a male, Pakistani advocate who, in referring to 'The Bed', wrote:

> It reminded me of a couple of occasions when I was trying to ask someone certain questions. He was replying in a similar style and I was trying to work out if he was trying to hide his emotions by using practical problems as an excuse or was he telling the truth ... ? I think a bit of both maybe!

Aestheticising suffering?

Although art holds a potential to incite critical reflection, Adorno (1984), amongst others, has warned of the limits of representation and the dangers of aestheticising 'barbarism', suffering and injustice. Adorno's warnings, written with Auschwitz in mind, articulate the risks of the immoral and arid distances that can open up between works of art, the artist and the horrors of worldly realities; distances scorned and deplored at the level of everyday life, by the doctor and poet William Carlos Williams. In his poems, Williams assaults the reader with the ethical distinctions between 'ideas and action; between the abstract and the concrete; between theory and practice; and not least between art and conduct' (Cole, 1989, p. 193). For instance, a Williams' poem that I have used in presentations 'Death' (Williams, 1950), confronts audiences with the fleshy realities of death ('Put his head on/ one chair and his/ feet on another and/ he'll lie there/ like an acrobat').

In the midst of the very beauty of the poem, Williams refuses to concede to the aesthetic and pushes us closer towards the shame and existential terror that death and dying people provoke ('his eyes/ rolled up out of/ the light — a mockery/ which/ love cannot touch/ just bury it/ and hide its face/ for shame'). My experience of using art, such as Williams' poems to talk about the intersecting relationships between death and difference is that art can evoke an emotional and sensual involvement with difference that 'erupts from the tension between the mimetic and the rational/ constructive' (O'Neil, 2002, pp. 83–84) elements of a presentation. This is not to say that such aesthetic experience is based upon a pleasure in the suffering of others. As Meltzer and Harris-Williams (1988) have pointed out, all aesthetic experience contains 'aesthetic conflict' based upon the deeply held tensions between beauty and terror that emanate from infantile experiences of the mother's body. Similarly, Bollas (1987) has suggested that:

> ... aesthetic moments are not always beautiful or wonderful — many are ugly and terrifying but nonetheless profoundly moving because of the existential memory tapped.

(Bollas, 1987, p. 29)

Against the backdrop of such theorising, I do not wish to give the impression that art *per se* can be a more effective medium than say a research report or more traditional presentation in communicating research findings, nor that it can close the distances between an 'us' and a 'them'. It is more the case that artistic representation can convey meanings that are independent of linguistic systems and rationalist, sequential ordering — this is why I believe that art can move us at an emotional and sensual level and have an impact upon thinking. Moreover, art in its ambiguities, discontinuities and reversals, can be more open than linguistic representation to holding the threatening dynamic between 'knowing' and 'not knowing' that can involve denial, avoidance and detachment from difficult or painful realities, forms of evasion that Cohen has named in the wonderful term 'pseudo-stupidity' (Cohen, 2001).

This capacity to convey ambiguity and incoherence is why art is always a gamble in communication and relationship for presenters and audiences, full of risk, chance and possibilities of 'hit and miss'. Somewhat paradoxically, I believe that it is through our very awareness of its risks, omissions and limits, that art as opposed to more rationalist research accounts can expose us to a fuller relationship to otherness and to what is unknown and unfathomable. It is this contradictory relationship that the novelist and philosopher Maurice Blanchot (1993) describes when he considers the affinities between our attempts to 'grasp' difference and otherness (p. 43) and the 'eternal torment of our language when its longing turns back toward what it always misses' (p. 36).

Conclusion

In a recent project on palliative care, older people and ethnicity (Gunaratnam, 2006) involving group interviews with health and social care professionals, I was struck by the recurring metaphor of tightrope walking used to describe professionals' feelings about intercultural care. The metaphor with its evocations of a perilous balancing act, using interacting combinations of knowledge, vulnerability, danger, risk, intuition and skill has some relevance to my use of art in public presentations. This vulnerability has different facets. It involves 'the tug of our vain selves' (Cole, 1989, p. 195) that is a part of the fear of public 'failure' and the sense of spectacular humiliation such failure can entail. It involves exposing something of the highly personalised coincidence of external and internal events that lie beneath creative moments, whilst taking the chance that such coincidence may have broader resonance. It also means some level of engagement with the presuppositions of public presentation that include performance, authority, persuasion and illusions of connectedness; an engagement that is coupled with an ever-present awareness that once a presentation is over the 'speaker and the audience rightfully return to the flickering, cross-purposed, messy irresolution of their own unknowable circumstances' (Goffman, 1981, p. 195).

The tightrope walking metaphor is not without its limitations however. In producing research presentations, I am aware that for my research to have an impact — 'to make a difference' — it must engage its 'target audiences' and within constraints of time and relationship. I am therefore concerned with questions of accessibility, relevance and economy. Yet, unlike the tightrope walker, I am not wholly concerned with playing to the immediate audience. I have obligations to my

research participants, to the density of their stories and to the meanings of their lives and deaths which always far exceed, but must by necessity fit into the 'sound bite' opportunities provided by public presentations. It is this positioning between an open-ended responsibility to others and a set of disciplinary practices with their own demands and constraints that Spivak has recognised as being 'caught between an ungraspable call and a setting-to-work' (1994, p. 23). Creativity and art do not lessen this taut ethical position of being 'caught' any more than rationalist presentations do. Rather, art in its open ambiguities and limitations can reconnect researchers and audiences to the precariousness of internal and external worlds and to fundamental questions of what can be communicated and understood, as well as what is 'not yet' (Bloch, 1986).

What I have learned through my experiences and experiments with using art in public presentations — through my breathing, nervous hands and faltering voice — is that the value of aesthetic experience — creativity and receptivity — can be less about the representational qualities of a medium and is more about the mutual social, emotional and corporeal vulnerability that connects us to one another. A vulnerability that is all too often resisted, denied or avoided in research and in professional practice.

Where is the love?/ the love/ the love? ...

Note

1 The photograph in figure 1 was taken with Steven McDermott as part of the 'Sociology Live' training programme at Goldsmith's College, 2007.

References

Adorno, T. (1984) *Aesthetic Theory*, translated by C. Lenhardt, Routledge, London.

Arendt, H. (1978) *The Life of the Mind*, Secker and Warburg, London.

Bar-on, D. (1999) *The Indescribable and the Undiscussible: Reconstructing Human Discourse After Trauma*, Central European University Press, Budapest, Hungary.

Benjamin, W. (1992) *Illuminations*, Fontana Press, London.

Blanchot, M. (1971) *Friendship*, translated by Elizabeth Rottenberg, Stanford University Press, Stanford, CA.

Blanchot, M. (1993) *The Infinite Conversation*, translated by Susan Hanson, University of Minnesota Press, Minneapolis & London.

Bloch, E. (1986) *The Principle of Hope* (vols 1–3), translated by N. Plaice, S. Plaice & P. Knight, Blackwell, Oxford.

Bollas, C. (1987) *The Shadow of the Object — Psychoanalysis of the Unthought Known*, Columbia University Press, New York.

Bourdieu, P. (1990) *The Logic of Practice*, Polity Press, Cambridge.

Bourdieu, P. & Waquant, L. J. D. (1992) *Invitation to Reflexive Sociology*, University of Chicago Press, Chicago.

Caputo, J. (1993) *Against Ethics: Contributions to a Poetics of Obligation with Constant Reference to Deconstruction*, Indiana University Press, Bloomington & Indianapolis.

Caputo, J. (1997) *Deconstruction in a Nutshell: A Conversation with Jacques Derrida*, Fordham University Press, New York.

Castoriadis, C. (1987) *The Imaginary Institution of Society*, Polity Press, Cambridge.

Clark, N. (2003) 'The play of the world', in *Using Social Theory: Thinking through Research*, eds M. Pryke, D. Rose & S. Whatmore, Sage in association with the Open University, London, pp. 28–46.

Cohen, S. (2001) *States of Denial*, Polity Press, Cambridge.

Cole, R. (1989) *The Call of Stories: Teaching and the Moral Imagination*, Houghton Miffin Company, Boston.

Connell, C. (1998) *Something Understood — Art Therapy in Cancer Care*, Wrexham Publications in association with Azimuth Editions, London.

Croft, S. (2004) *Social Work and Health Inequalities — A Palliative Care Perspective*, [online] Available at: http://www2.warwick.ac.uk/fac/cross_fac/healthatwarwick/research/devgroups/socialwork/swhin/esrc_seminar_series/seminar_1/croftpaper.pdf, accessed March 2007.

De Hennezel, M. (1997) *Intimate Death: How the Dying Teach Us How to Live*, translated by Carol Brown, Warner Books, London.

Deleuze, G. (1994) *Difference and Repetition*, Athlone Press, London.

Deleuze, G. & Guattari, F. (1987) *A Thousand Plateaus: Capitalism and Schizophrenia*, University of Minnesota Press, Minneapolis (originally published in 1980).

Denzin, N. (1997) *Interpretative Ethnography: Ethnographic Practices for the 21st Century*, Sage, London.

Derrida, J. (1995) *Points … Interviews, 1974–1994*, Stanford University Press, Stanford, CA.

Diprose, R. (2002) *Corporeal Generosity: On Giving with Nietzsche, Merleau-Ponty and Levinas*, SUNY Press, New York.

Frank, A. (1995) *The Wounded Storyteller: Body, Illness and Ethics*, The University of Chicago Press, Chicago.

Froggett, L. (2002) *Love, Hate and Welfare: Psychosocial Approaches to Policy and Practice*, Policy Press, Bristol.

Giddens, A. (1991) *Modernity and Self-Identity: Self and Society in the Late Modern Age*, Polity Press, Cambridge.

Glover, N. (2000) *Psychoanalytic Aesthetics: The British School*, [online] Available at: http://www.human-nature.com/free-associations/glover/, accessed March 2007.

Goffman, E. (1981) *Forms of Talk*, Blackwell, Oxford.

Gunaratnam, Y. (1997) 'Culture is not enough: a critique of multi-culturalism in palliative care', in *Death, Gender and Ethnicity*, eds D. Field, J. Hockey & N. Small, Routledge, London, pp. 166–186.

Gunaratnam, Y. (2001) 'Eating into multi-culturalism: hospice staff and service users talk food, "race", ethnicity and identities', *Critical Social Policy*, vol. 21, no. 3, pp. 287–310.

Gunaratnam, Y. (2003) *Researching 'Race' and Ethnicity: Methods, Knowledge and Power*, Sage, London.

Gunaratnam, Y. (2005) 'The Bed', in *Relating Experience: Stories from Health and Social Care*, eds C. Malone, L. Forbat, R. Martin & J. Seden, Routledge and Open University, London, pp. 120–121.

Gunaratnam, Y. (2006) *Ethnicity, Older People and Palliative Care*, Joint report from the National Council for Palliative Care and the Policy Research Institute on Ageing and Ethnicity, National Council for Palliative Care, London.

Gunaratnam, Y. & Lewis, G. (2001) 'Racialising emotional labour and emotionalising racialised labour: anger, fear and shame in social welfare', *Journal of Social Work Practice*, vol. 15, no. 2, pp. 125–142.

Hand, N. (2000) 'Hedda Gabbler, psychoanalysis and the space of (the) play', *Free Associations*, [online] Available at: human-nature.com/free-associations/hand.html, accessed March 2007..

Jones, C., Ferguson, I., Lavalette, M. & Penketh, L. (2006) *Social Work and Social Justice: A Manifesto for a New Engaged Practice*, [online] Available at: http://www.liv.ac.uk/sspsw/Social_Work_Manifesto.html, accessed March 2007.

Keats, J. (1958) 'Letter to George and Tom Keats, 21 December 1817', in *The Letters of J. Keats: 1814–1821*, ed. H. E. Rollins, Cambridge University Press, Cambridge, pp. 193.

Lather, P. (2001) 'Postbook: working the ruins of feminist ethnography', *Signs*, vol. 27, no. 1, pp. 199–227.

Lather, P. & Smithies, C. (1995) *Troubling the Angels: Women Living with HIV/AIDS*, Westview Press, Colarado.

Lawton, J. (2000) *The Dying Process: Patients' Experiences of Palliative Care*, Routledge, London.

Lyotard, J. (1988) *The Postmodern Condition: A Report on Knowledge*, University of Minnesota Press, Minneapolis.

Marcus, G. (1994) 'What comes (just) after "post"?: the case of ethnography', in *The Handbook of Qualitative Research*, eds N. Denzin & Y. Guba, Sage Publications, Thousand Oaks, CA, pp. 563–574.

Marcus, G. (1997) 'Critical cultural studies as one power/knowledge like, among, and in engagement with others', in *From Sociology to Cultural Studies: New Perspectives*, ed. E. Long, Blackwell, London, pp. 399–425.

Mason, C. (ed.) (2002) *Journeys into Palliative Care: Roots and Reflections*, Jessica Kingsley, London.

Meltzer, D. & Harris-Williams, M. (1988) *The Apprehension of Beauty*, Clunie, Ogden, London.

O'Neil, M. (2002) 'Renewed methodologies for social research: ethno-mimesis as performative praxis', *Sociological Review*, vol. 50, no. 1, pp. 75–88.

Schroeder-Sheker, T. (1994) 'Music for the dying: a personal account of the new field of music thanatology history, theories, and clinical narratives', *Journal of Holistic Nursing*, vol. 12, no. 1, pp. 83–99.

Spivak, G. (1994) 'Responsibility', *Boundary 2*, vol. 21, no. 3, pp. 19–64.

St Louis, B. (2000) 'Readings within a diasporic boundary: transatlantic black performance and the poetic imperative in sport', in *Un/settled Multiculturalisms: Diasporas, Entanglements, Transruptions*, ed. B. Hesse, Zed Books, London, pp. 51–72.

Stanworth, R. (2003) *Recognising Spiritual Needs in People Who Are Dying*, Oxford University Press, Oxford.

Tanba, K. (2006) 'Care mind in thirty-one syllables', *Progress in Palliative Care*, vol. 14, no. 5, pp. 252–254.

Taussig, M. (1993) *Mimesis and Alterity*, Routledge, London.

Thrift, N. (2004) 'Performance and performativity: a geography of unknown lands', in *A Companion to Cultural Geography*, eds J. S. Duncan, N. C. Johnson & R. Schein, Blackwell, Oxford, pp. 121–136.

Waddell, M. (1989) 'Living in two worlds: psychodynamic theory and social work practice', *Free Associations*, vol. 15, pp. 11–35.

Williams, M. & Waddell, M. (1991) *The Chamber of Maiden Thought. Literary Origins of the Psychoanalytic Model of the Mind*, Routledge, London.

Williams, W. (1950) 'Death', in *The Collected Poems of William Carlos Williams, Volume 1, 1909–1939*, eds A. Walton & C. MacGowan (1987), Carcanet, Manchester, pp. 346–348.

Winnicott, D. (1971) *Playing and Reality*, Pelican, London.

Wordsworth, W. (1995) 'The Tables Turned — An Evening Scene on the Same Subject', in *Wordsworth: Poems Selected by Seamus Heaney*, Faber and Faber, London.

Karen V. Lee

GEORGIE'S GIRL: LAST CONVERSATION WITH MY FATHER

Introduction

In this article, the author uses dialogue to reflect on the father–daughter parenting relationship. The thematic analysis culminates in recommending the use of reflecting on pivotal conversations between parents and children during the mourning process. The dialogue begins in the hospital during the last day of her father's life. After 29 years, her father begins to express his thoughts and feelings about her life. This last conversation gives the author strength to cope with life, love, death, and parenting.

This article represents the usefulness of a dialogic approach to social science research. Denzin and Lincoln (1994) emphasize that qualitative researchers are searching for ways to tell stories. Crossover between creative, personal, and research writing has become a valid research method for composing narratives in discursive fields of scholarly research. There are important narrative researchers: Jerome Bruner, Helen Cixous, Maxine Greene, Milan Kundera, Patti Lather, Natalie

Goldberg, Susan Wooldridge, Mary Catherine Bateson. Bruner believes people are, by nature, narrative beings.

There are pros and cons in auto-ethnographic research. Arguing the pros involves the transformation process from writing stories. First, auto-ethnography 'refers to writing about the personal and its relationship to culture. It is an autobiographical genre of writing and research that displays multiple layers of consciousness' (Ellis, 2004, p. 37). Second, Palmer (1998) claims a sense of relatedness requires 'teaching students to intersect their autobiographies with the [subject's] story' (p. 108). Cone and Harris (2000) argue for 'a holistic approach to reflection that involves the student's intellectual and emotional capacities, as well as written and oral skills' (p. 48). Third, auto-ethnography intersects life stories that excavate, analyze, and critique assumptions in relation to other social and cultural aspects of personal experience. Writing auto-ethnography can become an epiphany (Denzin, 2001) that can heal grief (Lee, 2006a) and loss (Lee, 2006b). Thus, auto-ethnography reveals actions and feelings affected by history and social structure.

Discussing the cons outlines the challenges from writing auto-ethnography. First, there is the emotional challenge of putting the self in research. This kind of research involves a panoramic view that evokes emotional undercurrents. Thus, reflecting on the dialogue from 17 years ago resurfaces many emotions that need to be resolved for the author. Second, writing auto-ethnography becomes problematic as it needs aesthetic assessment standards. Grumet (1989) problematized the notion of beauty by discussing how the 'mediation on the meaning and significance of beauty of curriculum theory and practice' (p. 226) requires words with double reference to address aesthetics about educational policy. I believe that standards, evaluation, and accountability of beauty become slippery slopes. Eisner (1991) advocates connoisseurship and criticism of art-based inquiry with an enlightened eye. An eye, ear, and touch provide language that richly describes, explores, and explains art. Arguably, a well-received area of narrative research stems from disseminating writing in various textual forms (Richardson, 1994; Barone, 2000) like poetry, stories, autobiography, and auto-ethnography. Third, performative writing from the heart (Pelias, 2004) challenges that nature of subjective knowing. It brings out ambiguity and vulnerability while engaging the emotional and intellectual. Fourth, a discovery approach to learning about oneself and the world can become political as one pivots between theory and substance. It challenges readers to a transitional epistemology about writing as a form of knowing and research.

The following conversation between the author and her father unfolds *post facto* from yearly memories of the funeral service. The emotional terrain surfaces memories of love, strength, denial, compassion, withdrawal and helplessness. Weaving snippets of conversation invites 'qualitative researchers to become engaged pedagogues within our communities and to create spaces for "honest talk" that opens our hearts and minds to the pains and joys of social diversity' (Pilcher, 2001, p. 283).

While the *post facto* account becomes a transformational educational process, it also raises the issue about the fallibility of immediate memory, which happens close to the time of experience, as opposed to true memory, which involves recalling the experience many years later. As the dialogue was created from a written journal account the author saved for 17 years, it is believed the conversation is from

immediate memory. A new study by Harvard psychologists reveals that memories of good times can be less accurate than memories of bad times (Cromie, 2006). As the dialogue recalls more bad than good times, it is believed to be as accurate as possible.

Writing this auto-ethnography demonstrates the importance of transformational writing in the field of health, counselling, education and social work. Writing inquiry becomes a method of research (Richardson, 1994) as one composes themes and counterpoints that enable change. As harmonies probe and deconstruct, writing and rewriting creates understanding that surrounds grief, loss, bereavement, and the importance of father–daughter relationships. In Vancouver, B.C., there has been a recent interest in narrative research at the International Multidisciplinary Conference on Spirituality and Health: Interweaving Science, Wisdom, and Compassion. The use of constructing stories is a natural human process that helps individuals to understand themselves. Thus, when subjects write their deepest thoughts and feelings about traumatic experiences, the writing can change their lives (Pennebaker, 2000).

At the hospital

'I want you to be happy', he says.
'But I am, Dad', I reply.
'I want you to have some kids.' Sitting on the side of his hospital bed, he folds his arms.
'Maybe', I say, wanting to please him.
'I want you to get along with your mother. The two of you have so many loud arguments. I want you to be better to your mother.'
'Why are you saying this now?'
'Because I don't think I'll live much longer. I'm tired and sick and don't feel good.'

Tears roll down my face. I doubt him. But I cannot doubt him. In the last spasms of a father–daughter affair, I am a committed romantic. A blooming feminist from scholarly influences. My mind fills with thoughts. I pant, in and out, and explode. Fighting the fight for my father. I couldn't live without him. Tears roll down my face.

'Don't', I sniff. 'Don't say that.'
'Look, it's the way it is. I'm not well. You'll have your mother and brother.'
'No', I wail. 'I'm moving back to Vancouver now. We'll spend more time together. Don't say all this.'
'I just wish you would get along with your mother. Both of you argue about so many unimportant things.'
'Okay, I'll try', I assure him. 'But you'll get better. Please. Believe me. They're checking you out. Mom says it's a bad case of the flu.'
'I don't know.' His voice softens.

The room is white and barren. An old man sleeps across from my father with an I.V. in his arm.

'I'll get you some water', I say and take a paper cup. Walking to the washroom, I wipe the tears from my face. Filling the cup with water, I return to his bedside. 'Here Dad', handing him the cup, 'fresh water'. Taking the cup, he sips and lies back in bed. A man of 69 years, he is pale as the walls. He does not smile or give eye contact.

'Has anybody else come to visit today?'

'No, your mother is busy and I don't know where your brother is.'

'I just decided to drop by on my way to the airport. I'm looking for a place to live now that I'm moving back to Vancouver.'

'Whereabouts?'

'Maybe I'll get a place near you and Mom in Richmond. Are there apartments around there?'

'I guess so. But don't get an expensive place. Save your money to buy a house', he says sharply.

He tried to get a bypass operation but did not qualify. He heart is old and his arteries clogged.

'You hungry, Dad?'

'No.' His face grows ashen.

'You must be dehydrated. More water?'

'No thanks. So', he pauses, 'tell me again why you want to go back to school?' he asks with probing eyes.

'Well, I want to get my Master's.'

'How many courses will you take?'

'Just a couple of counselling courses. I'll be working at the crisis centre, training to answer phone calls.'

'Why do you want to do that?'

'Because I want to help people.'

'Those people have serious problems.' His lip curls.

'They need someone to talk to. I don't resolve their problems, just listen. People need empathy.'

'Well.' He pauses again. 'It's your life.'

A nurse enters the room with his medication. With a sip of water, he swallows the pills.

'How many years to get your Master's?'

'Two years if I go full time.'

'What will you do afterwards?'

'I don't know. Maybe get a PhD.'

'That's so many more years of university. You need to be healthy, get lots of sleep. Look at me, my body is weak.'

'You'll get better.'

'I don't know. I may not make it.' His voice is monotone. 'Take care and get along with your mother. That's all I ask.'

That night he died. A heart attack during his sleep. No pain, just instant death. The phone call, the loud words. I didn't want to hear it. It's not true. Late at night, I drive back to the hospital. Slowly, I enter his room. Darkness everywhere. He lies peacefully in bed. His eyes shut, no movement. I grab his hand, it is cold. No response. Tears roll down my face. It's not true. The tight air surrounds me. Gasping, I bend over. Kiss him goodbye.

That was 17 years ago, a vivid memory. My heart pounds, I think of our last conversation. A long time ago. Sweat runs down my forehead. The blood in my arms, legs, chest, and heart speeds up. I'm cold. Though my teeth chatter, I fall into a trance. Cannot sleep. My body wants a large amount of wine. All I know is time slows down. There is nothing I can do. When I remember his words, I want to be with him. Can't let go of what once was. What will never be again. He is gone. Gone.

I bite the inside of my mouth, a habit of mine. A small trickle of blood flows around my teeth. In my pocket, a Kleenex. Open my mouth, dab the blood. A motion takes hold. Taking a deep breath, I lean back. Sip the wine. Let the warm heat of booze soothe. In the heat of memory I reflect, like a bird watching the horizon. There are shadows. Reflections in window panes, a hundred and a thousand. It's his face, everywhere.

I believed we'd have more time together. We would talk and eat. A quiet man but he would talk when we drank coffee, ate donuts, ice cream, dim sum and played cribbage. Patches of relief, moments of tranquillity as he spoke with his calm voice. My father, George, was a patient man. From years of daughterhood I learned he only wanted to give me candles and champagne. Georgie's Girl. The song he loved to hear me play on the piano; the expression of a traditional father watching me grow up. A typical conversation with him involved mild-mannered words. He was tactful and honest, salt of the earth. No psychological babble, just practicality. My father had black and white views. Gentle, conservative, no shades of grey. Many times, we agreed to disagree while eating a lazy dim sum in a Chinese restaurant. With him, I learned to be an apostle of ordinariness. His words were very important to me. If only he could be in my life now.

His funeral, etched in stone. I see everything: the simple recipe for Chinese funerals. My father had taught me at his mother's funeral. Stand tall, bow three times. Take the burial seriously to avoid bad luck. Older people do not attend funerals of younger people. If a baby or child dies, no funeral rites, just buried in silence. With my father, an elderly person, there are prescriptions. Cover statues of deities with red paper to avoid exposure to the body or coffin. Remove mirrors as reflections from the coffin bring another death. Hang a white cloth across the doorway of the house. Place a gong on the entrance: on the left for a male, right for a female. Dress the corpse in best clothes. Cover the corpse's face with a yellow cloth, the body with a light blue one. No jewellery or red clothing to the funeral. Wear a piece of coloured cloth on your sleeve to signify mourning: black by the deceased's children, blue by grandchildren, green by great-grandchildren.

After his funeral, clothes are to be burnt. A red packet with candy and money is given to others. Rid the bitterness by eating sweet and buying something new. There is a 10-course Chinese meal. Nobody talks of the funeral, only happier times. Mourning is 100 days. One cannot visit other Chinese during this time. Children and

grandchildren of the deceased cannot cut their hair for 49 days after the death. His funeral etched in stone.

I return to standing at his grave. It is on a hillside to improve feng shui. There is a stream of tears. Dressed in black, my mother and brother by my side. Pieces of black coloured cloth on our sleeves. We hold hands. Throw a handful of earth into his grave. We stand for a long time. Sunlight festers in the veins of summer rot. The bitter juices of an unfinished afternoon. Silence soils the hillside, madness stirs the air. I let the curtain fall. A silence I have never known, gazing speechless upon his coffin. His verses floating upon the wind, I discover he had been a man, like all good men, that died. He was more reverent towards me than anybody else.

I dream of my father. His slippers against the floor, standing in the middle of the kitchen. Making breakfast. He wears jeans and a sweater. Quietly, slowly, he walks around the kitchen and wipes the stove, fridge, counters. He takes his time. Over and over, the memory of him cleaning. I recall him teaching me how to make rice. Rinsing, draining, putting in my finger to measure the water, and placing the pot on the stove. I made rice but never at his slow pace. Turning on the water, rinsing, draining, and finger measuring the water was done quickly and efficiently. But he never complained when eating the rice I prepared. No difference between what he did slowly and methodically and what I did quickly and efficiently. Each meal, he ate slowly. Enjoying each morsel of food. I was convinced the world was well when watching him eat.

In the mornings, he drove me to school. Making sure I had my homework and lunch. Never a comment on my clothing or hair like my mother. When he came home from his tailoring store, I rattled off my day to him. He would nod and smile, listening to my stories. He listened like he watched TV: Bonanza, Maverick, Ed Sullivan, Clint Eastwood, Three's Company, The Ropers. He sat for hours watching TV. Once, I got out of bed to see if he was still watching TV, and he was. 'Go back to bed', he said. 'You need your sleep.'

He taught me how to play cribbage. He said scoring was easy if you memorized what pairs, 15s, and runs were worth. I memorized the score sheet. He was impressed. We kept a record of the games we played. Day after day, we played crib. Before dinner, after dinner, on weekends, during his TV shows. An entire record book of cribbage scores.

Eyes closed, I wake from a dream of wet marigolds. The smell of tree branches surrounds me. I miss the steam from his breath, his shadow. The smell of coffee from his lips, leaning over me. The dry, unruly hair on his chin. Sitting on my bed, kissing me good night. I grew up in a working-class neighbourhood. When I was 12, we moved to a larger house because I needed a grand piano.

Both of us bound together, edging along the rim of growing up. The story of my father makes meaning. My story, his story. But some stories have no words. Words drop away, some things unsaid. From his expressions, gestures, I knew what he meant. We would sit across a table, eat slowly. The food would settle inside. For half a second, I would look him in the face. He would lean towards me. A tiny moment between us.

Taking a deep breath, I celebrate another year of his death. I reach for my wine, take a sip. A palpable hint of festivity. I inhale years of his upbringing. His intense

fatherly love. I sip alone. I hear laughter like distant chimes. The windless core of the moment lifts me to his image. A maze of bright lights, clean air. A still, quiet hour ends at Big Scoop Ice Cream Parlour. As we emerge with cones, there are words and laughter. I smile and he smiles. He steps forward, puts his arm around me. He hugs me and I hug him. It is pure and real. My father, my blood, the person I was created for in the world. The person who knows me best.

Startled by a plane, I turn. Reach for my glass, I sip to the bottom. I exhale, take a deep breath. My stomach stretches. I stare at the empty glass. Don't hear or smell anything. Suddenly, I notice a narrow opening through the trees. I smile, thank him for the gifts and memories. Celebrate his life. If I could write him a letter, I would thank him for teaching me to love, share, forgive, have compassion, ride a bike, order dim sum, play cribbage, make rice. For words of wisdom. For wanting to see me happy and healthy. For helping me understand simplicity.

I wish him to know the joy, security and ordinariness of my life. The peace, clarity, sanity, serenity, pleasure, satisfaction, he gave me. I make a list of things I want to tell him. That I get along with my mother, that she is remarried and happy. I visit her often and we eat dim sum. I respect her wishes and advice. We are close. That I am healthy, taking care of myself. A diet of fish, fruit, salads, and vegetables. That I ride my bike and keep fit. That I have a doctorate, a career I love. That I enjoy teaching at the university. That I have a 10-year-old daughter, adorable and wonderful. Decorating my life with happiness. That I taught her to play cribbage.

Trembling, I linger on memories sheathed in honey, in nostalgia. It is true that I will never see him again, but I have the warm rise of memories. They will not fade into the miasma of time but instead, bring satisfaction to my day. Many years ago, in the valley of a dry summer, his life ended. The sound of his breath uninterrupted by the rhythm of my life. 'I'm happy Dad, wish you were here.'

A little red bird
Feathers that are wet
Bids farewell
In poetic verse
Leaves a path of darkness

References

Barone, T. (2000) *Aesthetics, Politics, and Educational Inquiry: Essays and Examples*, Peter Lang Publishing, New York.

Cone, D. & Harris, S. (2000) 'Service-learning practice: developing a theoretical framework', in *Introduction to Service-learning Toolkit: Readings and Resources for Faculty*, ed. Campus Compact Project, Campus Compact, Providence, RI, pp. 45–57.

Cromie, W. J. (2006) 'Bad times make for more accurate memories', *Harvard Gazette*, [online] Available at: http://www.news.harvard.edu/gazette/2006/05.11/01-redsox.html.

Denzin, N. K. (2001) 'The reflexive interview and a performative social science', *Qualitative Research*, vol. 1, pp. 23–46.

Denzin, N. K. & Lincoln, Y. S. (1994) 'Introduction. Entering the field of qualitative research', in *Handbook of Qualitative Research*, eds N. Denzin & Y. Lincoln, Sage Publications, Thousand Oaks.

Eisner, E. (1991) *The Enlightened Eye: The Qualitative Inquiry and the Enhancement of Educational Practice*, Macmillan, New York.

Ellis, C. (2004) *Ethnographic I: A Methodological Novel about Autoethnography*, Walnut Creek, CA.

Grumet, M. (1989) 'The beauty full curriculum', *Educational Theory*, vol. 39, pp. 225–230.

Lee, K. V. (2006a) 'A fugue about grief', *Qualitative Inquiry*, vol. 12, pp. 1154–1159.

Lee, K. V. (2006b) 'Her real story', *Journal of Loss and Trauma*, vol. 11, pp. 257–260.

Palmer, P. (1998) The Courage To Teach: *Exploring the Inner Landscape of a Teacher's Life*, Jossey-Bass, CA.

Pelias, R. J. (2004) *A Methodology of the Heart: Evoking Academic and Daily Life*, Walnut Creek, CA.

Pennebaker, J. W. (2000) 'Telling stories: the health benefits of narrative', *Literature and Medicine*, vol. 19, pp. 3–18.

Pilcher, J. K. (2001) 'Engaging to transform: hearing black women's voices', *International Journal of Qualitative Studies in Education*, vol. 14, pp. 283–303.

Richardson, L. (1994) 'Writing. A method of inquiry', in *Handbook of Qualitative Research*, eds N. Denzin & Y. Lincoln, Sage Publications, Thousand Oaks.

Claire Smith

INNOVATIVE REHABILITATION AFTER HEAD INJURY: EXAMINING THE USE OF A CREATIVE INTERVENTION

Introduction

I believe that, during head injury rehabilitation, participation in creative activities can serve a purpose comparable to that of social work. Ramsay (2003) maintains that the mission of social work is to 'enable all people to develop their full potential [and] enrich their lives' (p. 336). While undertaking research en route to a Masters of Arts degree at the University of Ottawa, I found that after individuals sustain an Acquired Brain Injury (ABI), participation in creative activities can be a positive factor in their altered lives. Creative involvement can provide opportunities for individuals to rehabilitate, re-establish, and enhance their intra-personal selves as well as their social skills when undertaken in a workshop setting (DiNitto & McNeece, 1997).

I begin by telling my story.

I came to academia circuitously, by way of a life narrowly focused on sport. In 1992 I was Canadian three day event champion. I was then named in the Canadian Equestrian Team. In that capacity I represented Canada at several international competitions, including the 1996 Olympic Games. A year later, in 1997, I sustained a severe head injury while competing in England at the European Championships.

Yann Martel (2001) eloquently sums up the effect that such a life-altering injury can have on a driven and motivated person such as I am. He writes that 'Things didn't turn out the way they were supposed to, but what can you do? You must take life the way it comes to you and make the best of it' (p. 101). My life certainly hadn't turned out the way it was supposed to — at all. I had been an athlete: dedicated, motivated, tough, driven, successful, and respected. Falling on my head was a life-changing event, causing me and my family endless grief, mourning, and loss. I am no longer the person I was before the fall; that person is gone. But, although I am different, I am still dedicated, motivated, and driven. Thanks in part to these qualities, I have recovered almost completely.

After the accident, I spent six months in hospital and then another six in rehabilitation. As is typical after head injury, I had difficulty letting go of my past. King (2000) and Rimmon-Kenan (2002) note that after experiencing a major life trauma, individuals can have trouble accepting that they may have to construct a brand new identity and envision a different future. So, I attempted to return to my old lifestyle. After almost a year trying to live life as I had before my injury, I recognized that I had no choice but to accept what life had chosen for me. When describing her battle with cancer, Grealy (1994) wrote that 'Sometimes the briefest moments capture us, force us to take them in, and demand that we live the rest of our lives in reference to them' (p. 78). My experience with head injury seems to have been my 'briefest moment'. Captured, and unable to resume my life as I had known it, I turned my energy towards researching the cause of the enormous change in my life. My research efforts at the Masters and now at the PhD level are both qualitative explorations of head injury. Completing a thesis towards a Masters of Arts degree at the University of Ottawa began the final chapter in the long journey on which I had embarked in order to resume authorship of my own life story after my head injury.

During my MA research, I found the process of writing stories that describe others' experiences with head injury to be therapeutic. Writing these stories helped to loosen the 'shadow hold' of the experience of head injury on my identity, an experience whose scars are nonetheless permanent (Richardson, 1997, p. 5). I now realize that, by undertaking the research process, I became empowered to commence construction of my own altered life story, a story that will always feel influence — and I hope also inspiration — from my memories of that unsettled time (Pillener, 2001; Van Nijnatten, 2006). It seems that my research, past and present, is for me yet another step I can take towards reclaiming my voice 'that bodily trauma ... [has] caused to be silenced' (Frank, 1998, p. 336).

My research

My MA thesis was a qualitative study, a participatory auto-ethnography of five participants in which I was not only the researcher but also a participant. The purpose of the study was to examine the use of creative activities as a therapeutic tool after ABI. Specifically, I examined how these activities can be used to aid survivors as they attempt to (re)establish their self-esteem. The idea for the study was born because my own self-esteem was bolstered when I used creative modes of expression, in addition

to traditional written papers, to convey my understandings for course assignments. My interpretations accompanying final papers have included a globe that artistically showed issues in education as they impact parts of the world, a papier-mâché figure of a 'learner in difficulty', and a painted game board.

At the same time as I was realizing the importance of creative activities in my life, the workshop *Creative Enterprises* was founded. This was the setting in which I conducted my research towards my MA degree, research culminating in a dissertation entitled *Creatively Rehabilitating Self-esteem: An Auto-ethnography of Healing* (Smith, 2004). Self-esteem is an intra-personal element of identity. Intra-personal identity also includes such attributes as sense of self and self-worth (Gardner, 1983). According to Coopersmith (1967), if these attributes are positive, individuals believe that they are 'capable, significant, successful, and worthy' (cited in Battle, 1990, p. 25). A healthy intra-personal identity suggests a capacity for reflection and introspection, an understanding of one's self, and indicates maturity (Collinson, 1996; Verkerk *et al.*, 2004).

Because of the nature of the environment in which the study took place, I was also able to explore the participants' perceptions of the interpersonal value of engaging in creative activities after ABI. Attuned social skills, a thoughtful understanding of others, and a self-awareness in social situations signal interpersonal acuity (Gardner, 1983; Heider, 1958; Verkerk *et al.*, 2004). A well-developed interpersonal identity leads an individual to heightened awareness of what 'the other person is perceiving, feeling, and thinking, in addition to what the other person may be doing' (Heider, 1958, p. 1). The data I collected suggest the positive interpersonal impact of participating in creative activities in a social environment for survivors of ABI. Working on their creative projects increased each participant's 'individual well-being in a social context' and strengthened their interpersonal skills (NASW, 1996, p. 1).

To collect the data, I engaged in informal conversations with the participants once a week while they worked on their creative projects at *Creative Enterprises*. During this time, I asked them about their injuries, their recoveries, and their perceptions of the lives they now live. I encouraged them to talk about the struggles that they have undergone. They each produced a creative product; the feeling that he or she had completed a project had a huge positive impact on his or her self-esteem. When she had finished making her watercolor set of cards, one of the participants, Sally, said to me:

It's nice to have something so concrete, that there's a start, middle, and an end. You end up with something you can see and for me, that's so nice because the rest of my life is so elusive; there's never really an end result.

During the time that I was writing the narrative that was the main part of my thesis, I underwent a process similar to the one described by Behar (2003):

I felt like a filmmaker with reels of ... story before me that I had to assemble using filmic principles of montage and movement ... I undid necklaces of words and restrung them, ... I dressed up hours of rambling talk in elegant sentences

and paragraphs of prose, ... I snipped at the flow of talk, stopping it sometimes for dramatic emphasis long before it had really stopped ...

(p. 16)

It took me some time for me to realize that I should also use multiple literacies, along with a traditionally written auto-ethnographic narrative, to convey my findings effectively. By enabling expression using alternative methods such as art, painting, and poetry, these multiple literacies allowed me to enrich 'the domain of expression [and] ... the capacity to realize new worlds' (Gergen & Gergen, 2002, p. 23). Because I presented the end product creatively, I was able to find 'a greater expressive range and [I was provided with] an opportunity to reach audiences outside the academy' (Gergen & Gergen, 2000, p. 1029). Therefore, more people were given the opportunity to make sense of the study (Szto *et al.*, 2005).

Because my use of multiple literacies meshed with the subject matter — creativity as rehabilitation — as well as with the data that were collected, the alternative representations of my findings turned out to be important and essential parts of the final product. The interpretation of the data was presented traditionally, but also creatively as a collaged four by six foot mural depicting the ocean floor (figure 1). Each participant was represented by a fish, each theme by a strand of seaweed. The positions of the fish among the seaweed indicated the themes most closely associated with each fish. I also transformed the focus group interview into a play script and my own experiences became a short story.

The kaleidoscope through which I now view the world is effectively reflected in the plethora of artistic methods of data collection, interpretation, and representation that I

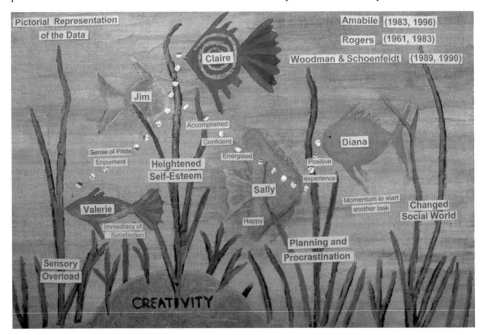

FIGURE 1 Pictorial representation of the data analysis of the MA thesis *Creatively Rehabilitating Self-Esteem: An Auto-Ethnography of Healing.*

used. This study will always be very close to my heart not only in terms of the subject studied, but also in the data collected and in the manner in which the findings were conveyed. I now realize that, for me, the project was 'a borderland between passion and intellect, analysis and subjectivity, ethnography, art and life' (Behar, 1996, p. 174).

Head injury and social work

A head injury can be classified as a Traumatic Brain Injury (TBI) or an Acquired Brain Injury (ABI). Thurman *et al.* (1999) define traumatic brain injury as 'an occurrence of injury to the head (arising from blunt or penetrating trauma or from acceleration–deceleration forces) that is associated with symptoms or signs attributable to the injury'. They explain that these symptoms include 'decreased level of consciousness, amnesia, other neuropsychological abnormalities, skull fracture, diagnosed intracranial lesions — or death' (p. 603). Acquired Brain Injuries encompass TBIs as well as brain injuries resulting from 'stroke, tumours, infections, dementing processes and cerebral anoxia' (Webster *et al.*, 1999).

The social worker's role is to intervene with survivors of head injuries who are living in changed worlds after their injuries to empower them once again (Sudbery, 2002). After head injury, individuals' everyday worlds have suddenly been rearranged and are irrevocably different as a consequence of trauma. The intra and interpersonal changes experienced by these individuals are exacerbated when they find themselves living in unfamiliar worlds and facing new positions of 'power, ideology, gender and social class [that] circulate and shape one another' (Denzin, 2002, p. 27). The site of my research, *Creative Enterprises,* has a goal which is similar to that of social work: to encourage clients to broaden their horizons and 'imagine how things could be different' in the new worlds in which they find themselves (Denzin, 2002, p. 32).

The site

At *Creative Enterprises*, clients work in a safe and comfortable environment on personal projects such as large and small decorative woodwork, furniture, children's toys, and small stained glass pieces. The site is valuable for its impact on the clients' cognitive rehabilitation because, while being creative, they are unconsciously (re)acquiring knowledge about how to plan, sequence, and then complete projects (Regev & Guttman, 2005). Since their learning is achieved through creative involvement, the clients' new knowledge reaches 'beyond merely reducing the fullness of reality into bits and pieces' (Szto *et al.*, 2005, p. 154).

As well as being valuable as a tool for cognitive rehabilitation, *Creative Enterprises* serves as a site for social rehabilitation. The environment is one that facilitates interaction between clients as they work on their projects. The social benefits realized by the clients were unforeseen but are now recognized and applauded by the site's parent organization. One of the aims of social work is to address 'the difficulties [people] experience in forming or maintaining relationships' (Sudbery, 2002, p. 150). *Creative Enterprises* attends to these difficulties because working at the site aids in the clients' journeys of interpersonal rehabilitation and paves the way for these individuals

to address their social functioning (Crisp, 1993; Parton, 2000). The setting provides individuals with increased opportunities for social interaction and participation, opportunities that are inspired and initiated by their involvement with creative activities (Van Nijnatten, 2006). Through conversations with other survivors, clients can begin to interpret their visions of the lives they lead now and expand their perceptions of how their lives should now be. Many were injured in the workplace and so are at home using equipment and tools in the workshop environment at *Creative Enterprises*.

Individuals who have sustained head injuries are usually not the same as they were before their injuries. Sadly, therefore, they are often perceived as being 'different' by others (Goffman, 2006). According to Woodman and Schoenfeldt (1990), creativity can help these individuals to develop their identities in light of these 'differences'. They maintain, in the *Interactionist Theory of Creativity*, that 'the consequences of the creative act in turn affect … the state and development of the person in a continuing feedback process as behavior unfolds over time' (p. 16). The impact of completing creative tasks reverberates throughout clients' intra and interpersonal identities as these identities evolve throughout the healing process. Working at *Creative Enterprises* provides opportunities for clients to 'articulate themselves, express this impasse and regain a grip on their lives' (Van Nijnatten, 2006, p. 133).

At *Creative Enterprises*, the quality of the clients' social lives increases, and, at least for the time they are at the site, the stigma that is often a consequence of head injury disappears (Reynolds & Lim, 2007). The presence of other survivors at the site contributes to *Creative Enterprises'* club-like, social atmosphere, an atmosphere which fosters casual conversation. While clients are always open about their traumas and discuss them freely if asked, the context of the workshop allows them, as they are being creative, to talk informally about matters not associated with their traumas or their healing processes. The setting encourages them to move on with their lives and carry on; their injuries are not the primary topic of conversation. But, although they do not necessarily discuss their injuries, clients can, while they are engaged in creative work, unconsciously open and then further explore their experiences of trauma and their journeys of recovery (Higham, 2001).

Shawn, the supervisor of the site, told me that one of the greatest benefits at *Creative Enterprises* is that 'you are just here having a good time and working at the same time … [you] have other people to communicate with because otherwise you are stuck on your own half the time'. Because the clients know that Shawn is not a rehabilitation professional, they are relaxed and comfortable in his presence. The clients' counselors and caregivers are secure in the knowledge that safety is the top priority for Shawn, and they applaud the fact that the atmosphere he creates is free of the professional barriers that exist in their relationships with the clients. While always keeping a very careful eye on things, Shawn tries to create a 'good atmosphere to be around. You are not being watched by anybody, you are not being watched by doctors or any other people'.

To underscore the value of *Creative Enterprises* as an environment for rehabilitation, I will tell two participants' stories to show how completing creative projects at this site can help both the sites' clients' intra-personal and social worlds. These stories exemplify the positive impact of creative activities carried out in a

workshop environment for survivors of head injury. I begin with Diana's story. She feels *Creative Enterprises* helped her to better understand the person she had become after her injury. Diana's work there has helped her to address the intra-personal consequences of her injury.

Diana

In 1994, at the age of 40, Diana was in a car accident. At the time, she was a single parent of two daughters, aged 12 and 15. After the accident, Diana was in the hospital for seven and a half weeks. Six months after her accident, she went back to work. She says 'it was way too early. All I can describe it as is like being a stranger in a strange land'. About a year after her accident, she was finally sent to a neurologist by her insurance company. The neurologist gave her a booklet about brain injury to read. When she read it, she realized that everything made sense; it described how she felt.

For a long time after her accident, Diana isolated herself from people, but she is now enjoying them more. Although she and her husband Bob socialize a lot, Diana commented that 'it's not close people, you know, it's more social friends. I used to have more close friends ... that's very different now'. For the longest time she didn't trust herself to 'get close to people and carry on conversations'. As Blanche (1998) described, Diana found that 'as a result of this accident, my old self died and was replaced by a new self' (p. 71).

As is apparent in Diana's story, the intra-personal attributes of self-esteem and sense of self are often diminished after head injury.

Self-esteem and sense of self

Individuals can feel lost after sustaining a head injury because such a life-altering traumatic event can redirect a life course. The resulting emotional, social, and psychological deficits are unpredictable and enormously varied, as is how individuals react to the treatment that follows such an injury. Individuals can feel vulnerable and uncertain about their future (Predeger, 1996). After an ABI, Lehr (1990) maintains that individuals' self-esteem may be jeopardized because they often possess a damaged 'sense of emotional and social integrity' (p. 160).

Creative activities are intra-personally beneficial because they can be used as another form of expression as individuals become aware of their feelings. The creative process can be a vehicle to use to unlock feelings and thoughts. Jennings and Minde (1993) write that 'There are many experiences in life which are not possible to verbalise but often through artwork they start to take form, which later may be transformed to verbal language' (p. 114). Creative activities can be used to open experiences of trauma because they are 'a tool to tap inner creativity, a method of inquiry, a form of making meaning, a way of connecting and empowering, and a way of knowing' (Predeger, 1996, p. 1). Art allows people who have sustained head injuries to experience 'a sense of re-engagement with life' (Reynolds & Lim, 2007, p. 8).

Because one has greater choice while experiencing learning and intra-personal growth when engaged in creative activities, these activities can foster feelings of accomplishment, improved sense of self, and can enhance individuals' control over their everyday lives (Gladding, 1995; Regev & Guttman, 2005). Simon (1997) underlines the sense of individuality that can result from creative activity, writing that 'none can paint another's picture, shape another's sculpture, or write another's poem' (p. 63). Individuals' discoveries of their senses of self are facilitated because they are set free by the will and freedom of their creative participation (Aldridge, 1991). As a result of engagement with art, patients who have sustained head injuries can learn to use past catastrophes in their lives, as well as positive experiences, to help re-build their self-esteem. According to Sacks (1986), involving people in creativity allows us to consider individuals' possibilities and abilities rather than focusing on their deficits.

Survivors are often forced to find new ways of learning, so the arts can be used to encourage them 'to find ways of interpreting and exploring knowledge in new and creative ways'. When they do so, survivors will 'become personally engaged in their work and ... [be able] to explore connections between concepts in creative and unique ways in a context which is emotionally and aesthetically rich' (Gamwell, 2002, p. 3). Because clients can employ new ways of understanding the world and connecting seemingly disparate knowledge when engaging in creative activities, such engagement can function as informal learning situations. While they are creating, survivors learn to implement and carry out the executive function concepts of planning and revising those plans during the design, implementation, and then completion of a creative project.

Diana also found that her time at *Creative Enterprises* broadened her social horizons.

Diana's story continues

Diana noted that her activities at *Creative Enterprises* added a social aspect to her life as well as helping her intra-personally. She has met new people and feels comfortable around them, which has been difficult for her during the last few years. Although she did not actively seek out friends, Diana found that she was beginning to enjoy the company of others. Diana thought that her involvement in this study, for which she completed a stained glass door for a cabinet, had 'added a new dimension' to her life, by 'adding a social aspect'. She was happy to say that one of the outcomes of the study for her was the 'social skills, working with you ... meeting new people, feeling comfortable with new people ... It's important for me to feel comfortable with new people. That's been really difficult in the last years'. Diana felt that the stained glass project had given her another dimension that would benefit her social life, because she would have 'more common denominators' to share with other people.

Taking part in the study increased Diana's ease and comfort with other people. She agreed with me that her engagement in creative activities was an intervention that increased her social world. Typically, head injury has a huge impact on the social world of head injury survivors.

The social toll of head injury

Loss of self-esteem and sense of self are not only huge consequences of head injury but they are also major contributors to changed social circumstances after such an injury (Seaton, 1998). Even a mild head injury can affect a person's ability to function socially (Kay, 1992). Writing that caregivers should find 'ways to reintegrate the survivor with a variety of positive social opportunities', Seaton notes that such interpersonal attention not only 'reduce[s] feelings of isolation', but that it fosters the development of the intra-personal attribute of self-esteem (p. 82).

Psychosocial development refers to psychological development in the context of a social environment. Factors leading to psychosocial problems include a loss of the sense of self, diminished self-esteem, personality changes, and changes in social and environmental support (Pillener, 2001; Sohlberg, 2000). Psychosocial problems can leave individuals 'embroiled in cycles of failure, frustration, loss of confidence, anxiety, avoidance, depression, and eventual isolation, social alienation, and unemployment' (Kay, 1992, p. 375). Personality changes in ABI patients are generally psychosocial in nature and affect the ABI patient's ability to develop and maintain quality relationships that are meaningful. Therefore, individuals who have sustained head injuries often cannot re-assume the social roles that they had pre-injury. A central role of social work is to help individuals (re)learn the social skills necessary to seek out and then nurture relationships with others (Sudbery, 2002).

Jim is an example of a survivor who has found that *Creative Enterprises* has helped him socially since his injury.

Jim

Jim is 45 years old. While he is talking, he looks unwaveringly and penetratingly at you with bright, shining eyes. He is about five foot eight with blond curly hair, and he wears a diamond earring in his left ear. At the age of 40, Jim suffered at stroke while watching television at home. He spent over six months in the hospital, and continues physiotherapy every two months. He walks with a pronounced limp. His most noticeable impairment is his speech, and it is the one at which he works the hardest.

Jim is married, but, during the data collection period of my study, he was not living at home. He finds his tolerance level too low to handle his 16-year-old son's loud music and his 11-year-old daughter's TV shows. He has effectively and admirably dealt with this problem by moving to a bachelor apartment within easy walking distance of his house. He and his family think this arrangement works wonderfully. He maintains access to his house, eats many meals with his family, and says he probably sees more of his children now than he did before his stroke. Heinemann and Shontz (1984) would view that the fact that Jim has experienced changes in feelings, attitudes and values since his stroke and has adjusted his lifestyle accordingly as an indication that he is coping positively with these changes.

Jim's Wednesday visits every week to *Creative Enterprises* are times when he can spend social time with other people. He told me: 'I very much look forward to the weekly interaction at *Creative Enterprises*. I spend time in my shop at home but 90% of

the time I'm alone'. Jim feels that *Creative Enterprises* has 'certainly helped me socially', and says that some of his time at *Creative Enterprises* 'definitely fills a job void. It provides me with some social contact that everyone needs'.

Not only does Jim derive social benefits from *Creative Enterprises*, but he perceives that his experiences at *Creative Enterprises* have increased his self-esteem. He has built countless gifts for members of his family, including a decorative shelf for in his daughter's bedroom. He told me that there are more 'things that I will do or at least attempt to do' because of the time he has spent at *Creative Enterprises*. Jim's efforts are never 'by the book'. He enjoys tweaking published designs, such as adding carved supports to his daughter's bookshelf. He knows that the increased self-esteem he feels that originate in his creative work 'by osmosis, spills into my life in other forms'. If you are given the chance to 'build things that you never dreamed of ... that can't help but increase your self-confidence and self-esteem, and in turn benefit you as a person in your everyday life'.

Jim had been coming to work at *Creative Enterprises* for a long time before I conducted the study. Jim's speech is unclear so he communicated with me by email throughout the study. He synthesized the influence that he perceives that creative activities have on him when he wrote to me that:

> When you've had a brain injury and survived, this is probably near the top of the hurdles you [will ever] have to get over ... I tend to believe that you can learn a great deal about the 'new you' after you've completed a creative task.

Conclusion

The findings from the study were validated for me by Diana. At the end of the study, she told me that completing a creative project 'gave her joy'. I feel that, with that pronouncement, she encapsulated the benefits of creative activity for those who have sustained a head injury. Her words made my undertaking of the study completely worthwhile.

I have endeavored to convey my beliefs about the value of creative activity after head injury. The three stories above: my own, Jim's, and Diana's, effectively summarize the positive impact that creative involvement can have. These stories give a personal glimpse of the role that creative interventions can play both for intra-personal and social rehabilitation. They are real world examples of the theoretical indications that creative activity is an important component of rehabilitation after head injury.

References

Aldridge, D. (1991) 'Creativity and consciousness: music therapy in intensive care', *The Arts in Psychotherapy*, vol. 18, pp. 359–362.

Battle, J. (1990) *Self-esteem: The New Revolution*, The University of Alberta, Edmonton, AB.

Behar, R. (1996) *The Vulnerable Observer: Anthropology that Breaks Your Heart*, Beacon Press, Boston.

Behar, R. (2003) *Translated Woman: Crossing the Border with Esperanza's Story*, Beacon Press, Boston.

Blanche, D. (1998) '''Rime'' of the survivor', in *Living with Brain Injury: A Guide for Families and Caregivers*, eds S. Acorn & P. Offer, University of Toronto Press, Toronto.

Collinson, V. (1996) *Becoming an Exemplary Teacher: Integrating Professional, Interpersonal, and Intrapersonal Knowledge*, JUSTEC Annual Conference, Naruto University of Education, Naruto, Japan.

Coopersmith, S. (1967) *The Antecedents of Self-Esteem*, W.H. Freeman, San Francisco, CA.

Crisp, R. (1993) 'Personal responses to traumatic brain injury: a qualitative study', *Disability, Handicap, & Society*, vol. 8, pp. 393–404.

Denzin, N. (2002) 'Social work in the seventh moment', *Qualitative Social Work*, vol. 1, pp. 25–38.

DiNitto, D. & McNeece, C. (1997) *Social Work: Issues and Opportunities in a Challenging Profession*, Allyn & Bacon, Needham Heights, MA.

Frank, A. (1998) 'Stories of illness as care of the self: a Foucauldian dialogue', *Health*, vol. 2, pp. 329–348.

Gamwell, P. (2002) *Learning Through the Arts: An Investigation of the Experiences of Intermediate Students as they Explore and Construct their Understandings of Language and Literature through Artistic Activities*, Doctoral Dissertation, University of Ottawa, Ottawa.

Gardner, H. (1983) *Frames of Mind: The Theory of Multiple Intelligences*, Basic Books, New York.

Gergen, M. & Gergen, K. (2000) 'Qualitative inquiry: tensions and transformations', in *The Handbook of Qualitative Research*, eds N. Denzin & Y. Lincoln, 2nd edn, Sage, Thousand Oaks, CA, pp. 1025–1046.

Gergen, M. & Gergen, K. (2002) 'Ethnographic representation as relationship', in *Ethnographically Speaking: Autoethnography, Literature, and Aesthetics*, eds A. Bochner & C. Ellis, Altamira Press, Walnut Creek, CA, pp. 11–33.

Gladding, S. (1995) 'Creativity in counseling', *Counseling and Human Development*, vol. 28, pp. 1–12.

Goffman, E. (2006) 'Selections from stigma', in *The Disability Studies* Reader, ed. L. Davis, 2nd edn, Routledge, New York, pp. 131–140.

Grealy, L. (1994) *Autobiography of a Face*, Houghton Mifflin, Boston.

Heider, F. (1958) *The Psychology of Interpersonal Relations*, John Wiley & Sons Inc., New York.

Heinemann, A. & Shontz, F. (1984) 'Adjustment following disability: representative case studies', *Rehabilitation Counseling Bulletin*, September, pp. 3–13.

Higham, P. (2001) 'Developing an interactive approach in social work research: the example of a research study on head injury', *British Journal of Social Work*, vol. 31, pp. 197–212.

Jennings, S. & Minde, A. (1993) *Art Therapy and Dramatherapy: Masks of the Soul*, Jessica Kingsley Publishers, London.

Kay, T. (1992) 'Neuropsychological diagnosis: disentangling the multiple determinants of functional disability after mild traumatic brain injury', in *Physical Medicine and Rehabilitation: State of the Art Reviews*, Hanley and Belfus Inc., Philadelphia.

King, N. (2000) *Memory, Narrative, Identity: Remembering the Self*, Edinburgh University Press, Edinburgh.

Lehr, E. (1990) *Psychological Management of Traumatic Brain Injuries in Children and Adolescents*, Aspen Publishers Inc., Rockville, MD.

Martel, Y. (2001) *Life of Pi*, Vintage Canada, Toronto.

NASW (1996) *National Association of Social Workers — Code of Ethics*, [online] Available at: http://www.socialworkers.org/pubs/code/code.asp, accessed 25 March 2007.

Parton, N. (2000) 'Some thoughts on the relationship between theory and practice in and for social work', *British Journal of Social Work*, vol. 30, pp. 449–463.

Pillener, D. (2001) 'Momentous events and the life story', *Review of General Psychology*, vol. 5, pp. 123–134.

Predeger, E. (1996) 'Womanspirit: a journey into healing through art in breast cancer', *Advances in Nursing Science*, vol. 18, pp. 48–58.

Ramsay, R. (2003) 'Transforming the working definition of social work into the 21st century', *Research on Social Work Practice*, vol. 13, pp. 324–338.

Regev, D. & Guttman, J. (2005) 'The psychological benefits of artwork: the case of children with learning disorders', *The Arts in Psychotherapy*, vol. 32, pp. 302–312.

Reynolds, F. & Lim, K. (2007) 'Contribution of visual art-making to the subjective well-being of women living with cancer: a qualitative study', *The Arts in Psychotherapy*, vol. 34, pp. 1–10.

Richardson, L. (1997) *Fields of Play: Constructing an Academic Life*, Rutgers University Press, New Brunswick, NJ.

Rimmon-Kenan, S. (2002) 'The story of "I": illness and narrative identity', *Narrative*, vol. 10, pp. 9–27.

Sacks, O. (1986) *The Man who Mistook his Wife for a Hat*, Pan, London.

Seaton, J. (1998) 'Psychosocial effects of brain injury', in *Living with Brain Injury: A Guide for Families and Caregivers*, eds S. Acorn & P. Offer, University of Toronto Press, Toronto.

Simon, R. (1997) *Symbolic Images in Art as Therapy*, Routledge, New York.

Smith, C. (2004) *Creatively Rehabilitating Self-esteem: An Auto-ethnography of Healing*, MA Thesis, University of Ottawa.

Sohlberg, M. (2000) 'Psychotherapy approaches', in *Neuropsychological Management of Mild Traumatic Brain Injury*, eds S. Raskin & C. Mateer, Oxford University Press, New York.

Sudbery, J. (2002) 'Key features of therapeutic social work: the use of relationship', *Journal of Social Work Practice*, vol. 16, pp. 149–162.

Szto, P., Furman, R. & Langer, C. (2005) 'Poetry and photography: an exploration into expressive/creative qualitative research', *Qualitative Social Work*, vol. 4, pp. 135–156.

Thurman, D., Alverson, C., Dunn, K., Guerrero, J. & Sniezek, J. (1999) 'Traumatic brain injury in the United States: a public health perspective', *Journal of Head Trauma Rehabilitation*, vol. 14, pp. 602–615.

Van Nijnatten, C. (2006) 'Finding the words: social work from a developmental perspective', *Journal of Social Work Practice*, vol. 20, pp. 133–144.

Verkerk, M., Lindemann, H., Maeckelberghe, E., Feenstra, E., Hartoungh, R. & De Bree, M. (2004) 'Enhancing reflection: an interpersonal exercise in ethics education', *The Hastings Center Report*, vol. 34, pp. 31–38.

Webster, G., Danisley, A. & King, N. (1999) 'Relationship and family breakdown following acquired brain injury: the role of the rehabilitation team', *Brain Injury*, vol. 13, pp. 593–603.

Woodman, R. & Schoenfeldt, L. (1990) 'An interactionist model of creative behavior', *The Journal of Creative Behavior*, vol. 24, pp. 10–20.

Olivia Sagan

AN INTERPLAY OF LEARNING, CREATIVITY AND NARRATIVE BIOGRAPHY IN A MENTAL HEALTH SETTING: BERTIE'S STORY

Introduction

> Life can only be understood backwards. In the meantime it has to be lived forwards.
>
> (Kierkegaard)

The social context within which mentally ill adults with low levels of education can access learning opportunities offering scope for creative expression is fraught. Pressures exerted through the educational policy discourses of Widening Participation (HEFCE, 2000), Inclusive Learning (Tomlinson, 1996), Skills for Life (DfEE, 2001), and the requirements of the Disability Discrimination Act part 4 (DRC, 2001) have urged educational and community providers to act upon obligations to offer learning opportunities to adults with disabilities and/or mental illness. Corollaries of Care in the Community (DoH, 1990) continue to highlight concern over what support is

provided for the reintegration of mentally ill individuals into a society both hostile to mental illness (Cross, 2004) and increasingly unable to offer employment opportunities to vulnerable, less skilled individuals. Meanwhile, New Labour has promoted a discourse of social inclusion (Levitas, 1998) and is seen to have backed initiatives and strategies to increase participation. However, despite this climate within both health and education the socio-political context of this research appeared riddled with jarring discourses and beleaguered by eroded funding and ossified structural inequality. Whilst the learning needs of adults with mental health difficulties have, in the past decade, become the subject of increased concern at both educational and policy level and have triggered sometimes awkward marriages between the domains of education and health (Sagan, 2002, 2004), learning provision for mentally ill adults largely remains theoretically neglected, pedagogically unexamined and politically overlooked.

Many of the learning opportunities now accessible are designed, taught and assessed from within an ethos of education being instrumental in national development and commercial competitiveness. There is a heavy stress on technicist pedagogy and the aim of 'upskilling' the learner in ways most congruent with market demands. Both teachers and learners are subject to the audit anxiety which runs through heavily regimented provision (Cooper, 2001). This discourse, which collapses concepts of lifelong learning and social inclusion with an economic skills imperative (Barton *et al.*, 2004; Appleby & Bathmaker, 2006) circulates uneasily within the small, under funded community premises frequented by the long-term mentally ill participants in this study. Their concept of learning and writing was more tied to notions of day-to-day survival and the development and/or maintenance of a bearable personal narrative. Opportunities for social interaction were deemed important in breaking the isolation of mental illness, and the *concreteness* of writing (Pennebaker & Seagal, 1999) was highly valued, as expressed by one participant:

> … just … getting it down on paper, it makes me feel, better somehow to see it there … I know what I think then, when I see what I've said …
>
> Ben

Learning programmes are largely designed, funded and delivered with a fantasised non-gendered individual in mind, who is rarely consulted and seldom if ever considered as a whole person rather than a fragmented construction of 'bits' to be manipulated, medicated, taught and processed, the 'subject-positions' of Foucault (1980). This individual is situated within a contestable social construction of mental illness (Busfield, 1996) which, though clumsy, offensive and ill-representative of experience, nevertheless feeds popular imagery and fears, and contributes to a constrained set of identities being formulated by mentally ill adults themselves. Any notion of learning or in this case literacy and self-expression as inherently *creative* acts is absent. Indeed, if creativity can be posited, as it is in this paper, as an ability to integrate, to link, bring together (Segal, 1957) and tolerate disparate ideas and warring identities, then the atomised and fragmentary mode of thinking and operating within education for mentally ill adults can be seen as not only denuded of any *creative* thought, but actually constituting an *attack* on thinking (Rustin, 2001).

It is within this problematic landscape that this research took place, seeking to catch a glimpse of whether such a terrain allowed space for individuals *not to discover what we are, but refuse what we are* (Foucault, 1982, p. 216) and make some attempt, despite all odds, at living life *forwards* through writing creatively.

Methodology

Immersion in the setting for substantial duration, typical of ethnographic research, was vital to being able to establish a working rapport and trust with the small group of individuals in this study. Comfortable, non-intrusive access not only to the writing sessions and work produced therein, but other activities and areas of the community setting, was essential to the gathering of data across a number of domains. The aim of the research was to observe what *use*[1] was made of a basic literacy/creative writing course which was provided for mentally ill adults with mostly low levels of literacy and limited verbal articulation.

All 12 individuals who took part in the three year study are long-term mentally ill and although they represent a range of diagnoses they all share the experience of debilitating depression for which they have been regularly hospitalised and are in receipt of numerous and varied medications. Ethical considerations were of paramount concern, particularly as the study progressed and I was told things informally, in the canteen, or on fag breaks, information which I considered important but for which I needed to gain renewed consent in order to use as data. Whilst both written and regularly re-requested verbal consent has been obtained for the information in this paper, all names and identities have been altered.

The research employed a critical ethnographic methodology (Tamboukou & Ball, 2003) primarily in its first phase, to examine a range of data and maintain maximum flexibility in a volatile setting subject to sudden funding crises; organisational restructuring and participant absence and/or withdrawal. In subsequent phases of the project the focus was on the biographic narrative interviews, which continued regularly throughout the three years. These interviews used an adapted form of the Biographic Narrative Interpretive Method (Wengraf, 2001) and aimed to elicit life story narrative from the participants in the study. Levels of articulation and verbal engagement varied dramatically however, and with two participants in particular it was not until the research progressed well into the second year that interviews began to contain more of the 'risky narrative' which was to afford insights into the identity work apparently being carried out.

It is the data from the individual narrative interviews which underpin the substantive focus of this paper, although other data in the form of session observation notes; interview notes (of the process rather than the content); course documentation and examples of participants' creative work are drawn on to substantiate and/or question the biographic data. It is from this tracing and juxtaposing that questions were raised regarding the narrative which was being performed in the interview setting, and how it differed in some cases quite strikingly from the 'self' portrayed in other domains. As the site of strenuous identity work, the course as a whole appeared to be 'used' in the psychoanalytic sense as a particular object, parts of which needed

to be nurtured and kept good, while others were subject to various forms of subtle attack. Whilst the aim of the sessions was to help mentally ill adults write creatively, (even, or specifically from within the bounds of very low levels of literacy) this paper suggests that the creative impulse was being expressed through a diligent development, maintenance of, or defending against particular identities. I also suggest that creativity is a hard-earned luxury for the individuals in this research, whose day-to-day survival was a paramount theme throughout their narratives. This hard-earned luxury appeared to demand a high level of containment (Bion, 1967) on the part of facilitators, the group and the setting itself; it also demanded the sense of at least the *potential* for secure attachments (Bowlby, 1969). These prerequisites were partially met through the sessions and the research itself by dint of duration, stability and sensitivity to psychic traffic and inter-subjectivity on the part of the facilitator (French, 1997) and researcher. These were the very factors which were continually under attack as a result of funding constraints and un-fit for purpose curriculum demands specifically, and the 'instrumentalism within modern welfare services' (Froggett, 2002, p. 39) more generally.

Psychosocial questioning positing a defended subject (Holloway & Jefferson, 2000) was applied in an attempt to understand undercurrents in the emerging data and to keep alive a constant awareness of each individual being at once a product of a particular constellation of psychological factors *and* a subject constructed by a particular socio-political structure whose cultural and historic creation of mental illness is shifting and contingent (Foucault, 1991). The psychoanalytic concepts drawn on are those most closely associated with Kleinian, post-Kleinian and object-relations theorists, predominantly splitting, projective identification, reparation and containment. Within this framework particular attention is paid to experiences of anxiety and defending against it, and perceived loss, both heavily implicated in a psychoanalytic understanding of learning. It is this framework that appears, in my experience as a counsellor and educator, to have greatest fluency when considering the learning process of mentally ill adults, which is usually fraught, often distressing, and sometimes potentially harmful as destructive behaviours are revisited upon the site of learning and interminable knots of suffering are tied through failure and stasis. The case study from which I extract here, however, depicts a special resilience and tiny yet significant changes. This accomplishment supports the claim that holistic, therapeutic and containing welfare can support the conditions in which learning, integration and more creativity can take place, even amongst learners who present with a range of characteristics which constitute formidable barriers to development. Unlike several other cases studied where the individual appeared entrenched in a paranoid–schizoid position (Klein, 1946) wherein self-narrative was locked tight in a denial of past experience and inability to envisage a different future, Bertie's case offered a glimpse of a movement into the depressive position, where ambivalence could be thought, reparation begun and a new narrative of self spun.

Bertie: when words don't come easy

A 65-year-old Yorkshireman, Bertie was well known at the centre, having attended on and off for more than 10 years. Stocky, with a plethoric complexion, pronounced

limp and difficult breathing, Bertie came weekly to the centre to share a cuppa, get some lunch and chat with the other users. He had never taken up any of the recreational or educational services on offer: art classes; yoga; computing for beginners. Neither had he ever added his name to the waiting list for counselling:

> ... No, not for me, not for the likes of me ... I w, w, w, wouldn't know what to say, 'livia, wouldn't 'ave a clue ...
>
> Bertie

Bertie came from what can perhaps be nostalgically and inadequately categorised as 'the traditional working class' — and his narrative is threaded through with the confusions and angers of a tribe displaced by a new work order (Collins, 2004) and demonised by a media which fails to recognise its own bigotry towards the British working class (Hari, 2007). Many of his comments regarding the changes he had been confronted with in his neighbourhood expressed fear and anxiety about not knowing or understanding the 'newcomers' and not being able to 'say nuffin' in case he was branded a racist. A disjointed cultural allegiance seemed to be further confounded by the ravages of mental ill health, which splintered chronology and memory, and demanded that Bertie reposition himself as mentally ill first and foremost, rather than a labourer, a father, a grandfather or an ardent Tottenham Hotspur fan who dreamed of going to Majorca. Bertie suffered with several serious medical conditions, was diagnosed with depression and acute anxiety, and lived in a studio flat on a council estate notorious locally for its declining standards and disgraceful levels of noise, dirt and despair. When he put his name down for the literacy/creative writing course, it came as a surprise to staff and volunteers at the centre who, while liking Bertie for his affable character, nevertheless saw him as a 'revolving door' user; one who due to his age, history and general low level of education and articulation would never really improve or progress therapeutically or educationally. Gradually however, over the course of our interviews and interactions in the writing sessions I observed, Bertie began to speak, through his stutters and malapropisms, of his contempt for the poverty in which he grew up, and the heavy burden of what he termed his 'dysleptic' (sic) problems, i.e. his lack of ability to write, which he put down to dyslexia (undiagnosed). Despite all predictions, over time he also improved his writing ability and began to broach the idea of self-expression — how this was achieved is reflected on below.

Bertie: Fords, fags and reparation

Observations of Bertie over the first year in which he took part in three 10-week courses show very little movement in terms of the educational progress required by educational providers and their funders, in this case the Learning and Skills Council (LSC). His rigidly upper case writing remained stubbornly at the level of a nine year old, void of punctuation and with a vocabulary predictably poorer than his verbal vocabulary. He often stuttered and stammered when taking part in the gentle group discussion around themes the group were encouraged to write about, and he frequently resorted to slap-sticky jokes and puns. Early interviews were a difficult 20

minutes to half hour, with Bertie responding to questions but unable or reluctant to elaborate, perhaps because he remained incredulous that anything of his life, of him — 'thick, or mad, they've called me, or white trash, something like that' — would be of interest to anybody. However, at the end of the second year, there were some shifts across the domains of writing, group session and the biographical interviews, and I want now to describe these shifts and to detail to what I believe them attributable. I will then suggest what the ramifications of these shifts may be in terms of the creativity of Bertie's pursuits, and what the messages are to emerge from this in terms of educational provision and creative processes for mentally ill adults with low levels of articulation and literacy.

Although Bertie made frequent jokes about his being 'dysleptic', too old to learn, that writing wasn't for him — 'I leave that up to my daughter, she's got lovely handwriting, she 'as ...' — the developing biographic narrative told a private, harrowing story about an upbringing in a charitable religious boarding school for boys which was riddled with humiliations, physical, sexual and emotional abuse. Much of the humiliation and bullying focused on his being 'thick' and not able to learn; and the stories Bertie gradually told me through stutters and stammers and wheezes suggested a bank of memories involving schooling and its loathsome authoritative figures. This bank, while long relegated to some distant and safe part of Bertie's mind, nevertheless had left him with a sense of unfinished business regarding learning, regarding literacy and writing in particular, which he felt as a noticeable absence in his life: 'if I could say it, like, get it down on paper ... it'd be out there ...'.

Bertie had a heavy emotional investment in learning which was two-fold; firstly, if he could learn, in the basic sense of moving from one point of knowledge to another, he stood to settle some old score with those who had written him off. Secondly, writing, literacy, the physicality of its presence on paper, would somehow restore validity to his stories which Bertie did not deem them to have without 'proof' — a written *proof* of a subjective experience (Milner, 1950), granted to those 'with letters' but denied him, who had few. For Bertie, the gap between an inner subjective experience and an expression of it had widened, for while his life had changed and circumstances had shifted, Bertie had not had appropriate spaces in which his verbal articulation and literacy might be allowed play and development. Milner (1950, p. 132) suggests this gap is what expressive pursuit seeks to address:

> ... there is (also) a gap between the inner reality of feeling and the available ways of communicating what we feel ... it is a gap that is bigger wherever the conditions of our living are changing rapidly so that the old forms for describing our feeling experiences become no longer adequate.

Yet it was not until the second year that Bertie began to show some changes in his writing, which, while remaining rigidly prosaic and arduous to execute, showed some embryonic signs of development in terms of subject matter. His writing become more autobiographical and included a moving short description of his many years at the Ford factory where he tumbled, as a result of ill health, from semi-skilled worker to floor cleaner. It also suggested he accessed more control and choice; words would be substituted for others — 'that's better, aint it, it says it better' — rather than the first

option being hurriedly settled for. Bertie's relationship to the product itself also changed. Whereas once torn up or stuffed into a pocket, his morning's work would now be carefully placed on the table for collection, or smoothed out and put inside a folder. By the end of the third year he was learning to word process his short paragraphs and poems and this also appeared to give a private sense of pleasure to him which was nothing short of moving to observe.

Simultaneously, Bertie's engagement with the interviews was deepening. This engagement I suspect was possible because whilst within the framework of the BNIM (Wengraf, 2001) interview Bertie was invited to tell me his life story, our time together was not flooded with the preconceived ideas Bertie held about what constituted counselling, ideas which jarred with his image of himself as a white, working-class man — an image which had been steadily under attack through ill health, divorce, changing socio-political circumstances, and the depletion of a local population to whom he felt affiliated. 'Doing the research' was bizarrely something he felt he could say to his mates downstairs during fag breaks, when they asked why he was late; 'Doing the writing' was also, just about acceptable — whereas 'doing counselling' sat less comfortably.

Bertie's interviews gradually deepened in scope allowing for a flooding of feeling and unearthing of memories. He spoke, still through stutters and stumbles, puns and quips, about his early life at the convent, his class allegiances about which he felt betrayal, and latterly his fears of aging and dying. The interviews became more poignant; strikingly candid; there was a sense, for me, of a childlike, 'true' expression: 'It is speech as true self, the verbal equivalent of Winnicott's "squiggle" or the moment when, according to Lacan, the subject discovers his own voice, revealed through slips of the tongue and curious wordings' (Bollas, 1999, p. 72).

This good use of the interview space and time was striking (and not mirrored by all participants) — but it took time, much more time than the short-term counselling Bertie would have had access to through the centre. This use was also augmented by the domains of the group sessions and the writing itself. So while Bertie was busy dissecting certain experiences in the interview setting, 'safe' parts of this could be taken into the writing sessions — without the fear of the emotional content of the work spilling out uncontrollably within the more public domain. In exchange, the potential loss felt in the sessions through the development, in writing, of a new narrative supplanting an old, fractured, obsolete but still habitual one, could be articulated back in the interviews — 'it's good, yeah (the writing) but it's not me, not like … I've never really written nothing, never been good with words …'.

This containment within which new subject positions could be taken up and new identities explored, appeared to be alleviating anxiety within the writing sessions sufficiently to enable firstly, some actual slow, hard learning to occur, and secondly, further strengthening of a new narrative as week after week Bertie saw stories of himself build up in the concrete form of writing on paper.

Furthermore, as his work slowly, incrementally progressed and his attendance stabilised, Bertie's connection with the group and his identity as a member in it strengthened. Bertie became well known as the group joker, with other members referring to previous jokes and quips within the new history of their time together:

… Bertie, remember the one you told us about the tea, the mobile phone and T mobile? Tell it again — go on!

<div align="right">Observation notes (Cathy)</div>

The affinity and empathy within the group was specifically aided through the weekly public demonstration of a shared weakness in writing. Although some members were clearly more adept than others, the combination of joint discussion of personal themes with the challenge of writing about these appeared to bind the group to itself in a private and intimate way not shared by other social groupings and cliques at the centre.

This time together spilled from the group sessions to fag breaks, to informal get-togethers — spinning its own history and narrative which fed back into the bank of memories to which the group itself began to refer. This particular group dynamic offered a personal supportive domain as learning came easily to none of them and all members shared a knowledge of the ravages of mental illness on words, self identity, memory and self-expression. It supplied Bertie with yet another arena in which *to be* and to try out a new identity. The containing function of the writing and the interview space which could ultimately hold the emotion and pain seemed to free up the site of the group sessions. Bertie could relax and be the joker without, for once, the jokes masking parts of himself which had nowhere else to be. Finally, but significantly, there was an unexpected and deepening companionship over the two years between himself and another user at the same centre with whom he discovered very similar shared experiences of class, whiteness, mental illness and the onset of older age.

So what was going on? I am not suggesting that Bertie was accessing a 'true self' nor that he was co-constructing (through his interaction with myself in the interviews, the individuals in the group sessions, the facilitator or the writing) a new, 'truer' narrative. The delightful, if frustrating challenges of postmodernism wrought upon the modernism of psychotherapy have highlighted hierarchical notions of 'truth' inherent in discourses which suggest a truer self is accessed through practices of therapy, creativity and autobiography. So the written Ford story, the development of Bertie the Joker, the painful narrative being unwound in the interviews, do not *in themselves* represent either more valuable, more articulate or in any way cathartic self narratives, and we need to be mindful of the danger *of reducing meaning to that which can be narrated* (Frosh, 2002, p. 134). What they do imply is that the gaps and leakages of the different practices and the challenges, for Bertie, of engagements with other ways of being — offered moments of both *frisson* and disjuncture. These could be experienced and tolerated by Bertie from the vantage point of the depressive position, partly because they were being contained within a sufficiently robust framework. This included not only the writing and the group sessions, but the research activity *itself*; the corrective emotional experience offered through Bertie's newfound form of companionship, and small changes in his socio-economic standing which opened the possibility of, quite simply, greater quality of life. A space was opening up for Bertie — and in this opening up, this man, with his stuttering, limited articulation, his slow and cumbersome handwriting, and his dreams of watching the world cup live, was thinking not only of the immediate, two-dimensional now, but of the past,

repopulated with richer stories and encounters, and of a future which held other than sheer fear — in Kleinian terms the mourning and reparation achieved were enabling the embryonic beginnings of creative activity (Klein, 1988). The words Bertie used, either in the interviews or his short written pieces, were now less populated with the intentions of others (Bakhtin, 1981) and more full of his own. Bertie's negotiation of the rocky terrain of frisson, disjunction, gaps and leakages *was* the creative act. It demanded tolerating ambivalence and the shock of the new; a capacity for symbolisation and the making of the reparative acts of remembering and recreating — it involved living life forwards.

Learning how to spell 'creative'

Learning, always a risky encounter with 'difficult knowledge' and necessary unlearning (Britzman, 1998, 2006) occurring at a place where the internal and external worlds meet, demands the very capacities which are under attack when we are caught anywhere along the spectrum from emotionally disturbed to chronically mentally ill. These are the same capacities which are denuded or eradicated in a paranoid–schizoid mode of being and operating.

At the same time debates surrounding what constitutes creativity seldom take place within the confines of policy and practice regarding mental health and adult literacy. Notoriously ill-defined and subjectively apprehended, creativity is regarded by the participants I worked with as something out of reach — 'not for the likes of us' was a term much used — because of their class, because of their illness, because of the myriad of needs in the quest for a day to day survival which are more pressing.

Despite persuasive evidence that there continues to be a link between some forms of mental illness and creative outpourings (Jamison, 1993) the sad truth on the ground is that for many mentally ill individuals their illness means a stripping away, a depletion of colour, sensitivity and delight, and a narration always 'dissonant with the experience intended by its account' (Stone, 2004, p. 19) which amounts to vacuum and loss rather than creation.

So both learning and creativity seem to request that we suspend reality, trust in a journey with an unknown destination and create an object able to hold *and* portray our abstruse intentions, yearnings and phantasies. This is a tall order when our notions of self are undermined, our narrative fragmented, trust betrayed and faith in objects eroded. Whilst creative pursuits and learning can also *restore* or recreate a sense of identity, narrative, trust and faith, this study suggests that both learning and creativity have a list of demands as prerequisites to their magic. These demands — which are pedagogic, psychodynamic, social — exceed what is on offer, both from the welfare sector and the education sector. What is on offer is usually something very different — the provision of a mechanistic course with a tick list of learning objectives complying with a scheme dreamt up in an adult education co-ordinator's office. This scheme, oblivious to the human waste caught up in its limitations, is designed in accordance with the spurious guidelines laid down by a government for whom Bertie, at the end of this food chain, is a faceless, mentally ill 'hard-to-reach' statistic in danger of social exclusion.

Note

1 'Use' here has the double meaning of (1) how participants used this provision, e.g. as a social, educational and/or recreational activity and what role it came to play in their lives, but also (2) what use was made in the psychoanalytic sense of 'object use' (Winnicott, 1969).

References

Appleby, Y. & Bathmaker, A. M. (2006) 'The new skills agenda: increased lifelong learning or new sites of inequality?', *British Educational Research Journal*, vol. 32, pp. 703–717.

Bakhtin, M. M. (1981) *The Dialogic Imagination: Four Essays*, University of Texas Press, Texas.

Barton, D., Ivanic, R., Appleby, Y., Hodge, R. & Tusting, K. (2004) *Adult Learners' Lives Project: Setting the Scene*, NRDC, Institute of Education, University of London, London.

Bion, W. R. (1967) *Second Thoughts*, William Heinemann Medical Books Limited, London.

Bollas, C. (1999) *The Mystery of Things*, Routledge, London.

Bowlby, J. (1969) *Attachment and Loss, Volume 1: Attachment*, Hogarth Press and the Institute of Psychoanalysis, London.

Britzman, D. P. (1998) *Lost Subjects, Contested Objects: Toward a Psychoanalytic Study of Learning*, State University of New York, Albany, NY.

Britzman, D. P. (2006) *Novel Education: Psychoanalytic Studies of Learning and Not Learning*, Peter Lang, New York.

Busfield, J. (1996) *Men, Women and Madness: Understanding Gender and Mental Disorder*, Macmillan Press Ltd, Basingstoke.

Collins, M. (2004) *The Likes of Us: A Biography of the White Working Class*, Granta Books, London.

Cooper, A. (2001) 'The state of mind we're in: social anxiety, governance and the audit society', *Psychoanalytic Studies*, vol. 3, pp. 349–362.

Cross, S. (2004) 'Visualizing madness: mental illness and public representation', *Television and New Media*, vol. 5, pp. 197–216.

DfEE (2001) *Skills for Life: The National Strategy for Improving Adult Literacy and Numeracy Skills*, DfEE Publications, Nottingham.

DoH (1990) *Care in the Community: Making It Happen*, HMSO, Department of Health, London.

DRC (2001) *Disability Discrimination Act Part 4* (SENDA) (Vol. HMSO).

Foucault, M. (1980) *Power/Knowledge: Selected Interviews and other Writings 1972–1977*, Pantheon, New York.

Foucault, M. (1982) 'Afterward: the subject and power', in *Michel Foucault: Beyond Structuralism and Hermeneutics*, eds H. Drefus & P. Rabinow, 2nd edn, University of Chicago Press, Chicago, pp. 208–226.

Foucault, M. (1991) *Madness and Civilization*, Routledge, London.

French, R. B. (1997) 'The teacher as container of anxiety: psychoanalysis and the role of the teacher', *Journal of Management Education*, vol. 21, pp. 483–495.

Froggett, L. (2002) *Love, Hate and Welfare: Psychosocial Approaches to Policy and Practice*, The Policy Press, Bristol.

Frosh, S. (2002) *After Words: The Personal in Gender, Culture and Psychotherapy*, Palgrave, Basingstoke.

Hari, J. (2007) 'Jaded contempt for the working class', *The Independent Newspaper* [online] Available at: http://comment.independent.co.uk/columnists_a_l/johann_hari/article2175017.ece.

HEFCE (2000) *Widening Participation: Special Funding Proposals*, Higher Education Funding Council for England, Bristol.

Holloway, W. & Jefferson, T. (2000) *Doing Qualitative Research Differently: Free Association, Narrative and the Interview Method*, Sage, London.

Jamison, K. R. (1993) *Touched with Fire: Manic-Depressive Illness and the Artistic Temperament*, Simon Schuster, New York.

Klein, M. (1946) 'Notes on some schizoid mechanisms', *International Journal of Psychoanalysis*, vol. 27, pp. 99–110.

Klein, M. (1988) *Love, Guilt and Reparation and Other Works 1921–1945*, Virago, London.

Levitas, R. (1998) *The Inclusive Society? Social Exclusion and New Labour*, Macmillan, London.

Milner, M. (1950) *On Not Being Able to Paint*, Heinemann, Oxford.

Pennebaker, J. W. & Seagal, J. D. (1999) 'Forming a story: the health benefits of narrative', *Journal of Clinical Psychology*, vol. 55, pp. 1243–1254.

Rustin, M. (2001) *Reason and Unreason: Psychoanalysis, Science and Politics*, Continuum, London.

Sagan, O. (2002) 'Teaching psychiatric patients: a psychoanalytic study', *Psychoanalytic Psychotherapy*, vol. 16, pp. 58–73.

Sagan, O. (2004) 'Mental health policy in FE — the spaces in between', *AUCC Journal*, Autumn, pp. 6–8.

Segal, H. (1957) 'Notes on symbol formation', *International Journal of Psychoanalysis*, vol. 38, pp. 391–397.

Stone, B. (2004) 'Towards a writing without power: notes on the narration of madness', *Auto/Biography*, vol. 12, pp. 16–33.

Tamboukou, M. & Ball, S. J. (eds) (2003) *Dangerous Encounters: Genealogy and Ethnography*, Peter Lang Publishing, Inc., New York.

Tomlinson, J. (1996) *Inclusive Learning: Report of the Learning Difficulties and/or Disabilities Committee*, HMSO, London.

Wengraf, T. (2001) *Qualitative Research Interviewing: Biographic Narrative Semi-structured Methods*, Sage, London.

Winnicott, D. W. (1969) 'The use of an object and relating through identifications', in *Playing and Reality*, Tavistock, London.

Martin Smith

SMOKE WITHOUT FIRE? SOCIAL WORKERS' FEARS OF THREATS AND ACCUSATIONS

I will do such things —
What they are yet I know not;
But they shall be the terrors of the earth.

(Shakespeare, *King Lear*, II, iv)

When working as a social worker several years ago I visited a father who was said to have physically abused his eight-year-old son. Having talked to them both I did not think the situation one of serious abuse or threat to the boy. It seemed more likely that the father had been unintentionally heavy handed in his attempts to discipline. When I returned at a later date the father was spluttering with annoyance as he told me that his son had filled his Wellington boots with tomato sauce and that he only discovered this when putting them on. When he turned to his son angrily to reprimand him for doing this he reported his son saying to him, 'Stop it — if you talk to me like that I'll tell the social worker about you'. The boy had learned the power of threat and accusation.

An accusation carrying more serious consequences is reported by Savill (2005) under the headline 'Builder hanged himself after boys' assault claims'. A 52-year-old builder was laying slabs at a leisure centre when some 13- and 14-year-old boys chanted 'Bob the Builder' at him. The jokes turned to insults and the boys threw missiles at him including cones and fruit. The builder confronted three of the boys in a changing room at the centre. Two of the boys told their headmaster that the builder had pushed them and a third that he had tweaked his nose. The headmaster called in the police. Twenty-four hours later the builder's wife found her husband had hanged himself in their garage. The coroner commented, 'What an appalling tragedy. What a loss. I have been a coroner for 20 years and words fail me'. The head teacher expressed 'sincerest sympathies' to the man's family and said that the pupils involved had been disciplined. Although we cannot know all the facts and circumstances of this case the implication is that the builder killed himself as a consequence of the accusations made against him and the threat they posed to him. This paper will show that threats and accusations can have profound and far-reaching consequences for social workers which, while rarely resulting in death, can 'kill off' something essential in the worker's motivation and commitment to the work.

'The threats were real' — the man upon the stair

Stanley and Goddard (2002) in their research on social workers in Australia write:

> A worker described an armed hold-up at her office. Another worker had been held hostage with a gun at her head. The man believed to be responsible was still free and continued to 'stalk' and 'harass' workers. He had also threatened to 'take out' some workers. The protective services office was closed as a result of this hold-up and its effects on the protective workers. The workers were moved to a new location … Since 1989 when child death inquiries were first instituted 17% of deaths were attributed to trauma inflicted by a parent or carer. In a number of cases parents are reported to have made threats to kill or harm their children prior to their death. The committee recommends that such threats 'should be treated with the same seriousness as *actual harm*'.
>
> (Stanley & Goddard, 2002, pp. 13, 31, emphasis in original)

This extract raises the question of how seriously should threats be taken? *The Concise Oxford Dictionary* defines a threat as: 'a declaration of intention to punish or hurt'. As a declaration, an un-acted-upon threat does no physical harm, any harm caused arises from the imagination of the person threatened. However, such threats can have fatal consequences.

Sargant (1973, p. 122) writes of 'hex' (voodoo or psycho-physiological) death:

> The power of the witch-doctor is very great in some regions … those who really believe in this power can actually die of fear, just as people in the West can die of fear when their basic terrors are aroused … The victim may become so frightened that he goes into a state of acute anxiety, in which most of the bodily

secretions and metabolic functions are severely disturbed: secretions essential to life are dried up by fear, and he eventually dies of fright physiologically.

In these cases the person dies as a consequence of having been threatened because of the fear that arises from the interpretation of the threat. Another example of this is provided by Bourke (2006, p. 61), writing of a fire at a cinema in 1929 when 70 children aged between two and 16 were killed in a stampede. The manager of the cinema had opened some doors through which the children could have escaped but in their panic they were unaware of this and crowded towards the only exits they could see. Their panic, rather than the fire, had killed them.

Martin (1997) provides a contemporary example of people dying of fear arising from being threatened rather than directly from the source of the threat:

> During the Gulf War of 1991 Iraq launched a series of missile attacks against Israel. Many Israeli civilians died as a result of these attacks. But the vast majority of them did not die from any direct physical effects of the missiles. They died from the heart failure brought on by the fear, anxiety and stress associated with the bombardment. *They died because of what was going on in their minds* ... The 'extra' deaths were concentrated in areas of Israel where the levels of fear and anxiety were highest.
>
> (Martin, 1997, p. 3, emphasis added)

There is, therefore, some support for Stanley and Goddard's claim that threats should be treated with the same seriousness as actual harm in that perceived threats can be as fatal, maybe even more fatal, than actual attack. However, this could pose problems for the police who can arrest people for making 'threats to kill'. Clearly a distinction has to be drawn between those who threaten and are thought to have the desire and means to carry out their threats and those who are just bluffing and blustering.

This dilemma was highlighted in my own research enquiring into social workers' experiences of fear. In this research I asked 60 social care workers to tell me about times when they had experienced fear in their work [for a detailed description of this research see Smith (2005)]. Eighty-two different fears were reported: 43 fears of being assaulted, 18 fears of being killed (see Smith, 2006), 11 fears of losing control, being overwhelmed or breaking down, and 10 fears of being disapproved of or rejected by managers. This paper is concerned with the last two categories of fears reported, as fears of losing control, being overwhelmed and breaking down were often inspired by (perceived) threats, and fears of being disapproved of or rejected by managers often arouse from workers' feelings about being complained about by way of complaints procedures.

One worker talked of having to remove a baby from its mother at birth. The wider family had threatened the worker who said, 'The family had a well-known history with the police and social services so the threats were real and I could imagine them carrying them out. The threats were to punch me, "deal with us", shoot us'. Her statement that 'the threats were real' highlights the debate about how 'substantially' a threat should be regarded as opposed to its actually being carried out.

In itself a threat is nothing, 'mere' words, a declaration of intention which might or not be meant or acted upon. However, simultaneously a threat can have a chilling 'reality' which causes people to fear for their lives. The power of threats is all the greater when they are vague and non-specific; to 'deal with us' as in this case. Generalised language such as 'You'll be sorry', 'I know where you live' and 'I'm going to get you' give threats an obscure potency when made by those who are seen as having the power to carry them out. The reality of something not real leaves a nagging doubt in the mind like the man who wasn't there described by Lee (2001, p. 110):

Yesterday upon the stair
I met a man who wasn't there;
He wasn't there again today,
I wish, I wish, he'd go away.

I've seen him in a black, black suit
Shaking, under the broken light;
I've seen him swim across the floor
And disappear beneath the door

And once, I almost heard his breath
Behind me, running up the path:
Inside, he leant against the wall,
And turned ... and was no one at all.

Yesterday upon the stair
I met a man who wasn't there;
He wasn't there again today,
I wish, I wish, he'd go away.

Sometimes workers themselves seemed unsure of how seriously to weigh the threat. Is this a 'real' threat or an illusory one? This was particularly the case when workers' experiences assumed a surreal quality:

I was asked to deliver a letter to a client. My knock on the door was answered by a client who was drunk; then, another client came down who was also drunk. I asked after the child and was told that she was sleeping. The child's father came to the stairs and said, 'Come on in'. I wasn't really sure of what I should be doing. In the room were six people, five of which were in different levels of intoxication. Again, I asked to see the child. I was getting a lot of sexualised innuendo, sexualised talk. I thought, 'What am I doing in this flat? I should have got someone to come with me'. Someone came out of a bedroom. I was afraid that I would get raped. I went up to the child's bedroom. There was more sexualised talk. The child was whimpering and clutching a pound coin. On seeing me it rushed to me and clung to me.

Through the course of an 'ordinary' working day this worker suddenly finds herself at a threshold to a world where normal rules do not apply. The child's father's

invitation to 'Come on in' recalls the ominous welcome given to unsuspecting victims in fairy tales or horror films. The worker registers that she might be in danger yet she proceeds across the threshold none the less. She recognises a high level of sexual disinhibition and wonders what danger she might be in. She dimly perceives a threat but walks up the stairs (deeper into a place of potential danger) despite this. The pound coin that the child clutches seems poignantly significant but the significance is not clear. The child's response of rushing and clinging to the worker seems an externalisation of the worker's inner processes as she wishes she had someone to rush to and cling to but there is no one there looking out for her well-being.

Stephen King (2003), reputed author of horror fiction, explains how fears are fed by the imagination to the extent that they evolve into something worse than the reality. Hence, when the 'monster' is eventually revealed in a horror film it is frequently less frightening than the audience have imagined it to be:

> You approach the door in the old, deserted house, and you hear something scratching at it. The audience holds its breath along with the protagonist as she/he (more often she) approaches that door. The protagonist throws it open, and there is a ten-foot-tall bug. The audience screams but this particular scream has an oddly relieved sound to it. 'A bug ten feet tall is pretty horrible', the audience thinks, 'but I can deal with a ten-foot bug. I was afraid it might be a *hundred* feet tall'.
>
> (King, 2003, p. 132, emphasis in original)

Threats work by fuelling the fires of the imagination that threaten to burn down defences erected by workers, as the following interview with a social worker employed in Northern Ireland illustrates:

> There had been a specific threat against my life from a man who had been involved in the murder of a British soldier. He thought I had made threats to remove his children although I had not. He was known to be in a paramilitary organisation and the murder he had been involved in was two avenues away from where I lived so it was encroaching on my home area. In Northern Ireland terms on a scale of 1–10 the threat was a minus 20 but it remains with me and it's quite vivid. It made a significant impact on me. It was like the bottom had dropped out of your world. I shared it with my wife as I was concerned for any possible danger to her or to my young family. Even though there was only a 0.1% chance of anything happening I needed to share it with her. People do come to your door and are shot dead for no better reason than their religion. My brother in law was murdered when he was 17 in a rural part of Ireland, supposedly for taking a younger child's ball. It was supposed to be a punishment beating but he was pistol whipped and shot through the head. Life is cheap as a commodity here and I am precious to myself. I was aware of altering my routes and being more aware of my personal safety. I became more vigilant and more security conscious. I avoided going to the road where the man resides in case I may come to his mind or to the front of his mind. I don't want to go cap-in-hand to terrorism and I wasn't going to provide an act of contrition for something that I didn't do. I

needed to remove my name from hospital records that had said I was to be contacted and replace this with 'Contact the office' instead. Over time the impact of threat has diminished although I haven't been given cases in his area and I've only recently driven down the road past where he lives.

This worker describes threats made against him arising in response to threats he is perceived to have made to remove a father's children. It is apparent from this account how the worker's conscious mind attempts to keep his imagination under control as he attributes numbers to the danger he was 'really' in — 'on a scale of 1–10 the threat was a minus 20' and 'there was only a 0.1% chance of anything happening'. Despite this he experiences a catastrophic reaction, feeling as if the bottom had dropped out of his world and that his wife and young family were also in danger. He links the threat with a previous bereavement and thus it gains potency. His daily routine is affected as he checks his car and changes his routes. He remains fearful about coming to the mind of the person who threatened him. His name is replaced on records with that of the (anonymous) organisation. The threat has a de-personalising, identity-eroding quality. With time, the power of the threat recedes and yet its influence remains, with the potential of being re-activated.

Obholzer (1997, p. 206) describes this kind of reaction to the work as embodying a

> primitive anxiety … the ever-present, all-pervasive anxiety that besets the whole of humankind … It is the terror of the baby afraid of being left alone in the dark, of the child who hides under the covers from 'the monsters under the bed', of the person who wears an amulet as protection against the 'evil eye'.

Such anxieties can lead to workers questioning their motivation for undertaking social work: 'The nobility of caring work turns out to be a myth … the worker often comes to the conclusion that he is unfit for the work he has chosen. A severe fracture of professional identity is a common result' (Mattingly, 1981, p. 157). Threats might or might be (perceived to be) real but they commonly have very real consequences.

Threats of being assaulted and killed can therefore be seen to cause social workers deep distress. However, for some, worse then being threatened with assault or death is the threat of being complained about through complaints procedures.

'That's you!' Poisonous bureaucracies and complaints procedures

It might seem extreme to claim that workers might fear complaints procedures more than being threatened with assault or death but this point was made by an eminent doctor working with fabricated and induced illness when talking at a conference (Jones, 2006). He said:

> I've been threatened twice by men with guns. On one occasion the police disarmed a man in front of me. On another occasion they intercepted a man on his way to see me in Court and took a gun from him. However, both of these

were as nothing compared to the three years I needed to spend clearing my name following a complaint made against me to The General Medical Council.

A participant in the research said:

I was rude to a colleague as he was being petty about some leave I wanted. He sent in a written report about the incident and I wrote a report in defence of myself just before I was due to go away on holiday. It's the 'no control'. You have some control — you write your report, you seek advice and all that but despite that you still feel things can turn against you … Some people go to court, they are the victim, but the whole thing could turn against them …

This worker's mention of court entails notions of examination, judgement and sentence. He might consider himself the victim to begin with but recognises how his situation might be seen differently and he be regarded as the guilty party instead. Cooper (2000, p. 253) writes of an 'inner courtroom' which people might experience:

One could say that the patient … has in his more disturbed areas a kind of inner courtroom in his mind. But it is a topsy-turvy courtroom, in which the innocent are on trial, the guilty are making false allegations, and the judges lack all compassion or capacity for balanced judgement.

The sadistic judge in this 'topsy-turvy courtroom' might be a version of the superego at its most destructive as described by Freud (1984, p. 394):

… the excessively strong super-ego which has obtained a hold upon consciousness rages against the ego with merciless violence, as if it had taken possession of the whole of the sadism available in the person concerned. Following our view of sadism, we should say that the destructive component had entrenched itself in the super-ego and turned against the ego. What is now holding sway in the super-ego is, as it were, a pure culture of the death instinct, and in fact it often enough succeeds in driving the ego into death, if the latter does not fend off its tyrant in time …

No wonder people might fear complaints procedures if their effect is to mobilise a 'pure culture of the death instinct' by way of the super-ego.
Another account of fear of complaints procedures was given as follows:

I was dealing with this woman who is known to be a pain in the backside but you can't tell her that because of the relationship. I did put the 'phone down on her and I probably said some unkind words as well. She said, 'I'm going to put in a complaint about you'. The fear is that the one moment you react, that's it, it will be used to say, 'That's you'.

This last sentence indicates how destructive complaints procedures can be to workers' identities. All the good work this worker might have done, all the skilled

interventions he might have made, all the kindness and compassion he might have shown, is reduced to nothing compared to the one wrong sentence he voices. 'That's you.' Dead.

Waiting for the outcome of a complaints investigation can be agonising for those suspended:

> More than one in four suspended hospital doctors have seen a psychiatrist because of their plight and more than one in ten has contemplated suicide … Of 105 suspended doctors surveyed, 27 per cent said that suspension had caused them to see a psychiatrist, 32 per cent to take medication and 13 per cent had felt suicidal.
>
> (Grant, 2003, p. 6)

Another participant in my research into fear reported:

> I came back to dictate my notes from a difficult visit to a client's mother who shrieked at me down the telephone saying that I had broken confidentiality and that she was going to lodge a complaint against me which she subsequently did. I hadn't been complained about previously and did experience a real sense of fear which was about being confronted by my manager with something that impinged on my practice. A real, somehow genuine, fear, going over in my mind's eye, what did I say? What did I do? It was quite a primitive fear about being accused, at some very simple level of having done something bad. You've been bad, somebody is saying bad things about you. It's as primitive as that … it's child-like, you've done something bad and will have to face the consequences. In rational terms I didn't think that anything dreadful was going to happen to me but I was afraid.

Once again there is the mention of 'real' fear as opposed to imaginary fear that can be discounted, along with the 'primitive' fear/anxiety written of by Obholzer and quoted above. The participant reviews her words and actions in her mind's eye. This can be helpful up to a point but fear can blind the mind's eye and prevent it from seeing (Marijana, 1996).

The participant's wording 'You've been bad, somebody is saying bad things about you' echoes the opening of Kafka's 'The Trial': 'Someone must have been telling lies about Joseph K. for without having done anything wrong he was arrested one fine morning' (Kafka, 1978, p. 7). Kafka's legal system is an example *par excellence* of the 'topsy-turvy courtroom' described by Cooper above. Joseph K's accusers are never apparent, the charges against him are never specified and yet from the time of his accusation he spends his life trying to prove his innocence in relation to a crime that is never stated. The fight to 'clear his name' (from he knows not what) occupies more and more of his time until he has no energy or resources left to fight anymore. He is ultimately killed by some ostensible representatives of the legal process and remains as clueless at the end of the novel as he was at its beginning: 'Was help at hand? Were there arguments in his favour that had been overlooked? … Where was the Judge whom he had never seen? Where was the High Court, to which he had never penetrated?' (Kafka, 1978, p. 250).

Greenberg (1971, p. 133) argues that the court only has authority over K. because he lets it. The minute he draws attention to its emperor's new clothes it loses power completely. Yet, K. does not do this:

> K's arrest is a comedy because the court pretends to an authority which it only possesses as long as K. lets it; it is a sinister comedy because K. lets it. All the court's (i.e. the world's) pompous gravity is so much grotesque buffoonery, all its orders naked bullying, its executions plain murder the instant K. refuses to acknowledge the court's authority. But instead of repudiating with indignation the court's authority to judge him and then judging himself, K. keeps protesting to the court that he is innocent — thus acknowledging its authority over him.

Why would anyone accept the (ultimately fatal) authority of a system that made no sense to the conscious mind? Bradbury (1983, p. 211) suggests an answer:

> ... they open your file and it is fat and everything is there, the notes and the pictures. And they tell you what you are and what you do. They know more than you, they remember everything, the things you don't ever remember that you did, but you did them. You say, 'It's not me, I am not like that, I was never there'. And they tell: 'Yes, it is you, really you, the other is your illusion'. They have made your story, a bad novel, and you are in it forever. And here is what is strange. You begin to agree it because it fits, because it has your images, your voice in a tape. You begin to confess it, yes, I am like that, how well you know me. And they are right, because in all of us is a doubt, that we do not know ourselves at all. We all feel a bit guilty to exist. And this they know very well. To be is the crime we commit, and anyone will confess it.

Bradbury suggests a deep, primitive existential guilt which covers an ontological fear. It is this fear that can be activated by complaints procedures and this is why they can give rise to such extreme fear in those who are (partly) aware of them and prepared to accede to this form of authority. This is why some would prefer the prospect of an assault or serious threat on their life made with a weapon as the 'outer' threat is gentler than this inner terrorising ontological fear. This section concludes with a quotation from a participant in the research into fear who expresses this preference clearly:

> A man was being verbally abusive, pointing his finger, f'ing and blinding. I wanted his child to be examined. I was afraid that he would make complaints about me and was afraid of the reaction of management if he did. I was also afraid that he was going to hit; or something worse — kill me. It was intensely difficult for seven weeks. He was a violent man with a criminal record and I would dream of the family threatening me. I began to dream that the man was following me, that he held me prisoner, at knifepoint and stabbed me. The family made complaints about me that chipped away at my confidence. It wasn't the complaints they made as much as the way they were handled that made it difficult. I'm more frightened when I'm in my work office than I am when out visiting people. It's the criticisms of your practice internally that are the most

difficult. You feel you can't do anything right. The people who deal with complaints haven't a clue about what we're doing. It's got worse recently. I'm happier when visiting clients, even that difficult one, compared to the fear that I feel in the office. I went off work for five weeks with stress and fear.

Chicken Licken and the failure of containment

What can help social workers who are threatened and falsely accused? The story of Chicken Licken (Southgate, 1969) provides a good example of what does not help. An acorn fell from a tree and hit Chicken Licken on the head. Chicken Licken completely misinterprets this and believes the sky is falling and runs off to tell the king. On the way he meets his friends, Henny Penny, Cocky Locky, Ducky Lucky, Drakey Lakey, Goosey Loosey and Turkey Lurkey. All of these friends accept Chicken Licken's account of what has happened without question or comment. They too believe that the sky is falling and join Chicken Licken on his way to tell the king. Chicken Licken and friends then meet Foxy Loxy who clearly knows that the sky is not falling and sees this as an opportunity ripe for exploitation. Thinking quickly (as foxes do) he offers to show Chicken Licken and friends the way to find the king. However, he leads them instead to his den where all are eaten up by him and his family. The king never did get to hear that the sky was falling.

In psychodynamic terms Chicken Licken and friends demonstrated an inability to contain their fear. Chicken Licken demonstrates a catastrophic reaction to a (wrongly) perceived threat and his un-thought through fear is projected into his friends who internalise it without thinking about it. They too become swept along by the fear which seems to get stronger the more of them there are to voice it. Their reaction is similar to the children cited above who panicked and died in the fire trying to squeeze through one exit while others remained unused. As soon as someone thinks about the threat it is seen differently. Unfortunately for Chicken Licken and friends it was the fox who thought first and quickest.

Writing of the importance of containment (Bion, 1988) of strong feelings, Agass (2000, p. 211) claims:

> ... projecting parts of ourselves is a normal aspect of human relating which continues throughout life and which forms the basis of our capacity to empathise or identify with other people. Normally this means that we can identify with someone else but then pull ourselves out again into our own skin, so to speak, without any real danger of being lost inside the other person or getting our own identity confused with theirs.

Fear is notorious for being infectious (try sitting next to someone acutely fearful on a plane for any length of time and not beginning to feel fearful yourself!) and a particular danger of being exposed to it as social work practitioners and supervisors is that it can be 'swallowed whole' without thought. This is what happened to Chicken Licken's friends. Instead of using the way they had been affected by his fear as a beginning of empathy they became caught up in it and by it, lost inside it, and rushed

around, without thought. They were not able to 'pull themselves out again, into their own skin'.

Agass goes on to describe visiting a client who was acutely distressed with a colleague. As the workers were about to leave the client draped himself across the bonnet of Agass' car. Agass describes himself as feeling agitated and angry and wanting to drive off at speed. His colleague, however, got out of the car, gently put his arm around the client, and spoke to him reassuringly. This calmed the client down and enabled the workers to leave. Agass reflects on the differences between his own response and that of his colleague:

> What the client needed, and what my colleague intuitively provided, was an empathic, containing response — while all I could think about was driving off as quickly as possible. Indeed, if I had been able to think at all about what was happening I might have realised that the client's internal state was being expressed in his behaviour ...
>
> <div align="right">(Agass, 2000, p. 213)</div>

Organisations, as well as individuals, have a part to play in helping to contain fear-provoking experiences. A specialist social worker working with drug and alcohol abuse reported a failure of his manager to contain anxiety:

> A client was in a street agency, a methadone clinic. He couldn't have looked meaner — a skinhead with a big Alsatian dog on a chain; the epitome of nastiness really. He couldn't wait to see the doctor, was not happy about this, and let us know it. He had to wait. He calmed down but the manager over-reacted. She ran off and hid. She asked, 'Should we call the police?' It took as much to calm her down as the client, if not more. She could easily have set him off again. She said later, 'We've got to review safety policies; we've all got to have mobile 'phones' ... It wasn't necessary. It was an over-reaction and really unhelpful.

By way of contrast a different worker described the response of her manager following an incident in a social services office where a violent service user had smashed his way through a reception area with a fencing pole in search of a worker who he wanted to attack:

> I did voice my feelings to a manager in charge. She was good and listened. I was afraid that I would go to work and never come back as there was a threat that this guy would go to court and be released and that next time he would come back and finish us all off. We had a meeting in the building with all departments. By going to the meeting and speaking I felt I was doing something positive. I said I thought the reception area should be reinforced. We live in violent times and we get all sorts of people in.

Considerable fear is voiced here — that the worker would never return from work and that she, along with all her colleagues, would be 'finished off'. However, it seems that the provision of an appropriate, safe place in which to think, talk and be listened to makes a containing difference.

In writing this paper I am not advocating that threats should not be taken seriously or that complaints processes cannot serve necessary and useful purposes. In a previous paper published in this journal (Smith, 2006) I claimed that sometimes social workers are insufficiently fearful of threats made and risks faced. This paper provides a balance in that it argues that workers should not be over-fearful because their own un-thought through and uncontained fears can bring about adverse consequences that would not happen were it possible to contain them, perhaps having shared them with a trusted other. Fears can find 'fertile footholds' in a worker's personality (Agass, 2000, p. 214) and wreck untold havoc unless thoughtfully evaluated. While this can be a difficult task at times it is a skill worth cultivating. In these days of performance indicators where social workers need to be seen as being profitably industrious the wisest advice might be, 'Don't just do something, sit there!'

References

Agass, D. (2000) 'Containment, supervision and abuse', in *Psychodynamic Perspectives on Abuse. The Cost of Fear*, eds U. McCluskey & C. A. Hooper, Jessica Kingsley, London.

Bion, W. R. (1988) 'A theory of thinking', in *Melanie Klein Today. Developments in Theory and Practice. Volume 1: Mainly Theory*, ed. E. Bott Spillius, Routledge, London.

Bourke, J. (2006) *Fear. A Cultural History*, Virago, London.

Bradbury, M. (1983) *Rates of Exchange*, Vintage, London.

Cooper, A. (2000) 'Desire and the law', in *Psychodynamic Perspectives on Abuse. The Cost of Fear*, eds U. McCluskey & C. A. Hooper, Jessica Kingsley, London.

Freud, S. (1984) 'The ego and the id' (1923), *Pelican Freud Library 11. On Metapsychology. The Theory of Psychoanalysis*, Penguin, London.

Grant, S. (2003) 'Suspended doctors suicide fear', *Health Service Journal*, 11 September, p. 6.

Greenberg, M. (1971) *The Terror of Art*, Andre Deutsch, London.

Jones, D. (2006) Conference talk on fabricated and induced illness, presented at Child Care Conference, High Wycombe, 26 September.

Kafka, F. (1978) *The Trial* (1925), Penguin, Harmondsworth.

King, S. (2003) *Danse Macabre*, Time Warner, London.

Lee, B. (2001) 'The man who wasn't there', in *A Poem for Everyone. A Treasury of Poems about People*, eds M. Harrison & C. Stuart-Clark, Oxford University Press, Oxford.

Marijana, S. (1996) 'When fear blinds the mind's eye', *Group Analysis*, vol. 29, no. 4, pp. 527–534.

Martin, P. (1997) *The Sickening Mind. Brain Behaviour, Immunity and Disease*, Harper Collins, London.

Mattingly, M. (1981) 'Occupational stress for group care personnel', in *Group Care for Children: Concept and Issues*, eds F. Ainsworth & L. Fulcher, Tavistock, London.

Obholzer, A. (1997) in *The Unconscious at Work. Individual and Organizational Stress in the Human Services*, eds A. Obholzer & V. Zagier Roberts, Routledge, London.

Sargant, W. (1973) *The Mind Possessed. A Psychology of Possession, Mysticism and Faith Healing*, Cox and Wyman, London.

Savill, R. (2005) 'Builder hanged himself after boys' assault claims', *Daily Telegraph*, 29 April, p. 12.

Smith, M. (2005) *Surviving Fears in Health and Social Care. The Terrors of Night and the Arrows of Day*, Jessica Kingsley, London.

Smith, M. (2006) 'Too little fear can kill you. Staying alive as a social worker', *The Journal of Social Work Practice*, vol. 20, no. 1, pp. 69–81.

Southgate, V. (1969) *Chicken Licken*, Ladybird, Loughborough.

Stanley, J. & Goddard, C. (2002) *In the Firing Line. Violence and Power in Child Protection Work*, John Wiley, Chichester.

Carolus van **Nijnatten** & Frida van **Doorn**

CREATING COMMUNICATION. SELF-EXAMINATION AS A THERAPEUTIC METHOD FOR CHILDREN

Introduction

Reflection on life, others and the self is what makes people human. People direct their lives by organising their emotions and cognitions with the help of symbols, mostly language. These symbols stem from the culture in which they live. This is how our social lives interweave with our individual lives; social realities are constructed by individual actions but these actions are also reproductions of that reality. Any symbolisation of life is of social origin. People speak in the language of society and make themselves understandable with symbols which are recognised by other members of that society. To become a social being and a member of the community, people have to appropriate the language of the culture, make this strange language a second nature.

Cultures are characterised by the dominance of certain types of individual organisation. Most people will assimilate and structure their narratives according to one of the dominant organisational principals. In Western societies, coherence (Hermans, 2004), chronology (Mooij, 1988) and continuity (Chandler, 2000) are central aspects of the narrative organisation.

Children learn to speak the language of the culture they grow up in; they are socialised in the dominant narrative structures. Children in Western societies learn to

tell their life stories in a chronological way, evaluating their life as a unity that has a historical and future link. They learn to consider themselves as remaining one and the same person in the course of time and in changing contexts. When they do not succeed in organising their lives in such a way, their stories will not be understood and they will be considered deviant.

The function of child psychotherapists is to help children to (re)learn to speak in the words of the culture, use the accepted narrative structures and find the words to express their emotions and cognitions. In this article, we present a therapeutic model in which the child's original contribution to the narrative organisation of its life is acknowledged. This is the self-confrontation method for children. We will clarify the procedures and techniques with a case description.

Dialogical development

People share experiences by exchanging signs, which refer to something beyond themselves (Bakhtin, 1984). Words carry experiences from one person to another. The use of socially accepted symbols is conditional for individuals to become members of a society. Little children do not have the tools to symbolise their individual and social condition available to them yet. To organise their lives, little children are dependent on adults. Adults scaffold children by giving words to their experiences and support them to structure their behaviour (Wood, 1988). They check if a child can manage without help and withdraw when it is successful on its own and in other cases become more precise in their instruction. In this communicative view on development, children learn to act individually by interacting and appropriating what is jointly produced (Rogoff *et al.*, 2003). Little children use the words of adults for comprehension and structuring. They gradually increase their autonomy together with their ability to find their own words to describe their experiences. Coming of age may then be characterised as the decreasing tendency to speak the words of the other, stopping being the extension piece of someone else's desire (Mannoni, 1967).

To become an autonomous member of society, children have to learn to become both an individual and a social being, to become a self-realising subject while remaining attached to others (Froggett, 2002). Although children's physical conditions define the start of their lives, their development is an implantation into a foreign social life. To experience a coherent self, the child has to acknowledge that it coincides with the image *other* people present of him or her, and to express emotions and cognitions, the child has to speak a common language that *transcends* the individual position. People achieve self-realisation in and through dialogues with other people (Bruner, 1990) and by internalising these into an internal dialogue. Children learn in interaction, meaning that at first experiences and cognitions are articulated by adults and that only later can they use the words for expression themselves. Vygotsky (1978) explains that in instruction situations children often reach a higher level of competence in interaction with instructors than without; in the zone of proximal development children can accomplish activities in co-construction with the instructor. The dialogical nature of this process is nicely demonstrated in the example of making a jigsaw puzzle: the instructor helps the child to find the corner pieces and the other

side pieces and his instruction is accompanied by *telling* what he does; he shows the child where to find the pieces and *tells* that the best strategy of making a jig saw puzzle is to look for the corner and side pieces. In a next phase, the instructor *asks* the child what kind of strategy he or she has in mind, and then the child will *tell* that he or she first wants to look for the special pieces. Still later the child will *speak out* the same kind of words without being asked and also without the instructor being present. In the last phase, the instruction has become an *inner speech*. This is similar to the famous Fort–Da observation of Freud in which he showed how a child literally manipulates the departure of a parent by taking an object with a string and throwing it away with a sad face and saying 'Fort' and saying 'Da' with a happy face when he pulls the string and takes again the object. Obviously, 'Fort' and 'Da' were the words mother spoke when she left and returned. Mother went away but her words stayed with the child (Mannoni, 1967).

The common aspect of these two examples is that the child's actions precede the psychological internal actions and that words play an important part in that process (Bruner, 1983). In the case study presented here we hope to show how the child's creative acts are an essential part of the dialogue with the therapist. The therapist's words are related to the child's creative products; this leads to shared understanding followed by a new internal dialogue of the child. Dialogue is both an interpersonal and intrapersonal process. Change is most likely to occur in situations where there is conflict at the intrapersonal or interpersonal level. If parts of the self-system are at odds, agreement with another person is an important condition for change. If no conflicts are experienced between several I-positions while other people consider some of them problematic, interpersonal disagreement may help change to occur. Situations where there is both intra-disagreement and inter-agreement are more likely to lead to change than situations of duplicated agreement or disagreement (Hermans, 1999). Agreement and disagreement appear on both the individual level (internal dialogue) and between persons. The individual I-positions refer to various external contexts: I as a brother, I as back in the football team, I as the one who is afraid of dogs. A child develops a flexible and dynamic personality if it is able to shift I-positions (Valsiner, 2002). This is a process of really changing perspectives, creating new positions in the self and in relation to others (Shotter, 1993). Psychological health depends on this capacity to organise a dynamic interchange between I-positions, accepting differences between them and maintaining a sense of coherence and continuity (Van Nijnatten, in preparation). Dynamic personalities develop in a field of divergence and convergence. It is therefore crucial that the child grows up in a dialogical environment in which it experiences a basic security to disagree with others. On the other hand, lack of confidence in other people may end in closing off communication (Siegel, 1999).

Developmental disturbances

In summary, the ingredients for a prosperous development are: a dynamic relation between different I-positions, a meta-position that brings coherence, an active position of the child in the construction of narratives that are linked with the child's emotions and cognitions. Overseeing these elements, we get an idea of the nature of

developmental disturbances. Problems will arise if children are captured in one or more I-positions and are not able to adapt to changing contexts or cannot take an adequate position in some social situations, or if children lack an overarching mechanism and as a result get overwhelmed by social situations. Finally if children cannot find the words to articulate adequately their feelings and thoughts, these utterances are empty speeches. Children often get into trouble as the deficiency of dialogical capacities causes individual, interactional and social difficulties. They do not know how to behave in certain social contexts and are fearful of making their way in these situations. They are considered deviant by others and start to behave accordingly. They feel helpless in front of unfamiliar people, are devastated at moments of sudden change, and in all these situations, the child can find no adequate words to articulate its inner experiences.

The causes of developmental disturbances are different, but from a dialogical point of view the role of caregivers is crucial. If children discuss their experiences with their parents and co-construct narratives about them, this helps them to express what they see on the outside and imagine and experience on the inside. Children who have discussed emotional reactions with their parents are more aware of the emotions of other people. Parents who elaborate on the feelings of their children, for instance after reading a book to their children, stimulate their memory (Siegel, 1999). In narrative contexts with little co-construction, poor elaboration and little attention for expressing emotions and cognitions, children run a higher risk of developmental disturbances.

The case of Paul

Paul is an eight-year-old boy who visits a regular school for primary education. He was referred to the child psychologist because of the frequency and intensity of his conflicts with peers. Paul is of superior intelligence, yet he does not seem to understand what makes him explode. The teachers have talked about his own role in the conflicts, but he does not accept their explanations. Firm agreements about how to behave are constantly forgotten. Several times the teachers have had to interfere because there was serious danger of physical harm for the children Paul was fighting with.

Paul does have a problem, but he does not seem to have a sense of responsibility for it. He is convinced that his classmates are out to get him. If only the teachers would watch the class more carefully and would punish the other children for bullying, there would be no problem at all. There is no need for him to change. Internal or external dialogues about his problems seem to be absent. There are no shared words to refer to his problems.

He agrees to come to the psychologist because his parents think it is necessary. When the therapist explains at the first appointment that she will help him to be heard by the teachers and that official meetings will be arranged for him and the teachers he immediately takes to the idea of therapy.

Identification and labelling of the child's emotions

Paul is presented with a pool of 36 emotions, written on coloured cards. The feelings of self-enhancement (S), contact and union with others (O), and positive (P) and

negative (N) feelings are each written on differently coloured cards. The differentiation of the four kinds of feelings is not explained to the child. Paul is asked to sort out four cards of each colour. The cards have to be about feelings that are important to him. He is asked to explain what the feeling on the chosen card represents for him. Each chosen feeling is put on an official sheet, representing 'Feelings that are important to ME'.

Paul does an excellent job sorting out the P-, N- and S-feelings. It is striking to experience the fluency of his explanations. He feels very self-assured. Yet the nine blue cards representing O-feelings appear to be a problem. None of them (e.g. togetherness; being part of the group; intimacy; beloved) are fit to describe aspects of his life and world of experience.

The therapist asks him if he can imagine any word referring to being not all alone that fits him. 'No, nothing fits me.' Paul looks depressed and puzzled now. 'Do you think that is normal for a boy of your age?', the therapist asks him. There is steady eye contact, and Paul is really making contact with the therapist. After a long silence he answers: 'I don't know. That is what puzzles me when I cannot sleep at night'. He agrees on choosing feelings that he thinks are normal for other children.

At this point in therapy Paul has a new reason for visiting the therapist: he has discovered a concern in himself about being alone. The physical activity of sorting out and rejecting cards makes it possible and acceptable for Paul to search for emotions that were absent until that moment.

Clarify connections between these feelings and events

During the next appointment Paul tells about a conflict between him and one of his classmates. The classmate had been making sizzling noises to hinder Paul during working hours. They were working separately from the group, so Paul could not ask his teacher for help. He attacked the boy and tried to stop the noises by squeezing his throat.

Paul only had a very limited narrative about the event. Efforts to explain to him that his actions are inadequate did not seem to reach him. Paul stuck to the noises the classmate made and the fact that it did stop after he attacked him. Without any further comment the event was valuated with 'the card of feelings that are important to ME'. During that valuation Paul could recognise feelings of fear and rejection on his part during the event.

After the valuation, Paul stated that he wanted to draw a fantasy picture.

Proposing alternatives to the problem behaviour

Following his lead, the therapist observes Paul drafting a 'batman-rabbit'. While drawing, he tells the therapist that the rabbit is very sweet and friendly, but it has to protect itself against all the enemies in the world. He provides the rabbit with weapons by drawing rockets and tells that the batman-rabbit will eventually destroy the world to get rid of his enemies.

The therapist says that there will be a problem then, because if the world would be destroyed, the rabbit would be dead too. Paul agrees with that, but he has a solution. He will encage the rabbit so that it will not be able to destroy the world.

The making of a drawing facilitates talking about being a gentle animal (person) who has to arm against outward aggression. In relation with the therapist, Paul is able to extend the story and find ways to control aggression.

The therapist agrees that the cage is a safe solution, and adds: '... but I don't think the rabbit will be happy in the cage. I sure wish that there would be a kind of solution that would be more safe and more pleasurable for the batman-rabbit'. Paul agrees that it would be wonderful to have a different solution. At this point in therapy Paul has offered the therapist a language of his own that makes it possible to further explore his problems.

Stimulating choices that will be more successful in interpersonal contacts

During the fourth encounter, the therapist and Paul are talking about the way the aggressive behaviour just pops up out of the blue. Analysing several events Paul comments: 'It seems to me that I am always afraid on the inside when I start fighting on the outside'. The therapist compliments Paul on the way he expresses this observation and tells him that it works that way for many children of his age. Now, Paul poses the question how he can feel safe in difficult situations. The therapist comments that he feels safe in this room even though he is talking about very difficult things that matter a lot to him. 'How do you manage that?' Paul cannot explain that, but he starts working with several materials available on the table. After five minutes he has constructed a 'safety-necklace'. 'It helps me to feel safe, but I can only wear it in this room.' We both agree that it would be nice if we could think of a way to wear a safety-necklace in the world outside too.

Again Paul has discovered symbols and language of his own to discuss his problems, and again this seems to be the result of his previous creative activities (making a talisman) and the extending dialogue with the therapist.

Discussion

At the time we are writing this article, Paul is still in therapy. Yet the first sessions already show the relevance of his personal creative contributions. During all eight sessions until now, the therapist has tried to involve Paul and supported his input.

A first way to do this was by accepting non-linguistic contributions. Several times during the sessions, the therapist asked Paul to describe his inner feelings and thoughts, for instance about the conflicts in the classroom. Paul makes quite clear that he does not want to discuss what happened at school and takes no notice of the therapist's questions, but then says that he wants to make a drawing. Both in the drawing and in the other products he makes in reaction to questions, Paul symbolises his inner world by his creatures. He does accept discussing the products of his mind and so the therapist and Paul have found a way for Paul to communicate about his blocked emotions.

In the interactions, Paul's expertise was acknowledged in several ways. In the first place, the child was asked to construct a list of emotions and the therapist asked him to give examples of incidents when these emotions were recognisable. For most

children, this is a good moment to start telling the therapist about their life. By telling these stories, Paul gave his own interpretation to the values.

Paul shows compulsive conduct, for instance in endless wiping off after having been to the bathroom. By this, the boy tries to keep others at a safe distance; he prevents them having any reason to be dissatisfied by keeping strictly to the rules. Paul had to disguise his subjectivity (cf. Mooij, 1988). The therapist has helped Paul to learn about this 'strategy' by first confronting him with the fact that he could not label any other-feelings in the first meeting. During the next session the boy was asked to use his list of S-, O-, P- and N-feelings to value recent happenings. By using the list of emotions for mapping feelings in reaction to new events in his life, during the next sessions, Paul learned to differentiate his inner feelings and present them. Little by little he took off his disguise. In one of the last sessions, Paul told the therapist about a birthday party in a swimming paradise, and the value list showed that his feelings towards other people had grown substantially.

Although the therapy has not come to an end as yet, the first signs of change are observable. In one of the last sessions, Paul told the therapist he wanted to bring his 'safety-necklace' home. As he first said that the necklace could only be worn in the therapy room, he now admits that he feels anxious at home as well (because of his father's aggression) and may use the necklace to feel better inside which will reduce the need to fight. Paul himself proposed to wear the necklace outside the therapy room, extending the range of his helping tool.

Talking about the process of therapy and about the way Paul expresses himself has been very helpful to the parents. They have learned to ignore all the rational statements Paul makes. Instead they try to react more sensitively to disorganised behaviour and to recognise avoidance behaviour. Reacting to these behaviours with reassurance and support has proven to be a fulfilling and adequate way of parenting for them.

Conclusion: dialogical child therapy

The theory of the dialogical self is related to the therapeutic practice of the *self-confrontation method* (Hermans & Hermans-Jansen, 1995). People are considered to be the active creators of meaning and the experts of their self-narrative. They know best which experiences in their life are relevant to themselves. Therefore the role of the therapist is to stimulate the process of self-reflection. The self-confrontation method is not a classical assessment procedure in which a client's psychological condition is established; it is rather a transformation *process* right from the start in which the client changes in and through the dialogue with the therapist. The self-narrative is an ever-changing story based on continuous valuations of experiences and cognitions. These valuations are expressions of the basic motives of self-assurance or alliance with others, and they are positive or negative. In the therapeutic process, with the help of the therapist, the client tries to cluster various valuations because they show the same profile of emotions.

The self-confrontation method is based on therapeutic practices with adult clients but was recently reconstructed for children and adolescents (Louwe & Nauta, 2006).

Children may need help, but they can also contribute by self-images and self-narratives. They 'enter into a community of minds', not inventing a private theory of mind 'but a cultural conception of what it is to be human within a human community' (Nelson, 2005, p. 29), and learn to read minds and become aware of the difference between other's and one's own state of mind. This adaptation was necessary because children have less capacity for reflection, verbalisation and simultaneous coordination of two perspectives (Piaget, 1947). The therapist may become an 'active listener' who helps the child to express emotions through a responsive approach thereby giving the child the experience that inner emotions and outer words can come together. This may be done by referring issues (especially emotions) that were previously mentioned by the child back to the child, relating issues to inner emotions of the child or relating certain issues to the consequences for the child (Hutchby, 2005).

In this case study, we described, how, in successive steps, a therapist helped a child to describe events and investigate the emotions that go with them. The first step was to enable the child to test its affective terminology and to get used to the procedure. Child and therapist co-constructed a personal list of relevant emotions.

The second step is to show the child that any person has a personal life narrative. From then on, the child will develop its self-narrative and make it more explicit. The child is helped in this process by 'elicitors'. Pictures are used for older children and drawings for younger ones. The images on the elicitor cards are not subtitled. The children are free to choose and to interpret what the image is about and are invited to tell if they have a similar experience. Children are free to bring their own pictures or drawings, or create them during the sessions, like Paul did. Contrary to the adult method, the helper writes down what the child verbalises. Children often use pithy formulations. The helper may propose the child to include images that are related to the problem that was the immediate cause for asking help, but these are only introduced after the child has had enough room to express itself in situations in which he or she feels competent, safe or happy. After having formulated each separate valuation, the child scores his or her affects with the help of the personal list of relevant emotions. For some children this affective valuation is a natural process, but other children need more explanation, comfort and exercise (which is a therapeutic process in and of itself).

If the child has succeeded in selecting concrete events and persons for his or her self-narrative and has linked these systematically to a list of feelings, the child is ready to make a more comprehensive self-narrative. Then the child is asked to score again the general experience and ideal experience. The child may then discover new emotions and cognitions, now linked to a more abstract level of the self-narrative. The helper may also invite the child to compare patterns of emotions in earlier narratives, but this is a rather complex task. The child may be assisted by the helper pointing out similarities and differences and so show the possibilities for change. Contrary to the adult self-confrontation method, the helper is more directive in therapy with children. Yet the aim is still to enable the child to construct a self narrative him- or herself, and to select themes to be worked on in the therapy.

The major objectives of the self-confrontation method for children are:

- to help the child with the identification and labelling of their own emotions;
- to clarify connections between these feelings and events;

- to help the child realise that there are alternatives to the problem behaviour; and
- to stimulate choices that will be more successful in interpersonal contacts.

These elements are recognised components of various cognitive behavioural treatment programmes. The self-confrontation method differentiates from most of the cognitive behavioural programmes because of its focus on the way the child gives meaning to its world. In this paradigm, the psychotherapist does not educate the child about feelings, connections to events and behaviour alternatives. Rather, the helping professional follows the child, helps it to create words or other symbolic forms to feelings that remained implicit until that moment. Finally the helper supports the child in formulating its dilemmas and self-chosen objects of change.

Most young people will learn to organise a self-story connecting beliefs about self and others to their life story in adolescence (Verhofstadt *et al.*, 2004; Angus & Mcleod, 2004). Until that moment, their self-narratives are still more or less fragmented. The self-confrontation therapy for children is not aimed at producing a complete theory of mind. Rather, the endeavour is to reach authenticity, that is to help the child to make an end to self-renunciation and to express his or her inner feelings in a genuine and accurate way.

The self-confrontation method is shown to be a useful way of constructing and reconstructing the self-narrative of children. Both the dialogue with the therapist and the child's creations in therapy (drawings and necklace) and his reflection on these products helped him to tell more about his inner world. He discovered some parts of his problematic emotions and came up with strategies to control difficult emotions and to deal with troublesome situations (cf. Hermans & Dimaggio, 2004).

The method of self-confrontation is aimed at helping children to find and construct their own narratives and explore and develop emotions that are hidden in these stories. That makes this method different from mainstream protocol-based strategies, whose methods allow the therapist to pronounce upon the child in a standardised way. The method of self-confrontation is rather an empowering strategy that invokes the child's active contributions. The child is stimulated to express his or her feelings in handcrafted products and new wordings, and so to connect emotions in his or her various I-positions. As such, this method uses fully the child's creativity.

References

Angus, L. & McLeod, J. (2004) 'Self multiplicity and narrative expression in psychotherapy', in *The Dialogical Self in Psychotherapy*, eds H. Hermans & G. Dimaggio, Brunner-Routledge, Hove & New York, pp. 91–107.

Bakhtin, M. (1984) *Problems of Dostoevsky's Poetics*, edited and translated by Caryl Emerson, University of Michigan Press, Minneapolis.

Bruner, J. (1983) *Child's Talk: Learning to Use Language*, Norton, New York & London.

Bruner, J. (1990) *Acts of Meaning*, Harvard University Press, Cambridge, MA.

Chandler, M. (2000) 'Surviving time: the persistence of identity in this culture and that', *Culture & Psychology*, vol. 6, pp. 209–231.

Froggett, L. (2002) *Love, Hate and Welfare. Psychosocial Approaches to Policy and Practice*, Polity Press, Bristol.

Hermans, H. (1999) 'Self-narrative as meaning construction: the dynamics of self-investigation', *Journal of Clinical Psychology*, vol. 55, pp. 1193–1211.

Hermans, H. (2004) 'The dialogical self: between exchange and power', in *The Dialogical Self in Psychotherapy*, eds H. Hermans & G. Dimaggio, Brunner-Routledge, Hove & New York, pp. 173–189.

Hermans, H. & Dimaggio, G. (eds) (2004) *The Dialogical Self in Psychotherapy*, Brunner-Routledge, Hove & New York.

Hermans, H. & Hermans-Jansen, E. (1995) *Self-narratives. The Construction of Meaning in Psychotherapy*, Guilford, New York.

Hutchby, I. (2005) '"Active listening": formulations and the elicitation of feelings-talk in child counselling', *Research on Language and Social Interaction*, vol. 38, pp. 303–329.

Louwe, J. & Nauta, J. (eds) (2006) *Zelfonderzoek met kinderen. Een relationele methodiek*, Agiel, Utrecht.

Mannoni, M. (1967) *L'enfant, 'sa maladie' et les autres*, Editions du Seuil, Paris.

Mooij, A. (1988) *De psychische realiteit. Over psychiatrie als wetenschap*, Boom-Meppel, Amsterdam.

Nelson, K. (2005) 'Language pathways into the community of minds', in *Why Language Matters for Theory of Mind*, eds J. Astington & J. Baird, Oxford University Press, Oxford, pp. 26–49.

Nijnatten, C. van. (in preparation) *Child, Welfare, Agency. A Dialogical Approach of Child Development and Child Welfare*.

Piaget, J. (1947) *The Psychology of Intelligence*, Littlefield, Adams & Co., Savage, MD.

Rogoff, B., Paradise, R., Arauz, R., Correa-Chavez, M. & Angelillo, C. (2003) 'Firsthand learning through intent participation', *Annual Review of Psychology*, vol. 54, pp. 175–203.

Shotter, J. (1993) *Conversational Realities: The Construction of Life through Language*, Sage, London.

Siegel, D. J. (1999) *The Developing Mind. How relationships and the Brain Interact to Shape Who We Are*, The Guilford Press, New York.

Valsiner, J. (2002) 'Forms of dialogical relations and semiotic autoregulation within the self', *Theory & Psychology*, vol. 12, pp. 251–265.

Verhofstadt-Deneve, L., Dillen, L., Helskens, D. & Siongers, M. (2004) 'The psychodramatic "social atom method" with children: a developing dialogical self in dialectic action', in *The Dialogical Self in Psychotherapy*, eds H. Hermans & G. Dimaggio, Brunner-Routledge, Hove & New York, pp. 152–170.

Vygotsky, L. (1978) *Mind in Society. The Development of Higher Psychological Processes*, Harvard University Press, Cambridge, MA.

Wood, D. (1988) *How Children Think and Learn. The Social Contexts of Cognitive Development*, Blackwell, Oxford.

Lynn Froggett

ARTS BASED LEARNING IN RESTORATIVE YOUTH JUSTICE: EMBODIED, MORAL AND AESTHETIC

This paper is concerned with the potential for reparative moral learning within arts based programmes of restorative youth justice. The extract from a creative writing session which will follow involves Stella, a young female offender, and Bob a local poet. The programme context — the 'garage project' — which took place within a mechanics workshop, was described more fully in a 'sister' paper: 'Making sense of Tom: seeing the reparative in restorative justice' (Froggett *et al.*, 2007) which was published in the previous issue of this journal. Whereas the earlier paper focussed on the liminal role of the artist in facilitating a latent creativity in the young offender, within a reparative process, this article will discuss the use of poetry to express an inner destructiveness in the absence of institutionalised shaming.

The project was located in a community based Youth Offending Team which works with young people on referral from the local courts, many of whom have committed serious offences and are immersed in criminal subcultures, but who for the present are being dealt with by community based disposals. The young offenders in this project are in transition between an education system from which they have been largely excluded and a labour market for which they are presently ill-equipped. The team has a strong track-record in developing arts-based interventions on the basis of a collective intuition that in the context of an individuated programme that addresses

offending behaviour, such interventions can facilitate moral learning and hence the restoration of links with family, peer group and community.

Issues of research and practice methodology

The data for the case-studies of these young people consist of filmed interactions, ASSET core profiles[1] and Biographical Narrative Interview Method (BNIM) questioning (see Wengraf, 2001). However, the filmed material proved to be by far the richest as this group produced meagre life narratives in interview situations. This may be partly because interview experiences have been 'contaminated' by prior exposure to the judicial or social work based interview. BNIM uses a loosely structured format beginning with an open narrative question — in this case 'Tell me about how doing creative writing with Bob has affected your life'. Responses were typically: 'ask me a question?' or 'what do you want to know?'. This did not appear to be dependent on verbal skills since some of the respondents produced accomplished narratives in other situations. Nor did it appear to be awkwardness with the interviewers (they were quite young, casually dressed and care was taken to dissociate them from the youth justice system). The research team eventually concluded that an open interview style, while markedly different from social work or judicial interviews, offered too little containment for this group, especially in relation to anxieties about family relationships. The wide-ranging rhythmically structured dialogue facilitated by the creative writer in this study elicited much richer material without overly intrusive questioning.

It may also be that the production and performance of a life story required by BNIM style interviews depends on a coherent identity narrative (however provisional) which these young people cannot easily achieve. Indeed social supports for such an identity may have been removed by the orchestrated shaming entailed by failure at school, limited labour market opportunities and exposure to the criminal justice system itself.

Biographical data held on file within Youth Offending Teams can underpin institutionalised shaming to the extent that it is structured by standardised assessment formats such as ASSET that reduce scope for biographical authoring by their subjects. Skilled practitioners in the YOT who must work with such tools point out that they leave the forms in the office and try to facilitate a naturalistic narratively structured conversation from which they extrapolate the required information. Even so, having to fit the information into boxes interrupts narrative flow in the professional presentation of the information and may intrude on the style of questioning. Practitioners also have to score for risk of offending thus bringing to bear a behavioural focus which is at odds with a whole life perspective which emphasises motivation and meaning. Professional front-line staff may try to make best sense of these conflicting orientations by collecting information that not only identifies risk factors but supports the construction of a 'positive' life story. Where this happens the well-intentioned 'theory-in-use' is that of the limitless plasticity of the narratively constructed self. This translates in practice to 'tell a different and more optimistic story and lives will change'.

According to this view, attempts to shore up the low self-esteem of these young people by nurturing their latent creativity might then help to re-direct life trajectories towards education, gainful employment and citizenship. In tandem with a life story approach story-telling is a popular creative intervention strategy and one which allows forbidden fantasies and allusions to unspeakable life experiences. When used in this way it facilitates the 'return of the repressed' and (as with many of the classic fairy tales) provides a mental theatre or screen onto which hatred, vengeance and aggression can be projected alongside desire and the benign emotions of love and compassion. However, it can also gloss over the negative and avoid confrontation, producing a spurious coherence that disavows the fragmented and conflicted parts of the self, which resist integration. Creative writing and story-telling can thus invoke reactions ranging from incredulity to sarcasm among magistrates and a public inclined to regard young delinquents as pernicious social pests. It also elicits a sceptical response among those youth justice professionals who feel that creative interventions may have educative value, but that the parameters of restorative justice are being over-extended.[2]

Having experimented (somewhat fruitlessly) with the Biographical Narrative Interview Method and other biographical interview techniques, the study in question took a different tack by eliciting life narratives about family, peer relations, offending, identities and aspirations to employment with the help of Bob. Bob engaged the young people in a form of dialogue resonant with the cultural idioms of the street cultures to which they belonged. The video-taped sessions were analysed using an adaptation of BNIM[3] analytical protocols.

Shame and guilt in reparative processes

Restorative justice aims to shift the emphasis from retribution to reparative and restitutive strategies intended to foster moral learning, personal responsibility and concern for the suffering caused by criminal behaviour. It may demand symbolic or practical reparation to victim or community. Shaming has been regarded as a precondition of rehabilitation *within* the restorative justice movement — albeit 're-integrative shaming'[4] designed to elicit community censure directed at the action, rather than the actor (Braithwaite, 1989). In this sense shaming is supposed to induce guilt and the desire for reparation in the context of inter-subjective relations which are aimed at restoring connection. According to Braithwaite the virtue of shaming in a properly constituted restorative justice context is that it invites an active choice on the part of the offender to accept the moral claims of community and the criminal justice system.

In a forthcoming volume on psychosocial criminology, Gadd and Jefferson (2007) commend Braithwaite's accent on the *active* engagement of the offender in re-integrative processes. They point out however that his work can be critiqued by reference to a number of writers on shame (for example, Scheff & Retzinger, 1991; Nathanson, 1992; Van Stokkom, 2002) who have pointed to the potentially over-whelming nature of the shame experience which may therefore inhibit rather than promote the assumption of responsibility for harmful acts. The literature on shame is

extensive and its review and analysis is beyond the scope of this paper, however it is important to point out that to the extent that shaming constitutes an assault on the self-worth of the offender, he or she is just as likely to respond with rage, masochistic submission or defensive withdrawal as with responsibility and concern for the other. Daly's empirical study (2001) of restorative conferences in Australia concluded that offenders were as likely to be motivated by a desire to preserve their own reputations as the wish to make amends and repair fractured social bonds.

Gadd and Jefferson argue that Braithwaite's concept of shaming is over-social in that it fails to take seriously enough the inner world dynamics which influence the ways in which any particular offender — with their biographically unique experiences of emotional and social development and their specific patterns of interdependency — can respond to the shaming experience. They argue instead for a psychosocial approach which grasps the 'deep-rooted' nature of shame and point to the dangers of deliberate public shaming, especially within societies such as the UK which do not have embedded communitarian traditions with which to re-claim deviant members.

An alternative approach — perhaps more consistent with Braithwaite's original intention of blaming the act rather than the actor — is taken by those (such as Tangney, 1995) who argue that guilt is the more moral emotion because it leaves the perpetrator of a harmful act with their self-respect intact and free to view their behaviour from the perspective of the other and focus on its consequences. Guilt, it is argued, is about what one *does*, whereas shame is about what one *is*. Guilt, then, is more likely to lead to empathy, sadness, regret and the assumption of moral responsibility. Van Stokkom (2002) takes issue with this line of argument asserting that remorse is the more other-regarding and hence the more useful emotion within restorative processes. The problem with this discussion is the absence of a depth psychology which would consider how guilt, shame and remorse are experienced and enacted within the particular biographies of individuals. If there is one point of consensus in the debate it is that a constellation of linked emotions are at play, and in real restorative justice practices they overlap and occur in situationally and personally specific configurations, which makes it hard to disentangle them.

This situation would seem to call for two lines of inquiry: firstly for in-depth case study based research which identifies the complex inter-subjective play of self- and other-directed regard within specific restorative justice settings and programmes; secondly for research which is sensitive to the specific biographical and emotional histories of the individuals in whom shame or guilt is to be induced. In the first case it is useful to consider whether shame or guilt can respectively support or undermine the reciprocal recognition between parties (without which no repair of social bonds can take place). In the second, it may be helpful to ask what is involved intra- and inter-subjectively in the realisation of concern, remorse and the wish to make reparation. The Kleinian perspective (Klein, [1937] 1975) seems to make sense of the processes observed among young offenders in this project. This view links guilt, concern and the wish to repair the harm one has done to the apprehension of one's own aggression. The fragment of data which follows is far less than a fully worked through case study, but the issues of shame, guilt, recognition, concern and remorse are all at play in an interaction which allows symbolised expression of a sadistic and vengeful inner destructiveness.

Stella arrives for the creative writing session with a social worker, Diane, who she asks to stay — mainly, it would seem, to double the live audience (from one to two) and to afford an opportunity for a narcissistic display of Stella's carefully crafted persona. This is put together from elements of 'super-cool' street style; 'girlie' consumerism and opinionated social commentary. The performance is all the more intriguing for the fact that her face is obscured under a 'hoodie'[5] for the duration, and her body remains impassive — apart from her long elegant hands. She begins by massaging them with hand cream inviting Diane to admire the perfume and observe her nails. As an off-the-cuff jingle she illustrates her preoccupations with 'My Poem About Me':

I have dark brown hair
The beauty in my face is rare
I have long legs
and well brushed pegs
I have a small tum
and a perfect bum
Am I a myth?
No I'm Stella Frith[6]

The languorous stroking of hands continues throughout the first half of the conversation, after which they (the hands) somehow contrive to remain in the centre of the tableau doing the expressive work that has been delegated from face and body, which are withheld from interaction. The effect is mesmerising: Stella seduces her audience whilst keeping them at one remove; she graciously assents to be present whilst ensuring her partial absence. The talk reveals an obsession with shape, weight and style and she preens and grooms under her hood — striving to a perfection which is carefully withheld from view. At first, the performance draws us in and after we have read the case files we marvel even more at its poise.

In the first and second sessions Stella remains resolutely in control and manages to turn the tables on Bob, who in his periodic flights of gangsta-rap mimicry emerges as the over-grown adolescent of the trio. Stella assumes a posture of withering contempt refusing to be amused or to respond to Bob's poetic sallies.

The performance has all the stultifying quality of a 'false self'[7] including somehow in the moments of self-reflectiveness when Stella shows insight and some remorse for people she has hurt. Even these seem contrived, however: insight put on display as a mature accomplishment, yet another mark of sophistication. The self-revelations always refer to past troubles now understood and resolved. They also have a star quality — as if Stella, mindful of the image she projects to the research camera and her live audience is applauding herself on confessional TV.

I act like myself … whereas other people act like somebody else … they want to fit in! *I* act like *me*! Because I'm proud of who I am … yeah … it probably sounds really really big-headed … you know, 'I've got confidence in myself' and stuff … but I don't really care what people think of me … it's not really important to me anymore … it used to be … but you know, I'm proud of who I am!

Stella is a prolific writer and has asked to come to the sessions yet by the third week the only thing resembling poetry has been 'My Poem about Me'. However, the poetics of the performance give some idea of the trap she has woven around herself which forestalls spontaneity and authenticity — and hence authorship.

Then just as we conclude that nothing new will come out of this encounter with Bob, we get another view: of the Stella who is aware of her own streak of cruelty and flaunts her sadism. She gleefully tells of going to the park, noisily, in a gang and kicking the park-keeper when he remonstrates at teenage loutishness. Bob and Diane are confounded. Bob emits a nervous giggle, Diane, shifts focus from the assault to the safer ground of rowdiness. This is rather shocking to watch and shows how Stella has fascinated and alarmed them. She has thrown down a gauntlet and braced herself for the challenge, but it never comes.

In the third session Stella finally appears without Diane — it is unclear whether Bob has negotiated this but by now we (the research team) are desperate to see how a one-to-one interaction will change the dynamics. Having paraded an idealised version of herself as beautiful, controlling, self-congratulatory and cruel, Stella is at last free of theatrical obligations. The veneer is discarded. She regresses and the words tumble out with chilling aesthetic discipline.

My Dad's a tranny
He thinks uncanny
Chop off his dick
Prod it with a stick
Saw off his head
Hide it in his bed [laughs]
Saw off his toes
Put 'em in his nose
Tie 'em in hair bows
Blow up your mum
Do her up the bum

In her subsequent interview Stella offers the following comment on her writing:

Violence! (she chuckles) I don't write about anything else! Just that! I can't write happy poems! It's not me! So, it's basically based on that!

As we later learn Stella witnessed persistent domestic violence between parental figures throughout a significant portion of her childhood. She was highly traumatised and has suffered severe anorexia for which she has been hospitalised more than once. She was excluded from school after repeated vandalism on teachers' cars and within the school building itself. She owns up to having manipulated someone else to victimise vulnerable children on her behalf and she herself was bullied to the point where she drew a knife on the perpetrator.

While much could be said about what the content of her poem might or might not reveal of her fantasy life and its bearing on her family situation, there is another point of interest here: Stella appears to find her voice when she is in a situation in

which the self-imposed requirements of performativity fall away and the recognition relations of the encounter allow an experience of authenticity. Visible to the research team is a relaxation of her conscious self-monitoring and a more spontaneous interaction with Bob. She becomes animated, her body takes over where her hands leave off. We even catch an occasional glimpse of her face as she tilts back her head to make eye contact from under the hood.

It would seem that when this more animated response arises destructive impulses find expression in the highly structured rap-like metre of her verse. Does the stylised aggression of this form camouflage or contain her rage? — or is it, as she tells us, 'just a poem'? Despite Stella's repeated assurances that her life is 'great', that she is 'really lucky' and her family 'incredibly supportive', the energy that impels this highly disciplined outburst lets the furies have their say. The important point is that her sense of authorship is only released when her violent fantasies can find full expression in the absence of shame.

Eroticism, destructiveness and identity

Within anglophone traditions of psychoanalysis Winnicott (1971) has much to say on the importance of the mobilisation of aggression in learning and hence the capacity for creative living. Initially he follows Melanie Klein (1957) in stressing the fusion of erotic and destructive fantasies,[8] but a careful reading of his work reveals a dialectic between destructiveness and eroticism and a preoccupation with the conditions which maintain a productive tension between the two. Winnicott shifts attention from the innate predispositions of the individual to the interpersonal environment of child/ parent relations where in adequate circumstances the erotic and destructive together impel the dynamics of recognition, which are essential to individuation and identity formation. The child identifies with the parents in an eroticised dependency but suffers the humiliation of learning that she can never be their sole preoccupation. She enters into a process of negation through which her particularity is further developed and presented for recognition. Hence the destructiveness implied in negation plays an essential part in the realisation of identity. If recognition is achieved, identity is re-constituted on a more elaborate plane and provisionally stabilised until another cycle of conflict and reconciliation moves it on once more.[9] Moments of recognition are those in which the erotic and destructive impulses of the child's personality are held together — without shaming — in the eye of the beholder, as essentially intertwined dimensions of the child's distinctive psychic organisation, which manifests itself in a 'personal idiom' (Bollas, 1995). It is the realisation of this in the eyes of the other that allows the child to 'feel real'.

If, as seems to have occurred in Stella's case, interpersonal relations have not been conducive to a sustained sense of recognition, a possible outcome is that instead of holding the erotic and destructive together in a dynamic tension that impels movement and learning, the destructive itself becomes eroticised. This seems to be the case in the poem presented above and others she has written. However her engagement in the process of creative writing, the way in which she returns again and again to the sessions, her growing curiosity about Bob and a developing capacity to

think about her own motivations suggest that a learning process is underway. For Stella there is a thin line between violence as fixation and violence as muse.

A psychosocial understanding of restorative justice is one which implies the repair of broken links, not only with the moral community from which the offender is excluded but also in the inner world between dissociated sides of the self. From this perspective it is not so much the particular content of Stella's fantasies that are important — nor the quality of her 'poetry' (too easily dismissed as doggerel) — but the fact that she seeks an aesthetic form to symbolise primitive visceral rage and render it communicable. In doing so her destructiveness and her creativity are brought into an initially awkward juxtaposition in a new medium. This allows her to express an embodied aggression in a startling child-like fury that is contained through the rhythmical discipline of form. It is witnessed without shaming by an older adult who does not attempt to deny, moderate or return the aggression but offers the possibility of interpersonal recognition. A previous paper from this project drew attention to the way in which Bob makes full use of the liminal position of the artist within the poetic exchange, and this allows him to assume a position of apparent moral neutrality. He is the 'trickster' who positions himself ambiguously between the youth justice system, the parental generation and the purveyors of culture, equally at home in the education system or the street. In this he opens up the space for a play of moral voices and leaves it for the young person to form their identifications.

Does this allow Stella to 'feel real' and find ways to express an identity which could attract social respect? More importantly for those who seek evidence for the efficacy of this kind of intervention within Restorative Justice programmes, does it have the potential to enhance moral learning? And what does it suggest about the relationship between guilt and concern? We can only infer, but the following points are worth considering.

Stella, who because of her troublesome behaviour received very little formal schooling, returns repeatedly and willingly to the creative writing process and produces material both with Bob and on her own, showing a growing facility with language and a capacity for expressing a range of emotional states. Unprompted and under some inner impulsion, she eventually breaks through her polished performance of moral sophistication and holds up her own violent and abusive behaviour for inspection and condemnation. It is hard to read this move as anything other than an expression of guilt, an appeal for recognition of her culpability, and of her capacity for remorse. Despite the fact that the adults are caught off guard by this candour, the admission (along with the key worker's departure) proves to be the turning point in the sessions. Stimulated by the conversation she is having with Bob, Stella intersperses her reflections and writings about herself with self-critical remorse for her own bullying behaviour and social concern over issues such as animal rights, attitudes to homosexuality and strategies for diverting young people from delinquent behaviour. She veers between mature self-reflective receptivity and child-like expressions of venom. As the sessions proceed she progressively discards a crafted 'false self' (in Winnicott's terms) and is increasingly spontaneous in her relationship with Bob, even though she is aware this does not show her in the best possible light. The interaction becomes 'jerky' and unpolished — a genuine improvisation which is sometimes uncomfortable to watch. The poems grate on the sensibilities and on the ear but it all

'feels real'. The poetry seems to establish a link to a perverse side of the self which needs to be brought into view, worked with and recognised as the source of embodied vitality if moral learning is to be achieved.

Shame and recognition

The young people in the study are subject to a range of disciplinary technologies imposed on their bodies and designed to limit their range of movement (ASBOs,[10] curfews, electronic tags) just as they are negotiating a critical life transition in which autonomy, especially of movement, is a principle marker of adult identity.

It is easy to see how this can result in subjective experiences of being infantilised and disrespected. The consequent sense of shame could, in terms of Honneth's theory of recognition (1995), induce a moral crisis by exposing the young person concerned to their need for the recognition and esteem of other people, in a context where such recognition is clearly withheld.

> ... moral shame represents an emotion that overwhelms subjects who as a result of having their ego-claims disregarded, are incapable of simply going ahead with an action. In these emotional experiences, what one comes to realise about oneself is that one's own person is constitutively dependent on the recognition of others.
>
> (Honneth, 1995, p. 138)

For Honneth it is the assertion that one's moral norms have been violated that rescues the individual from the social denigration and assault on self-worth of the shaming experience. These young offenders generally have no plausible grounds for such an assertion and this, combined with their meagre resources (in terms of both ego integration and the social legitimacy of their life trajectories) means that they are at risk of a shame 'overload' which is unmatched by any internal sense of guilt and remorse. Rather than facilitating moral learning and a sense of interdependence, this is likely to induce avoidant or defensive withdrawal from the shaming community.

The findings of this project offer little support for shaming — re-integrative or otherwise. On the contrary, they provide grounds for arguing that a crucial step in moral learning for these young people is the willingness to self-reflectively acknowledge their own destructiveness in a context which fosters an *internal* sense of guilt and concern for the hurt caused to others. This may be the pre-condition for a face-to-face encounter with the victim in which the wrong-doer can genuinely assume responsibility for the harm done to the wronged party in the context of reciprocal recognition. It is this reciprocal recognition, rather than any act of restitution (important though this may be within the process) that repairs the broken link between victim and offender, in that it enacts their belonging to the same moral community. This in turn requires that the destructiveness be apprehended by others without condemnation or celebration as an intrinsic and potentially enlivening aspect of a self which *also* has a capacity for creativity.

The problem that Honneth highlights with shaming appears to be the potential for paralysis rather than the transformative moral crisis which induces guilt and can be

stimulated by being *realistically appraised* in the eyes of another who is esteemed and worthy of recognition. For the offender there is no possibility of intersubjective recognition within a moral community if that community cannot bear to apprehend and contain its shared anxieties at the inner destructiveness of which the offender is only too aware. Loss of connection with that community can only be compounded if responses to the offender polarise into well-intentioned disavowal of liberal minded professionals on the one hand, or the strident demonisation of the tabloid press on the other.

Theories of recognition — and Honneth's is no exception — tend to emphasise that we are dependent on recognition as a constitutive factor in the formation of identity narratives. Implicitly this is recognition as *affirmation* which in theory involves being seen in the eyes of the other as one imagines oneself to be. This is thought to support self-esteem and allows the subject to recount a narrative of self intelligible to another who has, in a sense, already apprehended it. Psychoanalytically informed accounts, both Winnicott's (1965, 1971) and Lacan's (1977) in their very different ways emphasise the mirroring and integrating functions of the recognising gaze (whether or not this integration is regarded as fictional). Conventional practice wisdom among professionals insists on the need to shore up a fragile sense of self-worth through positive regard (Rogers, 1951).[11] Misrecognition entails a feeling of disrespect — a sense of not being worthy of regard in the eyes of the other. It calls in question one's integrity and authenticity. The experience is mortifying but it comes from *without* — it is a violation of one's moral status by the *other*.

Of course, defended and conflicted subjects are prone to violate their own moral norms — and this was particularly evident among the young people in this study. Being recognised then requires that one's own imperfections including one's at times destructive agency, are registered by another who can hold it in mind without identification, idealisation or denigration.[12] The value of arts-based approaches to restorative justice may be that alone among the various interventions directed at moral learning to which these young people are subject, they allow both for confrontation and the expression of a personal aesthetic in which the creative and destructive sides of the self are held in tension with one another. Indeed it is often the sustaining of this tension which animates the active moral faculty.

Acknowledgements

With thanks to Dina Poursanidou and Alan Farrier of the Psychosocial Research Unit, University of Central Lancashire. The research from which this case study was drawn was funded by *Crime Solutions* based at the University of Central Lancashire.

Notes

1 Standardised assessment formats approved by the Home Office for use with young offenders on court orders.
2 Thanks to Les Davies of the IIRP (International Institute for Restorative Practices) for a vigorous and productive discussion on this issue. The views presented here, however, are my own.

3 BNIM [Biographic Narrative Interpretive Method, see Wengraf (2001) for detailed English language explanation and Froggett and Wengraf (2004) for example of panel analysis] analysis is carried out on small chunks of data by future-blind conjectures on where the text will lead. A panel speculates free associatively on the meaning of utterances, the speaker's conscious and unconscious intentions and on what will come next. Conjectures are thus either supported or refuted as the panel works through the text. The aim is to decipher the speaker's distinctive gestalt. The method tends to demonstrate that the gestalt is embedded in the form and performance of the utterance rather than the content. In other words the utterances or text segments of the data that are being analysed are typically found to be formulated with a personalised idiom or aesthetic of which the speaker may be unaware. We used this method on small chunks of video data, where the text is accompanied by non-verbal communication giving access to the embodied quality of the utterance which is available for interpretation along with the spoken words.

4 Re-integrative shaming refers to processes by which the disapproval of moral communities is brought to bear on deviant acts with the purpose of inducing regret in the actor. In contrast to stigmatisation, censure is directed at the act whilst the actor is a candidate for forgiveness and re-integration once moral responsibility has been assumed.

5 The 'hoodie' refers to the hood attached to a sweat-shirt jacket which, when worn over the head largely hides the face. Though widely adopted as street fashion among some adolescents and young adults, it has acquired sinister connotations as it inhibits identification in the UK's culture of high surveillance of people observed or filmed in the process of committing crime.

6 Not her real name.

7 Winnicott (1965, 1971) developed the notion of the 'false self' specifically in order to describe the compliant child who, denied recognition of his or her destructiveness, loses the capacity for spontaneous authentic relating. It is not that the child consciously assumes a false self as a deceitful stratagem, rather that since destructiveness is part of reality testing, the child no longer 'feels real'.

8 By creative living Winnicott is referring to an essential capacity to shape the world one lives in rather than specific creativity embodied in a work of art. Nevertheless theorists of artistic endeavour in the object relations tradition (e.g. Milner, 1957; Segal, 1991; Ehrenzweig, 1967) have made much of the alternating rhythms of separation and fusion in the artistic process. These are thought to give material expression to fantasies of creativeness and destructiveness which characterise the artistic process but which are themselves a specific elaboration of the individuation process.

9 For Honneth these struggles for recognition are played out throughout adult life via demands for love (in the sphere of intimacy) and respect (inscribed in abstract juridicial rights) but the ethical life of the 'whole person' is achieved through solidarity: membership of a moral community in which each individual is valued precisely because of what makes them different.

10 The inversion of the Anti-Social Behaviour Order into a 'badge of honour' amongst some sections of the offending population could be seen as resistance to the (non-re-integrative) public shaming entailed: it is a celebration of outlaw status which despairs of recognition relations within the criminal justice system.

11 In English and American social work the pervasive influence of the humanistic
 counselling tradition (Rogers, 1951) has emphasised this attitude as a mark of
 humane practice. While this may be a good starting point for relationship building
 it has arguably undermined the capacity of professionals to recognise and work
 with the conflicted nature of defended subjectivity.
12 The idea that destructiveness and aggression are linked to creativity through
 eros is well embedded in psychoanalytic thinking, especially in the work of
 Klein and Winnicott and in theories of artistic production in the object relations
 tradition.

References

Bollas, C. (1995) *Cracking Up: The Work of Unconscious Experience*, Routledge, London.

Braithwaite, J. B. (1989) *Crime Shame and Reintegration*, Cambridge University Press, Cambridge.

Daly, K. (2001) 'Restorative justice: the real story', *Punishment & Society*, vol. 4, no. 1, pp. 55–79.

Ehrenzweig, A. (1967) *The Hidden Order of Art*, Weidenfeld and Nicholson, London.

Froggett, L., Farrier, A. & Poursanidou, K. (2007) 'Making sense of Tom: seeing the reparative in restorative justice', *Journal of Social Work Practice*, vol. 21, no. 1, pp. 103–117.

Froggett, L. & Wengraf, T. (2004) 'Interpreting interviews in the light of research team dynamics: a study of Nila's biographic narrative', *International Journal of Critical Psychology*, vol. 10, pp. 94–122.

Gadd, D. & Jefferson, T. (2007 forthcoming) *Psychosocial Criminology: An Introduction*, London, Sage.

Honneth, A. (1995) *The Struggle for Recognition*, Polity Press, Cambridge.

Klein, M. (1937) 'Love, guilt and reparation', in *Love, Guilt and Reparation*, eds M. Klein & J. Riviere, Hogarth, London, pp. 57–91.

Klein, M. (1957) *Envy and Gratitude*, Tavistock Publications, London.

Lacan, J. (1977) *Ecrits: a selection*, translated by Alan Sheridan, W.W. Norton, New York.

Milner, M. (1957) *On Not Being Able to Paint*, Heinemann, London.

Nathanson, D. L. (1992) *Shame and Pride*, W.W. Norton, New York.

Rogers, C. (1951) *Client-centred Therapy*, Houghton Milton, Boston, MA.

Scheff, T. J. & Retzinger, S. M. (1991) *Emotions and Violence. Shame and Rage in Destructive Conflicts*, Lexingtom Books, Massachusetts/Toronto.

Segal, H. (1991) *Dream, Fantasy, Art*, Routledge, London.

Tangney, J. P. (1995) 'Shame and guilt in interpersonal relationships', in *Self-conscious Emotions: Shame, Guilt, Embarrassment and Pride*, eds J. P. Tangney & K. W. Fisher, Guilford Press, New York, pp. 114–139.

Van Stokkom, B. (2002) 'Moral emotions in restorative justice conferences: managing shame, designing empathy', *Theoretical Criminology*, vol. 6, no. 3, pp. 339–360.

Wengraf, T. (2001) *Qualitative Research Interviewing*, Sage, London.

Winnicott, D. W. (1965) *The Maturational Processes and the Facilitating Environment: Studies in the Theory of Emotional Development*, Hogarth Press and the Institute of Psychoanalysis, London.

Winnicott, D. W. (1971) *Playing and Reality*, Routledge, London.

Victoria Foster

'WAYS OF KNOWING AND SHOWING': IMAGINATION AND REPRESENTATION IN FEMINIST PARTICIPATORY SOCIAL RESEARCH

Introduction

The joy of writing

Why does this written doe bound through these written woods?
For a drink of written water from a spring
whose surface will Xerox her soft muzzle?

Why does she lift her head; does she hear something?
Perched on four slim legs borrowed from the truth,
she pricks up her ears beneath my fingertips.
Silence — this word also rustles across the page
and parts the boughs
that have sprouted from the word 'woods'.

Lying in wait, set to pounce on the blank page,
are letters up to no good,
clutches of clauses so subordinate
they'll never let her get away.

Each drop of ink contains a fair supply
of hunters, equipped with squinting eyes behind their sights,
prepared to swarm the sloping pen at any moment,
surround the doe, and slowly aim their guns.

They forget that what's here isn't life.
Other laws, black on white, obtain.
The twinkling of an eye will take as long as I say,
and will, if I wish, divide into tiny eternities,
full of bullets stopped in mid-flight.
Not a thing will ever happen unless I say so.
Without my blessing, not a leaf will fall,
not a blade of grass will bend beneath that little hoof's full stop.

Is there then a world
where I rule absolutely on fate?
A time I bind with chains of signs?
An existence become endless at my bidding?

The joy of writing.
The power of preserving.
Revenge of a mortal hand.

<div align="right">(Wisława Szymborska, 1995, p. 95)</div>

Qualitative social inquiry has seen much change over the past decades as postmodernism has had a resounding impact on the way we view the social world. Boundaries between disciplines have become blurred (Geertz, 1973; Brown, 1977) and the approach of studying society as if it were a series of stories or texts is often favoured [see Clifford and Marcus' (1986) postmodernist critique of ethnography]. Rather than a static and recordable phenomenon, social life is now generally understood as being in constant movement, a world where 'meanings and truth never arrive simply' (Plummer, 2001, p. xi).

In contemporary social research, no single method can grasp this world-in-flux, the 'subtle variations in ongoing human experience' (Van Son, 2000, p. 217). Thus, qualitative researchers tend to employ a range of interconnected interpretative methods. In traditional approaches to research, such practice would be known as 'triangulation', a means of 'validating' findings. Richardson (1998, p. 358), however, proposes that in postmodernist mixed-genre texts, the metaphor of the crystal is much more pertinent than that of the triangle since it is recognised that 'there are far more than "three sides" from which to approach the world'. She explains that 'crystals are prisms that reflect externalities and refract within themselves, creating different colours, patterns, arrays, casting off in different directions. What we see depends on our angle of repose' (Ibid.).

This metaphor has resonance for the participatory, arts-based project discussed here, in that it takes into account a host of standpoints as well as capturing the complexities and, not least, the *beauty* of life. In this project, the research process is every bit as key as the resultant findings. Janesick (1998), applying the metaphor of dance to qualitative research, sees the research process as a work of art, an aesthetic experience. Both dance and qualitative research design, she believes, are interpretive processes which connect experiences and meanings (Ibid., p. 37). Ultimately, for the researcher, 'the story told is the dance in all its complexity, context, originality, and passion' (p. 53).

The movement, energy and elasticity associated with dance make it a particularly pertinent metaphor when applied to the idea of a postmodern world in constant motion, a world that is difficult — nigh on impossible — to capture in written accounts. This notion has posed a dilemma for qualitative research, leading to what Denzin and Lincoln (1998, p. 19) term 'the crisis of representation'. Poststructural concerns over whether language can ever mirror reality [see Derrida's (1974) exploration of the nature of writing; also Clifford (1986)] have heightened this debate which has been taken up — alongside academics — by artists and writers, including the novelist A. S. Byatt; one of Byatt's characters notes that 'language was essentially inadequate, could never speak what was there, it only spoke itself' (1990, p. 473).

The article begins by exploring how ethnography and feminist research have responded to this crisis of representation. It then introduces the research project carried out at a Sure Start programme in North West England, highlighting the importance of the participation of the researched community. I have written more extensively elsewhere (Foster, 2007a, 2007b) about the process of applying an arts-based methodology to participatory social inquiry and about the findings of the study. Here, the focus is on employing art and the imagination as a way of researchers and research participants examining their lived experience, to reflect creatively upon these experiences, and to know themselves more deeply. It then moves on to address how this multi-faceted knowledge can be re-presented as authentically as possible to an audience. This dual concern is reflected in the article's title; it comes from Kemp's (1998) work where she describes her one-woman show as using performance 'both as a way of knowing and as a way of showing' (p. 116).

Denzin (1997, p. 61) makes the distinction between the textual and the empirical subject of research:

> The textual subject is the person created in discourse, a figure in a film, or an ethnographic text. The flesh and blood person is the actual person in the world who lives, feels, and thinks and has social relationships with other flesh and blood people.

The article aims to examine how, since 'it is not possible to represent a life as it is actually lived or experienced' (*Ibid.*), participatory, arts-based research can honour the flesh and blood person in the evocative representation of her life. In so doing, it can deepen understanding in others. I argue that it is crucial for the subjects of research to be actively involved in this process, not least because, as Fernandes (2003, p. 90) acknowledges, representation can too easily fall into the category of voyeurism. This was a particularly pertinent issue concerning the research at the Sure Start programme. As a middle-class academic researching poor, working-class women, I was aware that my work could be seen to have voyeuristic leanings, and that I might be at risk of imbuing the project with my own cultural values. I thus endeavoured to provide space for the subjects of the research to assert their own interests. As Skeggs points out (in Almack, 2003, p. 3), impoverished women are not uncommonly depicted in our culture as 'grossly repellent'. Moreover, such women are often assumed (by the government, as well as by sections of society) to be inadequate in the role of motherhood.

The poem which opens this introduction describes the power and pleasure inherent in the act of writing: the author is the creator of another world. The article acknowledges the knowledge and the joy that such creativity can bring, but argues that the subjects of research should be offered the opportunity to experience this for themselves. The article concludes by reflecting upon the status of the knowledge produced from following such a process.

Alternative accounts

Since postmodernism first threw up the unsettling notion that language is an insufficient means of describing the social world, the role of the writer of research accounts — for it is s/he who works most closely with these inconstant words — has required greater attention. In ethnography particularly, the privileging of the author's own account of 'otherness', unquestioned in traditional approaches, is now a practice which raises concerns, as is the actual process of writing 'tidy', 'cleansed' accounts of the research process (see Clifford, 1988; Atkinson, 1990; Van Maanen, 1988).

If it is no longer *de rigueur* for the observations of a subjective ethnographer to be held up as true representations of the field, one means of ameliorating the situation involves authors highlighting their own role in the construction of their texts. This makes the process of writing research accounts more transparent. Brown, in his *A Poetic for Sociology* (1977), explores how the arts, and aesthetic experience, can influence sociology. Here he considers this idea of reflexivity:

> We know that great novels are dominated by some point of view; but in modern times there has emerged a 'point of view of a point of view' by which the writer

incorporates into the text his [sic] awareness of his own awareness. ... A similar strategy, properly adapted, seems required of any sociology that seeks to represent not only the formation and conflict of multiple social worlds, but also its own presuppositions and political intents. ... Just as the literary use of a point of view helps integrate diverse elements into an artistic whole, so the reflective use of point of view in sociology can integrate into a consistent structure the irrationalities of the world, *yet without having to deny their irrationality*.

> (Brown, 1977, p. 75; emphasis in the original)

Another means of addressing the now problematic issue of the researcher's authority — and one which, for me, holds the key to a more participatory, emancipatory approach to social inquiry — is to make research accounts more collaborative. Tyler (1986, p. 126), rejecting the notion of 'observer–observed', discusses how a postmodern ethnography is a dialogical process, emphasising 'the collaborative nature of the ethnographic situation'. Such issues of dialogue and power relations between the researcher and researched have long been important for feminists, as has emotional reflexivity, both welcoming as they do personal experiences as evidence in social research.

For postmodern feminists, truth is a 'destructive illusion' (Olesen, 1998, p. 311). Instead we face an 'endless play of signs, the shifting sands of interpretation, language that obscures' (*Ibid.*). Grappling with the same issues as postmodern ethnographers, feminists have also been experimenting with ways of writing. Wolf (1992) has produced a work in which she has written up her ethnographic research in three very different styles: a short story, a copy of the fieldnotes collected, and an article written from the author's current position some years after completing the research.

As Wolf alludes (1992, p. 7; see also Linden, 1993, p. 4), the considerable feminist contribution to the debate has been largely ignored. Much of the new ethnography, whilst challenging notions of representation, remains ethnocentric and predominantly the preserve of the white male.

Standpoint feminists (see, for example, Harding, 1990) stress the importance of privileging lived experience. However, as Denzin points out (1997, p. 54), they do not show the reader how the experience of the 'other' is brought into the texts that they write. Marcus (1998, p. 390) believes that it is through the writing of 'messy texts' that both these issues are addressed. Such writings are open-ended, often marking a concern 'with an ethics of dialogue and partial knowledge that a work is incomplete without critical, and differently positioned, responses to it by its (one hopes) varied readers' (p. 392). Banks and Banks (1998) and Ellis and Bochner (1996) have edited volumes of social research texts that explore a host of approaches to writing (or presenting) research, including poetry, memoirs, photographs, narratives and fictions.

Walter Benjamin (see Linden, 1993, p. 6) had the ambition of writing a text made entirely of quotations, declaring that claims to truth made in a single, authoritative voice falsified history. In a 'surrealist montage' (Arendt, 1999, p. 51), these quotations would float freely from opinion and interpretation. Such a work would emphasise the fact that any text, whether presented as a seamless narrative or not, is a construction — and as such can never entirely mirror the outside world.

In spite — or perhaps because — of the eccentricity of his project, I would ally myself with Benjamin in his assertion that a plurality of voices in a text can bring us closer to some sort of truth regarding lived experience. Qualitative research has to question constantly whose voice is dominant, whose language is privileged. Traditional methods of social inquiry involve a researcher imposing — to a greater or lesser extent — his or her own beliefs and set of skills on a situation: reading about/identifying a social phenomenon, observing this phenomenon, and then writing about it. The resulting accounts, 'far from being simple, neutral or transparent reflections of the research process, are in fact, complex, rhetorical accomplishments' (Gill, 1998, p. 21).

The research at the Sure Start programme, discussed in more detail below, provided an opportunity for the researched community to explore their world imaginatively and creatively, and then to hold up the resulting representations to an audience. This methodology precludes an 'outsider's' interpretation of the world of others, and entails a 'humbling' of the professional researcher's or academic's position. Yet, in forsaking some of this 'power', a window is opened to greater understanding.

> The wish to own through your eyes collapses sensual appreciation onto an adjunct of power, just another back-up to the nasty ways of the world. And, of course, you miss all the magical things which are really going on.
>
> (Bhattacharyya, 1998, p. 53)

The art of participation

The two-year research project took place in a 'run-down', ex-mining community in the North West of England where particularly high levels of social exclusion are experienced. Funded by the Economic and Social Research Council (ESRC), it involved investigation of the local area and of the impact that a local Sure Start programme has had on families' lives. Sure Start is a government-funded initiative, announced in 1999, that works with children under the age of five and their families. It forms a link in New Labour's vision of 'joined-up' working between services. Connecting with health, education, employment and social services, it aims to provide a more cohesive service for children which will ultimately impact upon social exclusion and child poverty. Local Sure Start programmes have offered a range of parent and toddler groups, along with advice on breastfeeding and nutrition, and have provided opportunities for parents to become involved in the running of these services. More recently, local programmes have been incorporated into children's centres, often sharing physical space with health centres and employment services.

In a move contrary to traditional policy research, I was keen to conceive a project whereby the researched community would be able to set the agenda; they were to be intimately involved in designing the research questions, in creating and collecting data, and analysing and disseminating the findings. Subjects of research — who are so often the most marginalised groups in society, since rarely does social inquiry study

the affluent classes — should be involved in knowledge creation about themselves and their communities. The research at the Sure Start programme aimed to give those involved (for the most part impoverished, working-class women) the opportunity to tell their stories about raising children in a profoundly unequal society.

I also wanted to tackle the issues of representation discussed above. Postmodernist thought can verge on the nihilistic, collapsing under the weight of its own arguments and perpetual criticisms. Thus, it is at risk of being ultimately conservative, its battles with truth and meaning leading to little in the way of social change (see Eagleton, 2003, p. 109). This project, in contrast, contains an overtly political dimension which actively seeks to redress social inequality and to improve the lives of women and their families. Research findings should provide an insight into the lives and emotional experiences of the local community, with the audience given an insight into what it is to live such lives — that is, empathising with the research participants and seeing the world through their eyes. Yet, the results of such work do not solely concern individual lives but also tell wider truths about society, truths which have important policy implications.

The project involved recruiting and training a group of Sure Start parents — six women in all. Recruitment was greatly aided by the fact that, at the time, I ran an arts group at the Sure Start programme and was a well-known and trusted face in the community. Whilst I launched an extensive leafleting campaign to draw attention to the research project, it was largely through word-of-mouth that the women became involved. The training incorporated accredited basic skills English (provided by the local community college), as well as an introduction to research methods and ethics (which I delivered). This provided structure to the project, and, as a team, we were able to design the questions and collect and analyse data through in-depth interviews and questionnaires. These more traditional methods were employed, in part, as a means of satisfying the needs of the Sure Start programme. However, having local women carrying out this research led to results which, I argue (Foster, 2007b), are very different from those that would have been garnered by an 'outsider', being much richer and more intimate.

The research looked at women's experiences of raising children in an impoverished community. It examined the variety of reasons for why women might not access the local Sure Start programme, which included, significantly, the deeply embedded mistrust of statutory services. It also sought to find out from families who were attending Sure Start the impact that the programme had had on their lives.

Simultaneously, we made contact with a variety of local artists and practitioners and set up a colourful range of art groups: creative writing, short-film making and drama, in addition to the art group that I myself had been running in the community for some time. The Sure Start programme proved supportive in terms of providing crèches for the parents' young children and transport to and from the various venues. Having the team of local women on board was a tremendous help in terms of promoting these groups, which, as word spread, became popular amongst the local community.

I took an active role in each of these groups; whilst this participation was time- and labour-intensive, I also found it extremely rewarding. As planned (and discussed

more thoroughly below), the poetry, art, short-film making and drama all provided means for Sure Start mothers to explore aspects of their lives and to control the expression of these stories to an audience. Perhaps a less predictable outcome, however, concerned the *enjoyment* of the process by those involved (myself included), and the close relationships which were formed over the two years of its duration.

The creative writing group was, declared one Sure Start mother, the 'highlight' of her week. Another participant in this group found that writing poetry 'is a way for me to express my feelings and it's great to meet the people I meet'. One of the major themes that emerged from the research project was the isolation and loneliness experienced by mothers. Thus, whilst exploring such issues, the arts projects simultaneously provided a means for local women to meet each other and form friendships. A participant in the art group reflects:

> I did love the art group 'cause it was time to be an adult, really, for a little bit. Where everything else, it's around being with the kids and you do that at home, you know what I mean … so the art group for me was one of the best.

Another Sure Start mother speaks enthusiastically about the drama group:

> I thought it was a good laugh. It was nice being with everybody … I just loved it — thought it was brill.

The fact that through these groups we were exploring and sharing our own experiences and emotional lives meant that we were able to get to know each other more intimately. Reading out our poetry to one another, and performing role-plays and playlets, made us open and vulnerable, strengthening our ties to one another. Now, over a year after the completion of the project, we still meet — and, on occasions, we will re-view the video footage of the performances we gave, and laugh and cry!

Whilst I worked incredibly closely with the women at Sure Start Parr (as well as with the local artists and professionals who provided crucial assistance throughout the research project), I am aware now that, in writing this article, I am alone. Whilst I draw on our shared memories, this work is ultimately my creation. I acknowledge the power that I hold as I write about the project, and as I attempt to do justice to the extensive work to which we all contributed. The anxiety I feel about representing the work sensitively and authentically is, however, at times overwhelmed by the joy of writing in a 'world' where, as Szymborska understands, I have ultimate control.

Exploring the self through stories and images

Giving the researched an opportunity to tell their own stories seems, at first glance, an ideal way to privilege their experiences and thus to gain insight into their lives. The study of narrative has emerged through the interpretive turn in the social sciences and can be traced back to the early 1980s (see Elliott, 2005, p. 5). Riessman elucidates:

'[story telling] is what we do with our research materials and what our informants do with us' (1993, p. 1).

The simplicity of this statement perhaps belies the complexity of interactions with informants (see Holstein & Gubrium, 1995). Issues over whose story is being told and who is doing the telling need to be addressed. Confronting these issues can be, as Linden (1993, p. 2) describes it, 'shattering'. The process of conducting research that she had followed, allowing her research informants to speak about their own lives in their own words, was 'problematic' indeed:

> This seemingly innocent narrative practice served to obscure both subjectivity and agency: whose voice, point of view, and interpretation I was representing at any given moment — mine or theirs. It blurred the fact that meanings, by their very nature, are indeterminate, situated and emergent — negotiated between partners in discourse.
>
> (Linden, 1993)

Through making narrative accounts more reflexive, often involving the researcher's own story being told, such issues become increasingly transparent. Not only is the author's role in the construction of the text highlighted (as discussed above), but also it can lead, for the researcher, to a greater awareness of self. Working in a reflexive, thoughtful manner means that one can begin to understand oneself and one's experiences more deeply, as well as understanding others. In so doing, it becomes clear that 'the process of self-discovery is also the process of distillation and creation' (Lentin, 2000, p. 31).

If such an opportunity is given to the researched community to explore their own experiences in their own voices, the resultant stories will have an authenticity that conventional research cannot compete with. When the arts-based methods of poetry-writing, visual art making and short-film making are applied in this context, they open up boundless possibilities for self-discovery and self-expression.

When carrying out projects in communities where education and literacy levels are not particularly high (as in the case of the research project at the Sure Start programme), it is vital to respect the fact that reading and writing are not everybody's primary means of communication. Conquergood, concerned with the privileging of academic texts above other methods of communication, terms this practice 'textocentricism' (2002, p. 151). It is thus important to include visual and oral, as well as written, elements to research methods.

Sure Start parents began to explore this new territory as they attended the arts groups over the two-year duration of the research project. One of the mothers recalls one of the weekly sessions:

> Everybody was writing poems and getting in touch with their selves and the group thoroughly enjoyed themselves. They all got into it and in my eyes it was a great success as it got me in touch with my emotions and helped me solve a few things.

The project aimed, in addition to encouraging the women to investigate their own lives, to tell much more general social truths. As Evans (1993, p. 9) contends, 'a

study of the individual illustrates the social, and re-affirms the centrality of certain general themes in the lives of all particular individuals'. Through the arts we move closer to a portrayal of the world in all its emotional complexity. For Butcher (1907, p. 150), it is poetry that creates a 'world of the possible' which is 'more intelligible than the world of experience' since:

> [It] eliminates what is transient and particular and reveals the permanent and essential features of the original. It discovers the 'form' (eidos) towards which an object tends, the result which nature strives to attain, but rarely or never can attain. Beneath the particular it finds the universal.

The following poem, *What if* ... was written during the course of the project by a lone mother of three young children. She has been on a rollercoaster ride through drug misuse, domestic violence and homelessness. Her poem refers to battles with self-image and with losing an unborn baby through her then-partner infecting her with gonorrhoea. It also raises the virtually taboo subject of a woman imagining what life could have been without motherhood. It thus addresses issues that, whilst affecting a significant population of women, often remain hidden.

What if ...

What if the sky had tides
What if the fair had no rides
What if prostitutes didn't charge
What if extra wasn't large
What if my ex dean had been clean
What if, what if wouldn't have been.
What if I hadn't got 3 kids
What if my life hadn't been like this
What if ...

Telling tales

Such data as discussed above are rich and emotive, but also have the advantage of being in a format ready to be shown to an audience. After the completion of the project at the Sure Start programme, we presented the results to an audience of local residents, academics and practitioners in the form of poetry readings and displays of visual art work and short-film. In addition, we performed two short plays based on interview data [see Foster (2007a) for further discussion].

The fact that the research 'subjects' have had control over the creation and articulation of their experiences may go some way to allaying the concerns held by Riessman (1993) over the possibility of enabling/truly hearing 'marginalised voices'. Whilst agreeing in principle with the goal of 'giving voice' to previously silenced groups of women, she is dubious as to whether or not social research can achieve this: 'We cannot give voice, but we do hear voices that we record and interpret.

Representational decisions cannot be avoided; they enter at numerous points in the research process, and qualitative analysts including feminists must confront them' (p. 8).

Employing the arts in the research addresses such issues of representation as those to which Riessman alludes. Through creating art work, poems and short films, participants are able to construct their stories for themselves: a very different practice from that of the researcher selecting (methodically or otherwise) snippets from various interviews and piecing them together to tell a particular tale from his or her own perspective. As Mauthner and Doucet (1998, p. 138) reflect:

> The data analysis stage can be viewed as a deeply disempowering one in which our respondents have little or no control. Far removed from our respondents we make choices and decisions about their lives: which particular issues to focus on in the analysis; how to interpret their words; and which extracts to select for quotation. We dissect, cut up, distil and reduce their accounts, thereby losing much of the complexity, subtleties and depth of their narratives.

In the resultant accounts, academic convention means that the words of research participants would contrast uncomfortably with the much denser, abstract language of the social sciences (Standing, 1998, p. 192). Furthermore, this can have the outcome of limiting the audience of social research, particularly hindering the researched community itself from accessing the results of a project to which they have contributed. Participatory, arts-based research, however, widens the potential for a greater range of people to be party to the conclusions drawn from a project. Moreover, in capturing glimpses of the human spirit, it can foster empathy in its audience.

In order for any sort of truth to be glimpsed, the re-production of social life has to be able to capture some of its essence, to bring elements into sharper focus. And so the fictive imagination, the artifice of theatre, can lead to a greater closeness to the pathos of social life than can a more conventional approach to social research which lacks the world's myriad shades of colour and complexity. Malcolm (2004, p. 39) observes that 'we never see people in life as clearly as we see the people in novels, stories and plays; there is a veil between ourselves and even our closest intimates, blurring us to each other'.

Through fictions we can understand other people on a different level; we can see the world from their point of view and immerse ourselves in their stories. The experiences of the Sure Start mothers told in a variety of ways, allowed the audience an insight into their lives. One member of the audience, a professional working in the local area, felt the emotional impact of the presentation of results (my emphasis):

> Brilliant!!! It really brought tears to my eyes watching the short films of how families have come so far over the past few years ... Everyone worked so hard and were so brave, it has really put me on a high and makes you think about how people in [the local area] *are really feeling*.

A member of staff who had worked at the Sure Start programme for some time, commented on how the arts presentation had allowed her a glimpse of another aspect of the women she works with on a daily basis:

Excellent to see all the talents and strengths of people in the community, who often I see during my work hours. To see another side to their lives was fantastic.

Conclusion

Employing the arts in participatory social inquiry not only stays true to the goals of participatory research — which Reason (1998, p. 262) outlines below — but allows these goals to be authentically realised:

> This world-view sees human beings as co-creating their reality through participation: through their experience, their imagination and intuition, their thinking and their action.

Artists have the ability to create and rule over their own worlds, to take charge of and manipulate what is seen and what remains hidden. The work produced in such a fashion assumes an audience in a way that an interview does not, and has an ability to convey emotion and to engender empathy in this audience. Alternative methods of dissemination also 'force the terms in which [the researched] already express their experience to take on meaning in the reader's context' (Edmondson, 2000, p. 191).

The socially excluded are so often treated as 'other', as lacking the ability to achieve. The work carried out over two years at the Sure Start programme highlighted the strengths and the talents of the women involved, as well as their commitment to motherhood. It concluded that working holistically and, above all, respectfully with families is crucial to successful practice, whether in terms of conducting a research project or of running a Sure Start local programme. The understanding that any one woman is as worthy as any other, 'a political, moral and also spiritual assumption' (Stacey, 1994, p. 88), is key, and is as important as ever in the current social policy climate.

Perhaps the most beneficial element of Sure Start was its providing an opportunity for people to mix with each other and to make friends with others living in their community. Women so often reported experiencing loneliness and isolation prior to their involvement with Sure Start. Having a space to meet other adults, as well opportunities to use their skills, talents and intelligence, led to improved mental health and well-being and the development of a confidence in themselves that filtered through to their children. Whilst our recommendations were to sustain and develop this exciting, effective element of the Sure Start initiative, the government is currently favouring a service that views parents' role in their children's upbringing as much more clinical. Mothers are being encouraged to think about paid employment even before their babies are born; services such as employment and parenting advice are being delivered in families' homes rather than in group settings, thus preventing the opportunity for parents to meet one another.

The current emphasis on paid employment is not necessarily a straightforward solution to maternal and child poverty, not only because of the high rate of in-work poverty (Kenway, 2005), but also because, as the research demonstrates, so many women feel that they should be spending time with their young children. Indeed, they

gain much pleasure from doing so and feel that their children are more secure as a result. The emphasis on home-visiting by Sure Start staff may mean that more families are being targeted by the programme, but it raises questions of how life-changing this practice can be, particularly when staff members have been observed to judge negatively those families living in poverty. As the information-sharing agenda outlined in the green paper *Every Child Matters* (DfES, 2003) is put into practice, these families are going to be under increased surveillance, their homes and lifestyles subject to much scrutiny.

The arts projects actually validated the findings produced from the more conventional methods of data collection (extensive in-depth interviews and a questionnaire survey), echoing many of the themes, but furnishing them with greater intimacy and emotional impact. For instance, the importance of family (and frequently a matriarchal one at that) to the local women was a major theme of the research. It was not unusual to find three generations of women living in the same street who would rely on each other for advice on child-rearing and for childcare rather than look to external services and professionals (having repercussions for programmes such as Sure Start). Culturally, this was often alien to members of staff at the Sure Start programme, as well as to policy-makers who might assume that professional advice on parenting, as well as accessible childcare, is welcome.

The brief of the visual art work produced during the course of the project was for participants to record the elements of their life most meaningful to them. The resulting work predominantly featured the artists' families, their homes, even their Sunday dinners! One particular canvas (a multi-media piece which incorporates collage, photography, paint and ink) includes an image of the family's front gate, as well as intimate snapshots of the home. The gate is symbolic of what the women chose to share through the art work — the short-films similarly let the viewer in to families' homes and lives — and which elements of their lives remained 'gated off'.

Bhattacharyya looks at the process of storytelling, referring to the telling and re-telling of the *Arabian Nights*:

> As the big theorists say, the concept of reiterability has a special status in Western cultures: this is what makes truth, the ability to repeat and check. The error-filled and corrupt pleasures of the *Nights*, on the other hand, in any inauthentic version from orientalist translation to half-remembered half-embellished bedtime story, offer another way of telling the story and making sense of the world.
>
> (Bhattacharyya, 1998, p. 9)

Presenting more traditional data in addition to the arts projects imbued the research with the necessary validity to reach its academic and policy-making audience. The mix of methods allowed for checking and re-checking results. However, I prefer Bhattacharya's enticing notion of 'corrupt pleasure' over the less voluptuous concept of 'reiterability'.

Postmodernism has allowed for such discussion over what is acceptable as truth. It is, however, important to acknowledge here that dismissing truth altogether, as some postmodernists have done (see Eagleton, 2003, p. 103), would be politically disastrous. If truth loses its force then 'radicals can stop talking as though it is

unequivocally true that women are oppressed or that the planet is being gradually poisoned by corporate greed' (p. 109). Thus, truth is of vital importance; yet, I have argued here that truth is not always about observable facts. A holistic, artistic approach to social inquiry is about those involved following their intuition, drawing on felt experience and on the power of the imagination to create results which resonate with the researched community and their audience.

References

Almack, K. (2003) 'Interview: Beverley Skeggs', *BSA Network*, vol. 86, pp. 2–5.

Arendt, H. (1999) 'Introduction', in *Illuminations*, by W. Benjamin, Pimlico, London.

Atkinson, P. (1990) *The Ethnographic Imagination: Textual Constructions of Reality*, Routledge, New York.

Banks, A. & Banks, S. P. (1998) 'The struggle over facts and fictions', in *Fiction and Social Research: By Ice or Fire*, eds A. Banks & S. P. Banks, AltaMira Press, Walnut Creek, CA.

Bhattacharyya, G. (1998) *Tales of Dark-skinned Women: Race, Gender and Global Culture*, UCL Press, London.

Brown, R. H. (1977) *A Poetic for Sociology: Toward a Logic of Discovery for the Human Sciences*, University of Chicago Press, Chicago.

Butcher, S. H. (1907) *Aristotle's Theory of Poetry and Fine Art*, Macmillan, London.

Byatt, A. S. (1990) *Possession: A Romance*, QPD, London.

Clifford, J. (1986) 'On ethnographic allegory', in *Writing Culture: The Poetics and Politics of Culture*, eds J. Clifford & G. E. Marcus, University of California Press, Berkley & Los Angeles, CA.

Clifford, J. (1988) *The Predicament of Culture: Twentieth Century Ethnography, Literature and Art*, Harvard University Press, Cambridge, MA.

Clifford, J. & Marcus, G. E. (eds) (1986) *Writing Culture: The Poetics and Politics of Culture*, University of California Press, Berkley & Los Angeles, CA.

Conquergood, D. (2002) 'Performance studies: interventions and radical research', *The Drama Review*, vol. 46, no. 2, pp. 145–156.

Denzin, N. (1997) *Interpretive Ethnography: Ethnographic Practices for the 21st Century*, Sage, Thousand Oaks, CA.

Denzin, N. & Lincoln, Y. S. (1998) 'Introduction: entering the field of qualitative research', in *The Landscape of Qualitative Research: Theories and Issues*, eds N. K. Denzin & Y. S. Lincoln, Sage, Thousand Oaks, CA.

Derrida, J. (1974) *Of Grammatology*, John Hopkins University Press, Baltimore.

DfES (2003) *Every Child Matters*, Stationery Office, London.

Eagleton, T. (2003) *After Theory*, Penguin, London.

Edmondson, R. (2000) 'Writing between worlds', in *(Re)searching Women: Feminist Research Methodologies in the Social Sciences in Ireland*, eds A. Byrne & R. Lentin, [Institute of Public Administration].

Elliott, J. (2005) *Using Narrative in Social Research*, Sage, London.

Ellis, C. & Bochner, A. P. (eds) (1996) *Composing Ethnography: Alternative Forms of Qualitative Writing*, AltaMira Press, Walnut Creek, CA.

Evans, M. (1993) 'Reading lives: how the personal might be social', *Sociology*, vol. 27, no. 1, pp. 5–13.

Fernandes, L. (2003) *Transforming Feminist Practice: Non-Violence, Social Justice and the Possibilities of a Spiritualized Feminism*, Aunt Lute Books, San Francisco.

Foster, V. (2007a) 'The art of empathy: employing the arts in social inquiry with poor working-class women', *Social Justice*, vol. 34, p. 1.

Foster, V. (2007b) *Painting a Picture of Sure Start Parr: Exploring Participatory Arts-based Research with Working-class Women*, unpublished PhD Thesis.

Geertz, C. (1973) *The Interpretation of Cultures: Selected Essays*, Basic Books, New York.

Gill, R. (1998) 'Dialogues and differences: writing, reflexivity and the crisis of representation', in *Standpoints and Differences: Essays in the Practice of Feminist Psychology*, eds K. Henwood, C. Griffin & A. Phoenix, Sage, London.

Harding, S. (1990) 'Feminism, science and the anti-Enlightenment critiques', in *Feminism/Postmodernism*, ed. L. J. Nicholson, Routledge, New York.

Holstein, J. A. & Gubrium, J. F. (1995) *The Active Interview*, Sage, Thousand Oaks, CA.

Janesick, V. J. (1998) 'The dance of qualitative research design: metaphor, methodolatry, and meaning', in *Strategies of Qualitative Inquiry*, eds N. K. Denzin & Y. S. Lincoln, Sage, Thousand Oaks, CA.

Kemp, A. (1998) 'This black body in question', in *The Ends of Performance*, eds P. Phelan & J. Lane, New York University Press, New York.

Kenway, P. (2005) 'In-work child poverty', *Poverty*, vol. 122, Autumn, pp. 13–15.

Lentin, R. (2000) *Israel and the Daughters of the Shoah*, Berghahn Books, New York.

Linden, R. R. (1993) *Making Stories, Making Selves: Feminist Reflections on the Holocaust*, Ohio State University Press, Columbus.

Malcolm, J. (2004) *Reading Chekhov: A Critical Journey*, Granta Books, London.

Marcus, G. E. (1998) 'What comes (just) after "post"? The case of ethnography', in *The Landscape of Qualitative Research*, eds N. K. Denzin & Y. S. Lincoln, Sage, Thousand Oaks, CA.

Mauthner, N. & Doucet, A. (1998) 'Reflections on voice-centred relational method', in *Feminist Dilemmas in Qualitative Research*, eds J. Ribbens & R. Edwards, Sage, London.

Olesen, V. (1998) 'Feminisms and models of qualitative research', in *The Landscape of Qualitative Research: Theories and Issues*, eds N. K. Denzin & Y. S. Lincoln, Sage, Thousand Oaks, CA.

Plummer, K. (2001) *Documents of Life 2: An Invitation to a Critical Humanism*, Sage, London.

Reason, P. (1998) 'Three approaches to participative inquiry', in *Strategies of Qualitative Inquiry*, eds N. K. Denzin & Y. S. Lincoln, Sage, Thousand Oaks, CA.

Richardson, L. (1998) 'Writing: a method of inquiry', in *Collecting and Interpreting Qualitative Materials*, eds N. K. Denzin & Y. S. Lincoln, Sage, Thousand Oaks, CA.

Riessman, C. K. (1993) *Narrative Analysis*, Sage, Thousand Oaks, CA.

Stacey, M. (1994) 'The power of lay knowledge: a personal view', in *Researching the People's Health*, eds J. Popay & G. Williams, Routledge, London.

Standing, K. (1998) 'Writing the voices of the less powerful', in *Feminist Dilemmas in Qualitative Research*, eds J. Ribbens & R. Edwards, Sage, London.

Szymborska, W. (1995) *View with a Grain of Sand: Selected Poems*, Faber and Faber, London.

Tyler, S. A. (1986) 'Post-modern ethnography: from document of the occult to occult document', in *Writing Culture: The Poetics and Politics of Culture*, eds J. Clifford & G. E. Marcus, University of California Press, Berkley & Los Angeles, CA.

Van Maanen, J. (1988) *Tales of the Field: On Writing Ethnography*, University of Chicago Press, Chicago.

Van Son, R. (2000) 'Painting women into the picture', in *(Re)searching Women: Feminist Research Methodologies in the Social Sciences in Ireland*, eds A. Byrne & R. Lentin, Institute of Public Administration, Dublin.

Wolf, M. (1992) *A Thrice Told Tale: Feminism, Postmodernism and Ethnographic Responsibility*, Stanford University Press, Stanford, CA.

Hannele Weir

REPRESENTATIONS OF VIOLENCE: LEARNING WITH TATE MODERN

Introduction

This paper considers the use of visual arts in an academic educational context. It centres on an inter-professional Master's level sociology module where the focus is on the historical, cultural and social perspectives of violence, and in particular it refers to the last session of the module and the workshop held in Tate Modern, London, around the theme of violence. The aim is to describe the developmental aspects of the project, the process of the session, and to consider the impact on the participants. It offers some thoughts on the usefulness and appropriateness of art gallery based teaching. It is argued that such a method is conducive to effective and meaningful learning by extending considerations of violence to visual presentations. It presents an opportunity to access the feeling and impact as evidenced by the artist, and thereby examine the sense and understanding it may afford the viewer.

Learning with, or through, art is no new phenomenon. That is to say that art, such as paintings or music, is not confined to the galleries as exhibits for the sake of

being experienced in that context only, but that art has, in various contexts, offered a way of exploring life events and society as an organised activity; for example, numerous artists have examined and expressed in their work the physical and mental devastation that war creates. Therefore art is not just a visually (or aurally as in music) pleasing, aesthetic experience, but becomes a commentary on life itself. Increasingly, art is also used in a therapeutic context, where people use canvas as a recipient of their inner thoughts, and schemes such as art in hospitals introduce a function that may have a therapeutic influence on the viewer. It has been argued that participation in the arts is also beneficial to personal development (Matarasso, 1997, pp. 14–16) and that the power of creative art enhances opportunities for learning through trusting participants' intelligence and imagination (see Simons & Hicks, 2006, p. 80). Visits to art galleries by a variety of groups testify to the potential that art yields by extending our perceptions of the everyday through artists' presentations, which may speak with directness or which invite viewers to look for more hidden and obscure visions.

This article has two main aims. Firstly, it describes the collaboration between an inter-professional Master of Science module focussing on the historical, cultural and social perspectives of violence and Tate Modern, under the auspices of the *Art into Life* workshop programme. The aim of the visit is to explore representations of violence with the participants, who are mostly nurses and police officers working in settings that involve contact with people who have suffered intentional and unintentional violence. The visit considers how visual art can help to deconstruct and reconstruct meaning and representation of overt or hidden violence, conflict and aggression as depicted in a small selection of art works. It is argued that complex and difficult issues that surround violence, and seeking to understand the violence so palpable in everyday life, be it in war, terrorist threats, accidents, interpersonal relations, or even illness, can be explored not only in the conventional academic context of classroom and library, but also with the help of gallery visits to experience the 'live' visual impact of works of art. Secondly, the impact of the gallery learning is explored with reference to practice. The feedback reported in the article is based on discussions with the students following the tour of the gallery, and more specifically how three students viewed their experience some months after the visit with reference to their practice. Included is also material collated by Alison Cox, a curator in Tate Modern, who accompanied the group in 2006.

The rationale

Learning in an art gallery context is likely to be a new experience for many participants, and raises issues about what Bourdieu (1977 cited in Layder, 2006) calls 'habitus', the basic cultural stock of knowledge we carry in our heads. The influence of the cultural environment and resources feeds into our anticipations about what we want and can achieve in our interpersonal relations (see Layder, 2006). Sharing a stock of knowledge with people from the same social class background will ease such encounters. The implication, we can surmise, is that using art as a learning tool may make more immediate sense for those who are familiar with the symbolism that art

often uses for expression of emotions or as a representation of life events and issues; the representations may be more readily 'read' by those who not only consider art as an aesthetic experience. We also need to bear in mind Bourdieu's (Savage & Bennett, 2005) critique of the art museum serving as a primary site of cultural and social distinction, and that there may be significant inequalities of access to works of art and taking part in cultural activities. Thus using an art gallery and the exhibits as a site of learning may feel socially and emotionally threatening.

The partnership between the Department of Applied Psychosocial Sciences in the School of Nursing and Midwifery, City University and Tate Modern started in 2002. The first visit was initially a test of whether a largely unfamiliar method both to the module leader and the students could be used in a higher education, non-art, teaching programme. The module leader had an interest in using art in a live, art gallery context, but with no concrete idea of how to create that opportunity. The impetus for using art in the module came partly from the desire to make art 'speak' in a way that a lecture may not do. The artists' presentations of personal experiences, observations of social, political and cultural events in society and of the impact on those caught up in the events, may find a particular echo in the viewer. The comprehension and interpretation of the phenomena presented in the medium of art bring a multitude of aspects and possibilities to the fore mirroring the complexity of violence in real life. In such a context art may be effective not only politically and historically as Wolff (1993a) argues, but it can also be a tool in learning about the wider societal issues relevant to professional knowledge. Modern art has, for example, as seen in the works of Goya (Black Paintings) and Picasso (Guernica), presented the agony and impact of violence, be it war or the ravages that hunger brings about (Blackburn, 2003). Such presentations and commentaries have been, and are, (only) possible within the context of the nature of the contemporary society as Wolff (1993a) notes. Where only a small minority or a dominant group have access to culture, the potential effect and transformative power is 'extremely limited' (Wolff, 1993a, p. 85). The drive for widening participation in, for example, accessing art galleries may lead to a transformation in a variety of ways, although Newman and Mclean (2006, 2004 cited by Woodham, 2006) note the uncertainty about the impact being made on the broader audiences. In our case the aim was to extend learning styles and methods rather than follow the widening participation policy. However, it is possible that these two dimensions overlap.

More modestly, the rationale for the Tate Modern session was to present violence from a previously unfamiliar perspective, and context. How students approach the exposure to the works depends on their work and biographical background. Partly for that reason it is important that the teaching and learning takes place with a specialist, who knows the potential of art as a learning method and the way to lead sessions in that context. Thus a coincidental meeting with an artist educator working at Tate Modern ignited the opportunity for creating something with that purpose for the module. It was felt that the visit to Tate Modern was best placed as the final session, a culmination of previous classroom discussions, reflections on practice and reading. The students could formulate their opinions as to what the artists' visual representations on a theme of violence meant to them as viewers with the knowledge and information collected from the classroom sessions.

After a short introduction, the session focuses on between four and six selected pieces of art on display at the given time. The tour is led by one of the Artist Educators, who sees her role as a guide to discussion and building on individuals' responses rather than being the deliverer of expert opinion or historical 'facts'.

The implication and consequence of a kind of free association in such a context means that an understanding of what the link between the academic and the artistic can articulate, potentially, in the participants' minds needs to be thought about, but that it cannot be tied down too much to concrete and detailed learning outcomes. In this case the module learning outcomes covered the learning to be achieved during all the sessions of the module, building meaning and insight between theoretical thinking and practice. Setting prescriptive outcomes for the gallery visit would encourage 'observation rules' that would from the outset limit the exploration and impact made on the viewer and, possibly, could diminish the purpose of using art. Nevertheless, to encourage creative thinking rather than an instruction based approach (Lindblom-Ylanne et al., 2006; Simons & Hicks, 2006), the overall aim and focus was necessary, and the anticipation of benefit, but not as fixed elements of a specific outcome. In other words, the purpose of arranging the learning opportunity for a largely uninitiated group of students needs to be understood and agreed between the teacher and the leader of the session, but confidence in the students' openness and ability to discover new meaningful connections with previous learning, and experience, is fundamental to the approach.

The preparatory visit by the module leader to the gallery to finalise the selection for the session with the Artist Educator has been highly important as it has enabled a dialogue about the art works and has given an opportunity to consider the relevance and interest of the works to the student participants. The preparation has also been crucial in facilitating understanding and agreement about each other's work and roles. This phase is necessary preparation to make sure the works are accessible without demanding overt effort and sophisticated theoretical understanding (Wolff, 1993a). It also gives a chance to describe briefly the students' work context to the artist educator and how violence is explored in the rest of the module content, besides giving a sense of a shared endeavour, which is important in creating a sense of safety, and confidence in the proposed activity, as viewing art can be a challenge especially to those who are not familiar with that medium.

Engaging with art

The preparation also means that the session is not designed along the lines of 'let's see what art has to say about violence' as an add-on curiosity or even entertainment, but it is to examine the layers of violence in the variety of visual representations, which is integral to the module content. In some sense it is the construction, by the artists, and the deconstruction by the viewers that recall the dimensions of violence discussed and debated in the preceding weeks of the module programme. As one student, Ratna Golaknath, perceived it:

> The visit to the Tate was a great opportunity for me to explore a medium of expression that I felt ill at ease with. As mental health professional I am used to working with people and not with Art.

At the start of the module when it was shared with us that we would be visiting the Tate I had not understood the purpose. However, as the module proceeded I began to see how. Through the entire module we were encouraged to explore alternative and different approaches to understanding violence — through fairy tales, through current affairs, through football, among the topics. The stage in many ways had been set for us to reconstruct or deconstruct the various meanings of violence.

A minimum of biographical detail about the artists is given to the group. The information, however, offers an understanding of the choice of subject for the painting and the context. On occasion additional material related to the historical, temporal and biographical context of the artist, such as pictures of the artist's studio, or pictures of sketches, help to reveal developmental points in the creation of the work in question. The focus is on the impact of visual representation that challenges the viewer by directness, by obscurity, by subtleness, by discomfort, and ignites curiosity to explore and make sense of the artist's view of events and experiences. Whilst television images, to which we are regularly exposed, present a reality that can be graphic and 'naked' in detail as far as the camera can capture an event, art presents a potentially more multi-layered picture and commentary. The capacity for that reality to grow in the eye and in the mind of the viewer leads one to comprehend not only the obvious, but also the hidden force of violence. 'Reality' images such as on the television present the raw face of violence, but not all violence is so obvious and direct, and we argue that people need to look at more obscure representations to seek the presence and the meaning of subtle and mundane violence in order to 'discover' the feel of violence without being at the receiving end of a concrete event. In the session in 2006 one of the pieces viewed was Francis Bacon's *Second Version of Triptych* (1944), currently on view in the *Poetry and Dreams* section. It is an example of an artist presenting an interpretation of events in his personal circumstances, but in the context of the wider society. Bacon's work at first baffled most of the viewers with its raw obscurity, which also disturbed them: 'He (Bacon) must have been mentally ill' was one student's comment. For another participant the vibrant colours of Bacon's painting represented anger born out of frustration with his sexuality and his artwork was the way to express that anger in an intolerant society at the time.

Thus the fascination and invitation of such visual pieces and the others viewed during the session was that the artists' view and construction draws us to a way of puzzling over the works requiring engagement and through that route we are invited, if not propelled, to engage with the wider world. We can also argue that engaging with art is an end in itself, feeling pleasure with 'nice' pictures. Or, that we appraise the artistic merits in an academic sense, how skilful the artist is, for example, in composition, and positioning the work as autonomous and meaningful purely in formal terms (Jones, 2003). Therefore 'nice' and 'good' pictures have their aesthetic function, but by definition do not avail themselves directly to speak of the ugly, the violent; or of expressions of power and control. One important point for the students was to realise that 'taking time to look properly' at artwork was rewarding. It meant going beyond the obvious appraisal of the beauty/ugly dichotomy and, importantly, that it could be translated into spending more time viewing and assessing issues in

practice. Reflecting on the type of art we view in our session encapsulates or challenges the polarised forces that may help us to comprehend violence in its myriad dimensions. It can be a subtle or 'in your face' representation, but it ultimately presents a reality both in the way that the artist may have intended, or has seen it, or the reality that comes to the fore for the viewer looking at the work. However, because of the juxtaposition of the pleasure of beauty and the challenge of the disturbing, violent and ugly, it was important to be told at the beginning of the session that we do not have to *like* the works we are going to view, which freed the viewers from any bounds of assumed sophisticated or 'educated' viewing. The preparations for the session and encouragement towards awareness, rather than working within strict 'learning outcomes', lay the premise for approaching art as a means of educational/ pedagogical dialogue. The approach rests on the premise that art is like text and can be read as a symbolic text, as signs and works that mediate our self-knowledge (Ricour, 1981 cited in Solheim & Borchgrevink, 1993). So, it seems as if the violence observed on the canvas or in an artefact is mediated 'lived experience'; what the artist has objectified through signs and expressions (Solheim & Borchgrevink, 1993). What we come to 'know' about that experience is one side of the knowledge, and what we gain in self-knowledge by looking and absorbing the work/exhibit is the result of our reaction and understanding. Tacey (2004), with reference to ancient tradition, speaks of the role of arts as bringing new life or 'making new' tradition and linking it to contemporary awareness and experience. To look at conflict and turmoil of life with the eyes of the artist adds, it is envisaged, to the comprehension of how we feel about, and approach violence. Bringing the violence to the surface, to the consciousness, may also aid our dealing with it.

It is the invitation and process to look with the artist that draws the other possibilities out from a piece of exhibited work. There are two immediately available dimensions that impact on the way participants experience the exhibits. In their work context it is the professional response premised on a mixture of scientific and experiential work practices, which direct the thinking and activity. The other refers to the biographical resources that pattern the way people manage, for instance, illness (Zinn, 2005, p. 5), as a violation of health. How representations of violence and the metaphorical expressions are viewed and perceived in art adds insight to the way we in general have come to see violence, and how it may or may not connect with our lives. To work out the metaphors and symbols used by the artist leads to the hidden nature of aggression and abuse, and the resultant discomfort and suffering by the recipient. These possibilities throw meanings into different directions as discussion between participants reveals different aspects. The discussion around each piece viewed was crucial to gaining more from the works: it dispelled superficial value judgements and demonstrated what can be understood about the artists' achievement by engaging in the issues of its presentation. For we are not, to quote Tacey (2004), referring to fantasy, but to symbolic imagination that can be revelatory, and that we aim to go beyond the literally minded approach, in which people 'confuse symbolic imagination with fantasy' (p. 161). In other words understanding that experiences and phenomena can be presented by symbolic signs, images and words whilst referring to real observations, real events, rather than an imagined fantasy, and where the visual and the discomfort it presents

dredges up the hidden within oneself are here expressed in the words of Ratna Golaknath:

> The visit reminded me of the fear one feels of the unknown. I was reminded of my earlier visits when I felt unsettled by the displays because I could not understand them. Upon reflection I feel a similar way about violence. It scares me because I cannot understand it. There is not an explanation for why a bomb blast kills innocent people; there is not even one for why someone molests a child. We label these incidents as aberrations, as a sickness of the human mind, we avoid our exposure to this. Art for me is similar; I find myself avoiding the disturbing pieces and enjoying the 'renaissance art'. However, the experience reminded me that I needed to engage with the darker side to be able to address it and to do something about it. I needed to engage to be able to understand my own darker side.

We also explore the works in relation to other activities, such as finding out links between objects given by the Artist Educator and the pieces that are viewed. A tangible object in your hand may connect with the exhibits on display and create associations and extensions to the themes between what you see and hold; for example, a miniature skull in my hand led me to think how many of the pieces by Susan Hiller (*From the Freud Museum 1991–6* installation) contained messages of death or the finality of objects and life. The participants were also given a lump of plasticine to model as they wished, whilst viewing and discussing miniature human figures. For one participant these 'ugly plaster men' figures seemed like 'survivors of a nuclear holocaust, disfigured, fragile' on the brink of survival, which resonated with our current political and potentially devastating human condition. Jones (2003) argues that our perception of the work and the identity we ascribe to a particular image or object is connected to our desires, fantasies and projections, and thereby informs our sense of who we are, and that our reading of the work changes us as subjects. Thus the work 'can't just mean anything' (p. 79).

Risk, debriefing and safety

The reflection that follows immediately after the tour of the gallery is an integral part of the session in order to clarify the perspective each student has on the impact and learning value of the session. It is anticipated that the feelings and views that are uppermost at first may develop into a deeper sense of relevance, or irrelevance, but the reflection and feedback is important for a number of reasons, and the first one is that it allows the group to discuss their observations and sense created by the session. The discussion with the group also affirmed the format of the session.

As Ratna Golaknath observed:

> I feel that doing the exercise with a group was useful to me. Not only did it remind me that people have different perspectives, but it also assured me that things impact on all of us differently. It helped me that we were all assured that our interpretations were not being judged and were acceptable realities. This

allowed me to really connect with the pieces and to draw in on my own experiences with the world and violence. However, there is a risk that lies in these experiences we carry within ourselves, experiences that are private and at times repressed. Experiences that we might not want to be made aware of and that no one can predict.

Other students' comments also emphasised the value of discussion whilst viewing the works. The ongoing questions and directed discussion amongst the group was helpful in the process of making sense, and extending the meaning of what was viewed, as some participants noted:

I experienced the work in a completely different way by discussing it with others.

Seeing it from another perspective is useful.

We learned from one another.

It's a chance to explore what's going on ... to go behind face value ... by discussing you get more and the process of this is useful.

It is also reassuring for participants to be able to vocalise the initial apprehension felt before the session and scepticism about what insights could be gained from 'looking at pictures', as one person put it neatly, summarising equally disbelieving comments by others:

I couldn't believe I was getting into this.

Whilst the ongoing development and the feedback from students has increased our confidence about the method as a valuable way to enhance learning, one student in each group, within the three groups that have now taken part in these visits, has in the immediate feedback reported limited or no meaning in the works that we have viewed. It is an inevitable risk taken with unconventional ways of teaching. The point is that it is important for sceptical views to be expressed and discussed in the group. It may give pointers for future sessions, but above all it also gives the opportunity to unpack some of the discomfort. However, it is possible that the initial lack of sense may develop later into an insight that helps to relate the session to other issues and events, including the work context. It is anticipated that further research will clarify the issue.

Another, closely related aspect of the risk is that students feel disappointed and confused. The de-briefing and reflection after the session is therefore crucial in order to be able to verbalise positive and negative feelings about the session, perhaps also about certain works viewed, for example, those that some may find disturbing. Symbolic and metaphorical representations of violence, hidden aggression and distress may also remain too obscure, or individualistic for participants to be able to relate to what is on view. However, exposure to symbolic and metaphorical thinking, and out of the classroom setting, may be an important developmental aspect of the learning. And as Paul (2006) notes with reference to Kandinsky's work (Tate Modern

exhibition in 2006): '… it is the mood of violence and chaos that is more important than the literal interpretation of objects or narrative' (p. 9). One student found it liberating that personal meaning and interpretation was possible and acceptable:

> It doesn't matter what the artist intended and that is revelatory … it is how you interpret it that is important and I didn't know that before.

The supportive and exploratory nature of the session is therefore very important so that participants begin to capture the language with which the artists speak.

A further dimension in the endeavour is the fact that participants, who are more used to teacher-centred, instructional teaching with linear content, receiving knowledge where fact retention and the ability to solve logically structured problems is the method (Lindblom-Ylanne *et al.*, 2006), can find the use of paintings and objects challenging. Delving into arts in a gallery context requires a shift in orientation to surroundings in a public place where other gallery visitors share the space (and even stop to listen to the session), which changes the culture of teaching to facilitative and, possibly what Lindblom-Ylanne *et al.* (2006) might see as supporting students' conceptual change (p. 287). The particular test is that as most students are not particularly familiar with art galleries, they have to overcome their doubts about the logic and meaning of art gallery teaching. It is noteworthy that the experience could deepen the sense of socio-economic divide and class relationships. A number of nurses and police officers have working-class roots, which means that the practice of visiting galleries as a mainly middle-class pursuit can be somewhat challenging. The following comment by one student begins to highlight the conceptual leap required:

> Listening to something that doesn't interest you and making that effort is useful and worthwhile …

to which someone else added:

> Yes, and this applies also to something or someone you don't like.

Link to practice

To view violence through artists' presentations in a context that is removed from the graphic detail of trauma, as observed by people who work in such situations, might help to engage differently with the emotions and thinking about violence in human lives and therefore take us towards comprehending violence from another perspective, whatever that may be.

> It made me take a bit of a step back and look at things a bit differently.

> Each participant had their personal view of each work, and they applied, or not, that view to wider aspects of their personal lives and work.

It made me think outside the box, outside my comfort zone.

What ultimately comes to the fore is also the hidden, or obvious, force that speaks of discord and conflict.

> At the end of the session I felt I had been able to tie together all the learning from the module. It seemed like I had moved from an objective exploration of violence in the classroom lectures to a more subjective understanding. I say subjective because I did not have any background of the pieces we saw, I had not heard of them or seen them before and therefore I was relying on my own beliefs and assumptions to understand them. I felt surprised and amused that I had enjoyed the visit.
>
> (Ratna Golaknath)

Comments elucidated by curator Alison Cox with the group in 2006 for her research with the *Art into Life* programme, demonstrate the initial impact the visit made on the participants. The fact that the some students noted that 'it's OK to have your own opinions' and that 'It's OK not to like art works', or that 'what I think is what I think and we are allowed to do that' seem to concur with the earlier point that fixed observation rules and detailed learning outcomes could restrict the burgeoning interest in art as a medium of learning.

One student also found it useful in terms of the course as a whole:

> It was thought provoking in a way that made you think more about previous class sessions.

Some referred to the depth of taking note of the works and how that was important:

> The art made you realise that there is a lot more to it ... you must look beyond it. I'm terrible for walking in and making up my mind after about four seconds ... I'm going to look (for) a lot longer now.

> I would have walked past the ones we looked at were it not for the workshop.

These comments suggest that an important step from superficial viewing to art making an impact occurred in the session. They may also consciously or unconsciously refer to the fact that art has signified elitism (and is a sign of affluence), or that a work of art suggests a cultural authority (Berger, 1972), but ultimately it is the variety and complexity of meanings and readings of art that are reflected elsewhere by Berger (2002) when he refers to drawings by Vincent van Gogh as the 'maps of his love' (p. 89).

Implications for practice

To what extent the visit makes any difference to the participants' practice, and how, is subject to further research. However, the initial comments, and later comments by

three participants indicate that the session indeed made an impact that can be translated into practice through various routes.

Some immediate benefits of the session were seen to be that by 'listening to something that doesn't interest you and making that effort is useful and worthwhile' and that 'It's about giving something a chance ... being open minded ...' or 'We all have limited views and we can dispel some of these'.

Another participant began to articulate the possible benefit in the following way:

> ... as policemen we can become institutionalised — sessions like this help us to think outside the box — to do some lateral thinking — which is very good and valuable.

The session appeared to have generated new insights into art and its place in the commentary on social and personal experience. Simons and Hicks (2006) have also sought to illustrate by using art in education that it facilitates trust, confidence and the expression of emotion. Our students' feedback has suggested that viewing art presented possibilities, which may develop into influential insights in varying levels of experience.

For Ratna Golaknath, looking back six months later, the session evoked the following thoughts:

> The first thing that struck me when I sat down to write this was that the images we saw are still so vivid in my memory. I still remember the feelings they evoked in me. It's been six months since I went to the Tate on a field visit to explore and understand paintings that can be described as being dark, depressing, grey, disturbing and violent and somewhere I find the word 'wrong' as most appropriate. Since then I have moved back to India, back from education to work and back from a year's break to full time experiences of working in a challenging context and with people facing extremely challenging circumstances.
>
> I see a parallel in my work and the art I viewed at the Tate. I work with survivors of human trafficking, with people living with HIV/AIDS and/or psychiatric disorders. I see pain and suffering very closely in the work I do. This is the dark side and yet I know that the only way to work through this is to understand it. That was how I felt about the Art we saw. I had to sit before it for long enough to understand it and that's when it stopped being as 'wrong' as I thought it to be. It was not pleasant but there was a story there that I had to understand that from all perspectives. My work is similar; I have to remember to understand it from all perspectives.
>
> Yet the most significant learning for me was that from time to time we need to allow ourselves to feel our emotions, we need to come out of our comfort zone and recognise that we are like everyone else, human. We think, feel and act just the same. As a mental health professional I fear that maybe in being objective and in being accepting and non-judgmental I would forget my own reactions. This is when I remind myself that like my visit to the Tate maybe I just need to move out of the confines of my therapeutic room and experience similar situations in a

different context. It reminds me that there are no simple solutions and no ways to make it better; you just have to give yourself time to understand the situation and make sense of it for yourself!

Not having to like the works on view was a relief to some participants. For a Metropolitan Police Inspector it became a crucial revelation as he had always avoided art as something he did not understand. He explained that the direct consequence of the Tate session experience and the work done during the module has resulted in a collaboration with journalists to accompany him to observe the work of the traffic officers dealing with traffic offences and emergencies (see Dickson, 2006; George, 2006).

To what extent the workshop may impact on practice in the long term requires further research; but the above responses indicate that there is value for participants' lives beyond the gallery.

Conclusion

Throughout this paper it has been argued that a formal educational visit to an art gallery (as described here) offers an opportunity to experience art as it has been created and released by the artist to become a public expression of their observation and inner feeling of the world and life. However, it is important to be mindful of the possibility that the art gallery session enhances a sense of demarkation between social classes, and yet the potential that museums and galleries offer in terms of social inclusion is a much discussed topic (see for example Simons & Hicks, 2006), albeit that not all agree that galleries should be part of the government agenda (Woodham, 2006). Our experience, and the evidence presented in the article, has been that with the specific focus on the module theme the session in Tate Modern has made it possible to extend thinking on violence. Liz Ellis, the Artist Educator who led the session, points out that 'it is a qualitatively different experience to learn at Tate Modern, rather than look at slides of the work in a lecture theatre'. The students' responses seem to endorse her argument. As a participant, engaging in free association and dialogue with pictures and artefacts encourages interaction with human events, and oneself, at times difficult and painful. In terms of imagination and vision the three positive aspects in the research on social impact of participation in art (Matarasso, 1997) concur with responses from our workshop participants: that the students tried things they have not done before; that the visit effected a change in their ideas and influenced thinking of practice, and encouraged creativity. It seems then, as Matarasso (1997) has pointed out, that participation in the arts may bring social benefits, tangible and less tangible.

It has been argued, and evidenced by the reflection and application to practice by some participants that art has a place as a learning medium outside art studies. As the examples have demonstrated the impetus for thinking about and implementing some change in relation to practice can take different routes.

Apart from these observations it may be worthwhile to remind ourselves of the aesthetic value of art, as Wolff (1993b) calls for retaining aesthetic autonomy from the social. The relationship could be seen as one where, following Wolff, the artists are

informed by the social, for example, as observers and interpreters of violence, which expands our understanding and exploration of the processes in violence, but obviates the independent aesthetic value of the works and 'appeal' to the viewer as works of art. Both aspects may be important as emotional processes even if we do not like every piece we look at.

This exploration of gallery visits as a useful element of teaching has begun to give some insights into the benefits of venturing outside the classroom to learn in a different physical and emotional space of an art gallery. The way that most students in the session have engaged with the input in an unknown territory has shown that the rationale and content of the session stand up for scrutiny.

Acknowledgments

My sincere thanks to Liz Ellis, Artist Educator at Tate Modern, for her inspirational collaboration with the module; to Alison Cox, Curator at Tate Modern, for her participation in the session and sharing her research findings; to Ratna Golaknath for her particularly detailed comments on the sessions, which have made a considerable contribution to this article; to Jeremy Jones for sharing his insights into the (indirect) transforming power of art; Paul McConnell for his generosity in discussing the many aspects of the importance of art; and lastly, thanks to all the other participating students for their open minded approach.

References

Berger, J. (1972) *Ways of Seeing*, Penguin Books, London.

Berger, J. (2002) *The Shape of a Pocket*, Bloomsbury, London.

Blackburn, J. (2003) *Old Man Goya*, Vintage, London.

Bourdieu, P. (1977) *Outline of a Theory of Practice*, Cambridge University Press, Cambridge.

Cox, A. (2006) *A Qualitative Study of the 'Art into Life' Workshop Programme at Tate Modern*, unpublished Mini research project.

Dickson, I. (2006) 'Emergency! It's a hold up', *Autoexpress*, 25 October, pp. 44–46.

George (2006) 'Pull over!', *Maxpower*, December, pp. 110–115.

Jones, A. (2003) 'Meaning, identity, embodiment; the uses of Merleau-Ponty's phenomenology in art history', in *Art and Thought*, eds D. Arnold & M. Iversen, Blackwell, Oxford.

Layder, D. (2006) *Understanding Social Theory*, 2nd edn, Sage, London.

Lindblom-Ylanne, S., Trigwell, K., Nevgi, A. & Ashwin, P. (2006) 'How approaches to teaching are affected by discipline and teaching context', *Studies in Higher Education*, vol. 31, no. 3, pp. 285–298.

Matarasso, F. (1997) *Use or Ornament? The Social Impact of Participation in the Arts*, Comedia, Stroud, Glos.

Paul, K. (2006) *Kandinsky: The Path to Abstraction*, Tate Modern, London.

Savage, M. & Bennett, T. (2005) 'Editors' introduction: cultural capital and social inequality', *The British Journal of Sociology*, vol. 56, no. 1, pp. 1–12.

Simons, H. & Hicks, J. (2006) 'Opening doors: using the creative arts in learning and teaching', *Arts & Humanities in Higher Education*, vol. 5, no. 1, pp. 77–90.

Solheim, J. & Borchgrevink, T. (1993) 'A rotten text? Gender, food and interpretation', in *Carved Flesh/Cast Selves: Gendered Symbols and Social Practices*, eds V. Broch-due, I. Rudie & T. Bleie, Berg Publishers, Oxford.

Tacey, D. (2004) *The Spirituality Revolution: The Emergence of Contemporary Spirituality*, Routledge, London.

Wolff, J. (1993a) *The Social Production of Art*, 2nd edn, Macmillan, London.

Wolff, J. (1993b) *Aesthetics and the Sociology of Art*, 2nd edn, Macmillan, London.

Woodham, E. (2006) 'Museums and social inclusion: the geography of school visits to museums', paper presented at *LCACE Symposium*, December 2006.

Zinn, J. O. (2005) 'The biographical approach: a better way to understand behaviour in health and illness', *Health, Risk & Society*, vol. 7, no. 1, pp. 1–9.

Paula Pope

'I THOUGHT I WASN'T CREATIVE BUT ...'. EXPLORATIONS OF CULTURAL CAPITAL WITH LIVERPOOL YOUNG PEOPLE

Creativity and cultural capital have become increasingly meaningful on Merseyside since June 2003 when Liverpool succeeded in its bid to become European Capital of Culture in 2008. The leader of the bid, Sir Bob Scott, declared it to be the means of a 'thrilling renaissance. This honour is rocket fuel to propel us to be one of Europe's premier cities' (Carter & Hetherington, 2003). Politically, the award gives recognition to the city's maritime and cultural heritage and the opportunity to pump prime city regeneration, bringing investment and jobs in its wake. Locally, however, residents are finding that booming house prices and frequent out-sourcing of contracts mean that not all the economic benefits have come to them (Ward, 2004).

The award has stimulated activity at different levels in the local region with the establishment of Liverpool Culture Company to steer the city's cultural programme and themed years of 'Faith in one city' (2004), 'Sea Liverpool' (2005), 'Liverpool performs' (2006) and 'Liverpool's 800th birthday' (2007) while the ongoing life cycle of city events is evident at the local galleries, theatres, cathedrals, museums, in its sporting fixtures, street festivals and highlight events that include the Liverpool Biennial.

This is the context for 'Cultural Capital', a module developed in 2004 in the wake of the city's successful Capital of Culture bid. It is a third year module on the university's youth and community studies degree programme. This professional programme introduces youth and community students to the professional skills, knowledge and value base of working with young people and communities. Students learn the theories, methods and principles of social education and community development, enabling them to build effective relationships, facilitate groups and develop curriculum projects around issue based work. Through their own professional journey, students become conscious that they have been 'in the middle of a big process', feeling like 'a butterfly emerging from its cocoon'; and conscious that 'I know what I have to do; I just need to organise it. I see myself as a turtle on the beach, but faster in the water, adapting to my surroundings'. The students develop through the taught and field based curriculum.

This year long module, 'Cultural Capital', is one particular opportunity for students to integrate their new learning experiences. Its development sits well with one of the recommendations of the *All Our Futures* report (DfEE, 2001, p. 162) that seeks to promote creative and cultural activity within youth work training.

The module is informed by the work of Pierre Bourdieu (Bourdieu & Passeron, 1977) and his analysis of social, cultural and symbolic capital and their relationship to an individual's social standing and mobility. This is of particular interest to youth and community workers who often work with those on the margins of society. Through the teaching and learning, students explore their own understanding of culture and how it has worked in their lives. They examine sociological explanations of cultural capital and cultural identity, engage in workshop activities and construct a project proposal to present to their peers. Students then negotiate an interactive culturally-based project with young people in the local community, aiming to stimulate creativity and learning that enhances young people's 'cultural capital'. Informal education principles are utilised in the project work. These principles are characterised by voluntary relationships with young people that promote education and well being in their transition to adulthood. During the module, students draw on tutor and peer support to deal with some of the dilemmas and resource issues that often arise. At the close, they return to university to provide a show case of their work to other students on the module.

The students themselves have varied ideas on the nature of culture and their place of study. There is a significant student population that gives the city a youthful identity, though the reasons for choosing one of the Liverpool universities are not always academic. For instance, some students report that their enthusiasm for football has enhanced the appeal of studying in Liverpool (with an academic year that is now shorter than the usual football season). Football is an important aspect of city life and its images have featured on young people's explorations of their cultural identity. Often individuals identify each other by the football team they support or their occupation as it spills over to other aspects of their lives.

Bauman (2004) drew on his experiences as a refugee to debate the nature of culture identity, depicting it as fluid and fragmented rather than fixed. He argued that identity is both transient and constructed through biography, whereby individuals redefine themselves and negotiate their place of belonging within society.

As such, our identity is not 'off the peg', though others may wish to define us in a particular way. We may be labelled in terms of our gender, race, faith, leisure activity or occupation, which may help to produce either a sense of community or difference to 'the other', who are outside our group. However, our identity is complex and changes over time, which can lead to a sense of detachment from our roots and frustration at having to explain ourselves. Historically, the locality was 'the world' in which people moved and understood each other. The postmodern era in contrast, generates a virtual world of electronic communities, where relationships and network contacts are flexible and mobile, often short-term as there is constant updating.

'I've learnt to see what is around me. Before I was looking but not seeing. All this stuff was in front of me but I didn't know it was there'

The starting point for both students and the service users was the meanings that culture has for them. One broad interpretation of culture as 'Everything that I do when I'm not working' was offered by the chief executive of the Liverpool Culture Company in a Front Row interview (BBC Radio 4, 6 November 2006). Another definition comes from a contributor to the *All our Futures* report on creative and cultural education: 'Culture is where we live our shared mental lives' (DfEE, 2001, p. 41).

Culture itself has been defined in the Collins *Dictionary* as 'the total of the inherited ideas, beliefs, values, and knowledge, which constitute the shared bases of social action'. Its roots come from the Latin verb 'colere' which means to till or cultivate. Sociologists interpret culture as the everyday way of life of a group of people.

Our cultural heritage is evident in the way we live our lives. It embraces language, patterns of living and dress, leisure activities, beliefs and values. Thus, the remark by one young woman is pertinent. 'My first creative thought of the day is what on earth can I wear?'

Capital is defined as 'wealth available for or capable of use in the production of further wealth' (Collins, 1994). Cultural capital is not only economic advantage but also intellectual assets that may be associated with access to material resources that affect life choices around health and education. Sociologists testify to links between ill health and inequality, with evidence that those with the financial means can access private health care and support (Giddens, 1997). Educational advantage is often secured by living in the right neighbourhoods to access higher achieving schools. Generally, those from middle class families are able to integrate more easily in to the dominant norms and values of school academia compared to those from lower working class backgrounds and this leads to their success in schools and other social institutions. This cultural reproduction (Bourdieu & Passeron, 1977) was evident in Willis's study of 'the lads' (Willis, 1977), where the counter culture of street knowledge that was essential for the everyday lives of these disaffected young men, earned little credit in traditional educational measures of success.

However, Willis's young men, like the young people involved in the students' culture based projects, are operating at a deeper level of awareness of the realities of their everyday life. This can be seen in examples of project material introduced later in this paper.

'Liverpool is full of lovely buildings. I'm glad I got to see them'

The city's cultural heritage can be seen in traditional ways and images. The origins of Liverpool lie in its natural advantages of a tidal pool at the mouth of a river. Early on, its strategic importance led to its establishment as a town by royal charter in 1307, the building of a castle (long since disappeared) and its development as a port. By 1880, it had achieved city status in recognition of its maritime expansion, colonialism and trade. The status of the period is reflected in the classical buildings that remain, including St George's Hall and the Three Graces (the Port of Liverpool, Cunard and Royal Liver Buildings) that form Liverpool's Waterfront, recognised as a UNESCO World Heritage Site in 2004.

For ordinary Liverpool people, notions of cultural identity lie not only in the familiar city buildings and symbols of the Liver Birds and the Pier Head but also in its sporting and musical heritage. As such, the Beatles and football still trigger popular sentiments and enthusiasm. However there are generational shifts and a changing city landscape that reconfigures what was known or understood. For example, recent additions to the city scene include Taro Chiezo's 'Superlamb Banana', a bright yellow street sculpture that begins as a sheep and ends as a banana, and which raises questions about genetic engineering, while Antony Gormley's 100 life size cast iron figures facing out into the Mersey estuary along two miles of Crosby Beach, makes visible 'Another Place'. Both images have proved provocative and have been used by students within their projects to trigger conversation and pose questions about how we see ourselves and the future.

The part that art and culture can play in national life was noted by the Prime Minister. In an address at the Tate Modern, Tony Blair presented the case that, 'dynamism in arts and culture therefore creates dynamism in a nation' (Higgins, 2007), though newspaper reports suggest that the government's record on the arts does not reflect this endorsement. There is a sense that engagement in the arts is being seen as the panacea to address the ills of society, a view that is reflected in government publications such as the Social Inclusion Strategy for the Arts (DCMS, 2001).

Notwithstanding, culture and creativity appear to offer a scintillating mixture of emotion and project activity as the city prepares for 2008. However, the enthusiasm of the city leaders for 2008 has not been paralleled by young people and communities who have felt on the margins of this experience.

An understanding of culture is distilled by context, tradition and time. We need to know what culture means to the individual as well as what is presented as culture in the community's name. If we know the individual better, we know better the culture that is produced in their name. The arts can appear institutionalised and removed from the everyday lives of ordinary people. However taking part in cultural activities

that value the experiences of the young can enhance 'cultural well-being' (Rubinstein, 1992) and create a sense of belonging.

'The best part of this was being treated like a person and not like some yob'

Students initiated project activities with many different groups. One group of young people aged 13–16, was drawn from the top 50 at most risk of offending that were identified by an interagency panel from four disadvantaged neighbourhoods. Another young men's group was formed in a drop-in youth information and advice centre. Here the creative arts project aimed to examine cultural identity and the meanings it had for them and the issues they face. The group created a banner with images that represented aspects of their lives and their Liverpool heritage. Some expressed reservations over being 'no good at art' but ways of projecting and tracing images onto the material were found. The images included a quotation from John Lennon on class, reference to the boycott of *The Sun* newspaper, the Somali flag, a Ferry across the Mersey, the Chinese symbol for friends, *The Big Issue* and so on.

Several young people have discovered through these culturally-based project activities that 'art isn't as bad as I first thought it was' and 'I thought I wasn't creative but I'm well pleased with these posters'. 'I suppose this (project) made me more confident 'cus I had to act and stuff and had to talk'.

In a second project, the youth worker used drama with fellow students to develop their skills in relation to bullying and disability. Their comments revealed some new insights gained: 'I've learnt different ways to dealing with these situations if they come up'. Participants felt more able to express themselves: 'I was able to stand up and in front of the group and get my feelings out ... it was really scary at first but it was really good'. Also, 'I never knew how easy it was to bully someone without even knowing it!'

In a third example, the worker commentated on the value of using art as a tool in her practice:

> I worked on an 18 week project with a group of young people from the local estate. A programme of art work was delivered which helped change the local communities' perception of the young people as they produced a piece of art work which went on display within the community. Here opportunities were created to explore with young people the consequences of some of their behaviour and why some local people were raising concerns. When the art work was displayed, many people from within the local community saw the young people in a different light giving them a positive image.

Youth workers believe that these types of activity improve communication and social skills, raise self-esteem and confidence and promote cultural awareness and cross-cultural understanding.

The workers recognise that they are contending with some common factors with 'hard to reach' young people. They include the complexity of young people's lives

with financial constraints, instability in some of their family relationships, limited motivation and ability to sustain levels of concentration. Many of these young people are at the most disadvantaged end of the spectrum with a lack of educational success or disaffection from schooling in comparison to their middle class contemporaries.

Among the multiplicity of variables are customs, beliefs and pressures that are differentiated through cultural traditions and beliefs; the mobility of groups into and out of neighbourhoods, where incomers are perceived as a threat; young people's expectations and motivation; cultural diversity and the changing perceptions of who 'we' are.

'Before this project I thought China town was in China'

Particular neighbourhoods reflect this cultural complexity and diversity. In a fourth example, a student is working in a neighbourhood that includes families from India, Pakistan, Somalia, Poland, the Czech Republic and the Caribbean, alongside large student communities. She developed a project exploring the history of different cultures within the local community and city. Membership of her particular project group included those of Chinese, Indian, Irish and Somali heritage. An early stimulus in the project was social interaction between young people and the local Irish Travelling Community. This experience presented an opportunity for emotional engagement. It encouraged the exploration of feelings and opened up new ways of thinking and learning about the lives of others.

The organic nature of this project enabled young people to develop relationships and learn from each other about their culture, producing a collage of their experiences. The negotiated project curriculum led to sampling of Chinese culture and its history in Liverpool, with some experience of Tai Chi at the Pagoda Community Centre; a drumming workshop, a visit to the museum's slave trade exhibition and introduction to Indian culture.

The young people gained an appreciation of the many faces of the city and the important part played by diversity in its heritage.

Baggini (2007), reflecting on life in a typical British community, identified that communities lead such separate lives that their lifestyle and the language they use about 'the other' are as likely to indicate ignorance as racism; that race and class draw like-minded people to group together so that it is more realistic to aspire to toleration of difference rather than a multicultural utopia.

The projects opened up opportunities for young people to gain some understanding of other groups and thereby promoted tolerance. They learnt to appreciate different frames of reference and also express aspects of their own lives. This was presented in different forms, through visual images, dance, musical and dramatic performance and the written word. These forms of expression are socially constructed and shaped through the language and culture of the person. This will mean that a limited vocabulary can minimise the full expression of what is meant in either its oral, written or physical form. It may mean that closer scrutiny inhibits the ideas, feelings and sensations that it may conjure up. Visual representations and semiotics can offer another way to create the meanings of an experience.

Some meanings are expressed through the creative work that young people do. They give fleeting glimpses of the patchwork quilt of their lives, where different strands appear gossamer or may lie hidden until caught in the gleam of the light.

'The project was boss'

A diverse range of project work was undertaken. In this section, a further four projects are considered. Amongst the memorable images that come to mind are a line of four young women stepping out across their own 'Abbey Road' pedestrian crossing in Anfield; creative writing from a gay and lesbian youth group; the construction of a tepee and face mask by another group on a local estate and a mural of a mobile phone surrounded by text messages that encapsulate the lives of young people.

In the fifth project, the 'Anfield Beatles', young women were interested in photography and this was the starting point for their activities. Liverpool becoming European Capital of Culture to this group meant little other than 'loads of renovation work was going to be done in the city'. They also expressed distaste for one of the controversial art works of the day by Yoko Ono: 'My mummy was beautiful'. The banners formed part of the Liverpool Biennial in 2004 but to the young women the intimate female images were 'the horrible pictures hanging up round town'. The girls were conscious of many negative images of their city and referred to Boris Johnson's disparaging remarks about Liverpool people and perceptions of the Hillsborough disaster. The remarks arose in an Editorial attributed to Johnson (*The Spectator*, 16 October 2004) which reignited the claim that drunken fans contributed to the disaster and the death of Liverpool football fans in the Hillsborough football stadium disaster of 1989. Although this was not upheld by the Taylor Report, Johnson accused the city of seeing itself again in victim mode by its display of sentimentality at the murder of its former resident Ken Bigley who had been held hostage in Iraq.

Thinking back to alternative images of Liverpool's past, the girls adopted the idea of recreating some of the famous photographic images of the Beatles but in their own style. The youth worker was keen to explore how the girls felt walking in the footsteps of the most famous 'male' icons in the city's music history. The project became a mixture of the well known and the unknown as the worker explored ideas of females as passive and objects subjected to male gaze rather than active and powerful as many male images in the media. She was hoping to challenge some male stereotypes and enable the girls to reclaim their Liverpool identity and to feel proud of their heritage.

A sixth example comes from a student who took members of a Gay and Lesbian Youth Group to hear the performance poet Rosie Lugosi 'the vampire queen' perform some of her poetry. It inspired the group into writing creatively about their experiences, letting others see below the 'glaze' that is 'the surface of my life', letting others in to see the real person, asking that others will 'see who I am and let me be'.

The dialogue in table 1 constructs the situation that presents as a typical teenage scenario with the undertone of the possibility of 'coming out' to family members. The contrasting poem on the right was inspired by Roger McGough's poem, 'Liverpool' (2004). Built on the project's title (GLYSS), it implies the freedom of being accepted as young and gay.

TABLE 1 Two examples of creative writing from a Gay and Lesbian Youth Group

'You coming out?	'**G**lorious gays greeting with giggles.
What me? Today?	**L**oving life, living lightly
I hadn't planned to …	**Y**oung, youthful, saying yes.
What do I say?	**S**imply symbolic and supportive yet.
Er, mum … dad	**S**ubtly suggesting signs to society'
Erm … by the way …	(Female, 14)
I have something to tell you	
Deep breath, I'm G …	
Going out, see you later!'	
(Group, 2006)	

The mixed views about the virtues of being named Capital of Culture came through in the class and project discussions. Students looked at the experience of other cities so honoured and the impact of this reality, speculating as to whether it had really changed people's lives for the better. One student began his project (Example 7), by recognising the link between the foundations of the city and his own community in Weston Point, Runcorn with its natural assets of sandstone (that was used in constructing the Anglican Cathedral) and salt. He looked at achieving capacity building through consideration of historical culture, food and art forms. This led into what became known as 'Operation Tipi'.

A group of young people from the estate came together as the Wezzy Point Crew and produced its own special hand sign (W); planned and constructed a tepee; improvised ways of testing its stability; designed and carved a totem pole. This dynamic project captured local young people's enthusiasm and led to networking with other community members to borrow a large cooking pot and acquisition of building materials.

In the review of the project, the group could identify that they had acquired skills in a range of spheres including friendship and co-operation; construction, fire-making and cookery; knowledge of good health and safety practice; the ability to carry out research on the Internet, particularly into the life of native Americans, and so on.

In the final eighth example, the prevalence of text messaging as the most popular form of communication was recognised by one student who collated some of their messages (with the participants' agreement) over a 24-hour period. The findings were presented on a mural (167 × 23), replicating the shape of a large mobile phone. The messages appear in table 2. The table presents the messages in two columns with those sent by young men on the left and those by young women on the right.

Through this innovative project, some of the concerns of young people in their everyday lives come to the fore. We hear of difficulties in family relationships, the importance of maintaining contact with their peers, some of the anxieties around dating and the type of social and leisure activities that occupy them. Reviewing them as an adult, it is a reminder of the different view of the world that is experienced by young people and the anxiety that can characterise it.

Text messaging which presents as a short-hand style of communication can nevertheless have a high emotional content, according to these examples. It appears to be an important medium to address misunderstandings in relationships. Meanings tend

TABLE 2 Diagram to illustrate sample of text messages by young people in 24-hour period

THE ART OF TXTIN COMMUNIC8TION CULTURE	
'I'm so sorry mum Ur all I've got but U didn't C evrythn I will try 2 find somwere els 2 liv' (Male, 16)	'I cant Ive GOT NO Money Who els is goin?' (Female, 14)
'I promis U lad he never I swer on me ma's life ring him lad+sort it out' (Male,14)	'Don't no yet he said to ring him 2nite! Ive got his new mob No!!!' (Female, 14)
'R U goin the veni 2nite?' (Male, 13)	'R U getting ale 2morow nite?' (Female, 13)
'Dad wer playin the Metal Box on Sat U comin 2 watch' (Male, 13)	'Im staying off 2morow 2 go 2 town with me mum 4 easter clothes' (Female, 12)
'What's 4 T+wot time WiLL it B Redy?' (Male, 14)	'I'm Really Sorry txt back if its OK 2 ring U' (Female, 15)
'He said he wont I askd him 2 day+said he won't' (Male, 14)	'Ive got babysit com round just u tho' (Female, 13)
'Im not ringin her lad I don't know what 2 say III Just wait till I C her in school or somthn' (Male, 14)	'What happened 2 U last nite?' (Female, 14)
'Did U get a ticket 4 Man U? Wer U sittin?' (Male 15)	'Champions League wer avin a laugh' (Female, 15)

to be local and culturally specific. The young people's discourse shows that their lives are characterised by uncertainty and some hard realities. There is value in the messages as snapshots of a moment in time, a window on aspects of youth culture.

Through the project activities the young people gained learning at the conscious and unconscious level. In some cases, it was tacit knowledge and taken for granted; young people were learning through the different opportunities and the experience of being engaged with others. There was an increase in self-confidence with some becoming role models for their peers.

Several workers undertook project activities that built on some pre-dispositions towards particular interests and that were relevant to the participants, on neutral or safe ground. However, other projects ventured into new spheres, allowing some experimentation with the creative arts and with new ways of working. Overall, students report that they have become aware of how meaningful the creative arts can be as tools in their work. It is evident that there has been learning in several aspects although some retain some scepticism about the value that the award 'Capital of Culture' has for the typical young people and communities where youth workers operate.

In terms of cultural capital, there is evidence that the young people are willing to express their views about their city and that this is very much in their own language and images. The project work shows that young people have views that need to be heard. Their feelings become transparent, varying from embarrassment at some of the biennial images, anger at criticisms of their city to anxieties in their everyday lives when they are trying to appease significant others. It is evident that their lives are not 'easy' and that as adults we are a stage removed from the complexity of situations and pressure that young people experience from peers, parents, teachers and other adults;

that their voice can easily go unheard. Young people's comments show that the project experiences provided new learning and insight, skills in negotiation and the arts, built confidence and were fun. There is evidence of meaningful work with young people that gave them a stake and sense of belonging, making their presence visible in local communities in ways that showed how this presence can be valued by others.

Acknowledgements

Full acknowledgment is given to the students and young people involved in the development and delivery of these projects as part of the module 'Cultural Capital'. This paper is based on discussion of module material and examples of project work undertaken between 2005 and 2007.

References

Baggini, J. (2007) 'How racist is Britain', *The Guardian*, 23 January, G2, pp. 13–15.

Bauman, Z. (2004) *Identity: Conversations with Benedetto Vecchi*, Polity Press, Cambridge.

Bourdieu, P. & Passeron, J. C. (1977) 'Reproduction', in *Education, Society and Culture*, Sage, London.

Carter, C. & Hetherington, P. (2003) '"Terrific" Liverpool carries off key accolade', comments by Sir Bob Scott on hearing the announcement of the successful bid, *The Guardian*, 5 June [online] Available at: http://arts.guardian.co.uk/cityofculture2008/story/0,,970682,00.html.

Collins (1994) *Shorter English Dictionary*, Harper Collins.

Department for Culture, Media and Sport (2001) *Building on PAT 10 Progress Report on Social Inclusion*, DCMS, London.

Department for Education and Employment (2001) *All our Futures: Creativity, Culture and Education*, National Advisory Committee on Creative and Cultural Education, DfEE Publications, Nottingham.

Giddens, A. (1997) *Sociology*, 3rd edn, Polity Press, Cambridge.

Higgins, C. (2007) 'Blair reminisces about Labour's "golden age" of the arts; others wonder where it went', *The Guardian*, 7 March, p. 18.

Johnson, B. (2004) 'Editorial', *The Spectator*, 16 October.

McGough, R. (2004) 'Liverpool', cited in Arts Council Press release 6 September [online] Available at: http://www.arts.org.uk/documents/press/phpISBltl.doc.

Rubinstein, P. (1992) 'Common culture for all: arts work with young people after Willis', *Youth and Policy*, no. 39.

Ward, D. (2004) 'Winners and losers in boom city', *The Guardian*, 12 August [online] Available at: http://www.guardian.co.uk/uk_news/story/0,,1281091,00.html.

Willis, P. (1977) *Learning to Labour: How Working Class Kids Get Working Class Jobs*, Saxon House, London.

Donovan Chamberlayne

CASE EXPERIENCE: 'DANCING SHOES', A BUDDHIST PERSPECTIVE

In the film classic *2001*, the hero takes on a super-intelligent robot, far more powerful in intellect than any human. As John Izod comments;

> Dave is an ordinary person. He possesses no extraordinary powers other than unflinching determination. He enters the cycle of rebirth simply because he gives himself fully to ... the most profoundly religious of human impulses — the passion to know both the universe and the self more deeply.
>
> (Izod, 2001, p. 145)

Introduction

Having worked closely with children and their families as a residential social worker, a social work assistant and social worker, I have come to see similar struggles in the

lives of service users, in my own life, and in the lives of my friends and work colleagues. People become social workers for various reasons and many cite their own difficult experiences as reasons why they chose the profession. For example, Cree (1996) found both family background and significant experience of loss were important while Rochford (1991) '… drew attention to the experience of loss, both normal and exceptional, as a major factor in motivation for social work' (Lishman, 2002, p. 99). First-hand experience of difficulties that a client is dealing with increases a sense of connection, understanding and compassion.

> … Compassion allows us to respond to a difficulty in a way that is truly helpful, rather than simply reacting and giving advice, trivialising, or taking over. We might say that true compassion is an effective form of concern and caring that contains within it the awareness of the actual difficulty at hand.
>
> (Young-Eisendrath, 2003, p. 304)

Behind these skills however can lurk other motivations, for example the need to feel needed or to be respected or a desire, as in my case, to also seek resolution for our own problems. In addition, over-identification can lead to attempts by professionals to use service users as tools to champion their own causes. Motivations of this kind are likely to be inappropriate if unrecognised in the professional and left unchallenged.

In this article I discuss a case study involving 'Sally' and her family and our work together while I was a social work assistant in a Children and Family's team.

I start with an outline of my own personal background and highlight my development throughout, including my increasing interest in and self-reflection through Buddhism. I try to show the interconnections between the different difficulties that Sally's family and I faced and how that informed my work. I look at some of the benefits, pitfalls and boundaries of working from the point of view that service user and professional are both working to overcome their problems. I also interweave interactions I had at the time with Carlos, a drug user friend in a crisis, and the impact that this had on me. Because I include my own situation I have called this article a 'case experience'. Throughout I refer to Buddhist and psychoanalytic thinking and particularly to agreement between the two around ideas that inner resistance is the main barrier to the evolution of both professionals and service users. I argue that ultimately faith is the key to unlocking resistance, not faith as in an attachment to an idea of a supernatural being but faith as the development of a belief within people that they are able to progress and not be destroyed by the problems they face.

Journey towards Buddhism

My upbringing was as an atheist as a lone child with a single parent. My mother was heavily involved with Trotskyist left-wing politics and there were many influences including the expressed desire from mum and the 'comrades' that society would radically change for the better. I did not see how their plan could work but was surprised at how upset I was as a teenager when my mother lost her 'faith' in the revolutionary struggle and when communism world-wide collapsed. The robbery and

murder of my father, a neurologist in Uganda, during my adolescence compounded my difficulties and I began a gradual then increasingly desperate search for meaning.

As I came out of adolescence I was on a downward spiral, in the midst of which I started reading about religion and myths and to my surprise came to a connection with spirituality. However the spiral continued and increasingly schizophrenic thoughts led one evening to a powerful religious experience in which I was convinced I was being visited by God who brought news that I was going to die that night — I assumed for my sins! I begged 'God' to show me a sign of the particular religion I should follow to get my life back on track and remonstrated when no such message came. After deliberating about what to do — run to the hospital, commit suicide, or phone a friend and say goodbye to my mum — I finally found the courage to go to sleep genuinely not knowing whether I would wake. When I did the next morning it was with a great sense of gratitude — I felt I had been saved and I changed my life in considerable ways. I studied various religions, reading the Koran and much of the Bible, but did not find anything that meshed intellectually and emotionally. I also experimented with Buddhism but at the time felt it too subtle and no match for the intensity of my initial spiritual experience.

Instead I practised my own cocktail mix of beliefs and prayers in isolation and over the next 10 years my intense spiritual feelings faded as a memory and I failed to translate any of it into useable life skills. Spirituality and religion, like other 'worthy' causes, do not always lead to salvation and can serve our efforts to avoid or subvert painful reality:

> Contemplative traditions neglect the way intentions and actions may have multiple unconscious meanings and functions. Altruism as a spiritual practice may hide vanity and sanctimony. Self-denigration may masquerade as spiritual asceticism. And humility can be fuelled by a sense of non-entitlement or fear of competition.
>
> (Rubin, 2003, p. 394)

Having previously felt I had overcome death I realised my fear of death had heightened as had my fear of life. I was trapped. I had retreated from society but was unable to come back. My faith had become something to hide behind. Rosenfeld explains a similar phenomenon from a psychoanalytic angle:

> One has here the impression of being able to observe the death instinct in its purest form, as a power which manages to pull the whole of the self away from life into a deathlike condition by false promises of a nirvana-like state, which would imply a complete defusion of the basic instincts.
>
> (Rosenfeld, 2002, p. 132)

Following a crisis in my marriage, a social worker friend of the family surprised me by revealing he was a Buddhist of the Nichiren tradition. He encouraged me to single out one of the faiths in my cocktail mix, and to engage it wholeheartedly to the exclusion of others. I was surprised by his clear message that my practice of faith was more important than the beliefs themselves. His radical suggestion to choose any religion spoke directly to a need I had to stop running away and to face myself. As he

spoke I felt something unlock within and I resolved to start Buddhist chanting the next day. I continued chanting and studied Buddhist ideas about the complete unification between the spiritual and the everyday physical realm, something that had seemed impossible to me previously.

A take on interconnectedness

This interconnection between the physical and the spiritual is particularly emphasised in the Lotus Sutra, which is from the fifth or sixth century BC, towards the end of the Buddha Shakyamuni's life.

> At the start I made a vow, hoping to make all people equal to me, without distinction between us.
>
> (Shakyamuni, 1993a, p. 36)

Also:

> In order to save living beings, as an expedient means I appear to enter nirvana but in truth I do not pass into extinction. I am always here preaching the law. I am always here …
>
> (Shakyamuni, 1993c, p. 229)

The 'I' in 'I am always here' refers to our own deeper identities, ever present, however often locked away and hidden from view. As Nichiren Daishonin explains:

> The Buddha of the true aspect of reality resides in the midst of the mud and mire of earthly desires. This refers to us living beings.
>
> (Daishonin, 2004, p. 91)

As I studied and practised I found the barriers between my inner world and day-to-day reality started to come down. I began to understand the value of focusing not on a God locatable somewhere outside daily life but instead on an active principle or immanence within every aspect of reality. Something Nichiren Daishonin refers to as the Mystic Law:

> It is called the Mystic Law because it reveals the principle of the mutually inclusive relationship of a single moment of life and all phenomena. That is why this sutra [Lotus] is the wisdom of all Buddhas. Life at each moment encompasses the body and mind and the self and the environment of all sentient beings in the Ten Worlds as well as all insentient beings in the three thousand realms, including plants, sky, earth, and even the minutest particles of dust. Life at each moment permeates the entire realm of phenomena and is revealed in all phenomena.
>
> (Daishonin, 1999a, p. 3)

'Existence' rather than 'life' probably best captures the meaning of this passage which emphasises that all physical entities from people to inanimate matter share

existence in the same way that individual leaves share a tree. It highlights the interconnectedness that Buddhism relies on and promises its realisation for all:

> When deluded, one is called an ordinary being but when enlightened, one is called a Buddha.
>
> (Daishonin, 1999a, p. 4)

South of France

My Buddhist practice grew and I joined the Buddhist organisation, the Soka Gakkai International (SGI) — which translates as 'Society for Value Creation' — and I was invited to spend a week at the European Centre outside Trets in the South of France. The primary role of our all-male team from Ireland and the UK was to take care of the Gohonzons — a scroll with 'Nam myo ho renge kyo' inscribed down the centre, which signifies devotion to the Mystic Law expounded in the Lotus Sutra and inherent in life. Nichiren Daishonin, a thirteenth century Japanese monk, developed the chanting of 'Nam myo ho renge kyo', as a practical means for people to manifest their inherent 'Buddha'-state as exemplified in the Lotus Sutra. The many fun aspects of the trip included gardening overlooking mountains that Cézanne had painted and sharing experiences with the waves of coachloads of members who came from France and Italy for two-day courses. The experience of meeting many different people from different cultures, classes and backgrounds who nonetheless all shared a desire to embrace their lives and breakthrough any barriers holding them back was moving and struck me as a modern and relevant form of revolution. The difficulty was the emotional and physical energy needed to challenge my own problems through working and chanting for long hours. However the same was true for most people especially those in my team who bonded well partly because, as it turned out, we had all lost our fathers prematurely.

I returned to England with a sharpened awareness of what was happening in the moment: this in my everyday life included my marriage and my roles as a father and social work assistant. However once back in the routine I did not dedicate adequate time and energy to chant enough and maintain my new optimism and my life did not get better or even stay the same — it got worse. Now when I sank I was more aware of it and it hurt even more.

Sally and the social worker's role

Sally was a grandmother who looked after the three children of her crack and heroin-using daughter. Sally began this role over a decade ago with the oldest child and when I took 'the case' she had recently won a Residence Order in the courts for her daughter's fourth child, an 18-month old son. I would visit, find nursery facilities for the happy go lucky baby, discuss health appointments, assist with any issues for the older children and importantly push for more spacious re-housing. I also liaised with the children's mother and negotiated disputes and encouraged contact. Sally spoke of

the pressure and strain of looking after a fourth child at this stage in her life and I encouraged her to seek therapeutic help. In addition Sally was a regular churchgoer, and we discussed aspects of her Christian faith and how it helped her in daily life. Sally enjoyed describing the support she got from participating in the church, doing local activities and the sense of joy from the church services and from prayer. I encouraged Sally to view her ability to connect with God as a personal achievement, something which I hoped would raise her self-esteem particularly to see her through difficult moments when she struggled alone with the burden of looking after four children. In this way I felt able to motivate Sally while resisting the temptation to promote my faith and how it works for me.

> How may we harness the positive and empowering aspects of our motivation and avoid the potential danger of using our clients or users to meet our own needs rather than responding to theirs? Developing and maintaining self-awareness is one way.
>
> (Lishman, 2002, p. 99)

In Buddhism developing self-awareness is key as it helps us navigate through a barrage of changing thoughts and feelings, as the Dalai Lama explains:

> When I'm uncertain or distressed, I look inside and check my motivation. Motivation is key. If I am motivated by afflictive emotions, I work on myself. If I am motivated by wholesome emotions, if that is clear after careful inward looking, I don't care what anybody thinks [about me].
>
> (Quoted by Bobrow, 2003, p. 246)

Awareness of my own suffering has facilitated a wider awareness including awareness of the suffering of others. It leads to a logical and emotional understanding that we do not live in isolation from others, that our happiness cannot exist in isolation from others and that focusing solely on our own happiness is essentially selfish. For example, having gained enlightenment, the Buddha Shakyamuni turned his attention to the wider suffering of other people:

> When I look at living beings I see them drowned in a sea of suffering ... At all times I think to myself: how can I cause living beings to gain entry into the unsurpassed way and quickly acquire the body of a Buddha?
>
> (Shakyamuni, 1993c, pp. 230–232)

I find it difficult to change the way I habitually respond to problems and in my work find it even more difficult to facilitate that change in service users. Success only seems possible with service users when there is a shared sense of connection. Few people today think of social work as simply 'dishing out' a service, be it money or housing etc., without developing strong working relationships. In her article on Transference, Polly Young-Eisendrath talks about the cultivation of hope and self-belief via the interaction of therapist and patient through psychoanalysis. I feel parallels can be drawn in the role of social worker and client:

This containing-transcendent transference is experienced first in the patient's hope that *this* therapist or analyst is knowledgeable and caring enough to be helpful in alleviating suffering. Eventually, or even at the beginning of treatment in some cases, the patient may also imagine that the therapist is a highly developed or spiritually powerful person. In short this is the transference of the patient's own developmental potential for wisdom and compassion for self and other. As well as the patient's inherent capacity (however unconscious or nascent) to transcend suffering.

(Young-Eisendrath, 2003, p. 305)

To effectively facilitate this sort of change social workers need to believe not only in their own potential, personal and professional, but also in the potential of the service user. Furthermore it could be argued that there needs to be a belief in the wider ability of society to accommodate change in what can be termed the underclass:

... society as a whole has to reconsider its stance on poverty and inequality and fundamentally challenge the contempt in which the poorest are held. The challenge for social work is whether or not it is prepared to commit itself to that goal.

(Jones, 2002, p. 49)

One theory used in social work that claims to work from this position is the task-centred approach. This starts from the perspective of equality between professional and service user and holds that as key throughout they work together:

The task-centred philosophy does not pathologise service users but sees them as fellow citizens who are encountering difficulties. These difficulties are often more severe and more enduring that those which non-service users experience (and clients have fewer resources at their disposal to overcome them).

(Doel, 2002, p. 197)

My belief in Sally's ability to change came via the empirical evidence of me struggling to change myself. My victory was important not so that I could detail my experiences to Sally, which would clearly have been inappropriate, but so that I could maintain confidence in the encouragement I gave her. I did not feel I was winning in my own life but at least everyday I was maintaining my battle to 'hang in there' and this small victory enabled me to confidently encourage Sally to do the same. Although Sally's problems were worse than mine the essential element of 'not giving up' seemed the same for us both.

Maintaining confidence requires faith in as yet unseen outcomes. As I worked with Sally I realised that my ability to 'hang in there' and battle to advance was being facilitated by my Buddhist practice. Whereas I previously viewed faith as a set of beliefs in a Supreme Being, I now saw it as the belief in the combined capacity of myself and others to effect change within ourselves and within society. More than an intellectual event or concept this was a challenging process, that I would need to work at everyday, and requiring me to both be aware of my negative feelings and to battle

through them. It could be argued that the highest function of Buddhist practice, and that of other religions and faiths, is to facilitate this battle.

Greasy pole

Conditions in Sally's flat deteriorated, but a momentum of pressure was put on the housing department from myself and the other professionals involved and Sally was offered an ideal four-bedroom house close to where she lived. The atmosphere was euphoric and the children, who were distrustful of adults after years of neglect and broken promises, started trusting me and we began to engage in conversations about their lives. Then the day before the definitive move disaster struck. Sally told me she was feeling ill and I advised her to go to the hospital where she had been recently with a minor complaint. I had a confused conversation with her eldest grandchild but was able to understand that he 'knew' Sally was going to die and had expected it. She did that weekend from meningitis.

The housing department insisted that the family could no longer use the new house. But immediate concern was that there was no family member to look after the children and all four children would have to re-enter care. Passing my condolences to the three eldest children over the telephone and listening to their muted reactions brought home to me the cruel sense of injustice that stunned everyone involved.

I was reminded of similar feelings as a teenager 15 years before when my father was murdered. I felt outraged and useless. Now to make matters worse my marriage was ending and I felt alone. Sally's death seemed to spark thoughts of these other things in my life and combine to form a critical mass under which I was again sinking. I turned to Buddhism, which teaches that there are no obstacles to spiritual enlightenment other than those erected by the mind:

> Samsara — what is disturbing, sorrowful, painful, traumatic, unsatisfactory, is transformed into nirvana itself, not by magic, not by pollyanna-like rending of it into glee, but by penetrating into the nature of the experience itself, and of the experiencer.
>
> (Bobrow, 2003, p. 244)

And according to Nichiren Daishonin:

> Your practice of the Buddhist teachings will not relieve you of the sufferings of birth and death in the least unless you perceive the true nature of your life.
>
> (Daishonin, 1999a, p. 3)

Some of the biggest barriers to breakthrough are unconscious processes. This was explained well by a psychiatrist during a session I had earlier attended as a social worker with a young female client who had been taking medication to combat depressive and paranoid tendencies. The psychiatrist explained that our minds are often persuaded by what we already think — if you think you are worthless then you will experience things that confirm this. If you feel people are out to get you then the sight of two friends talking quietly is likely to trigger this thought. If you think you are

wonderful then the same two friends talking will convince you that you are being idolised. This is backed up by Freud (1914), who in reference to narcissists wrote;

> ... everything a person possesses or achieves, every remnant of the primitive feeling of omnipotence, which is experienced as confirmed helps to increase the self-regard.
>
> (Quoted by Rosenfeld, 2002, p. 105)

This points to the problem of being trapped within our own minds within a false sense of reality.

> If we are too immersed in the past — haunted by old memories and experiences — then we betray the present. We greatly diminish the aliveness of the present when we accommodate it to old scenarios and expectations.
>
> (Rubin, 2003, p. 402)

I knew it was not inevitable that I should keep sinking and in a desperate attempt to achieve a breakthrough I determined to chant for at least an hour a day until the end of the year.

Carlos — a friend

Shortly before Sally died in hospital a close friend of mine, Carlos, who had also been a social worker, was admitted into the same hospital with heart complications following crack cocaine use. His heart had almost given way and the absolute rule laid down by the doctor was no pressure on the heart including stress. A mutual friend was so distraught that Carlos might throw his life away that they had a screaming match on the ward. I warned our friend that if he could not help then he should stay away. He chose to stay away and when Carlos came out he soon admitted to me that he was using crack again.

As Sally's funeral was being organised the world felt like a cold place. However Carlos let me introduce him to Buddhism and we began chanting together at his flat every morning before work. We created a space in the corner of his room to chant towards and at first he sat uncomfortably while I chanted. I felt stupid facing a random wall and chanting as if there was some unseen magic that could get you off crack. I was tense and my voice unconvincing. I genuinely feared that rather than me lift him up the weight of Carlos' experience would tip me 'over the edge'. However Carlos slowly began to join in and soon our voices boomed together. Following that we read silent prayers; to bring out our Buddha nature and work for each other's happiness. We also discussed the concept of 'human revolution' — the necessary fight we undertake to overcome our own self-doubt and resistance to change.

Human revolution

It felt crucial that, as well as friendship and support I was also able to pass on to Carlos an established practice, something that could become part of his life. I

reflected on the fact that because of the unequal power dynamics between professionals and service users this form of working together would be inappropriate in a social work context. I was also reminded of my left-wing revolutionary upbringing, those lost ideals and that by focusing on faith I was employing a practice that for me was its natural successor. According to current SGI President Daisaku Ikeda:

> ... this movement is dedicated to encouraging people to become aware of their own boundless inner power and to take responsibility for the welfare of humankind. Although it may seem an indirect approach, I am convinced that this human revolution, with its principle of inner reformation first, is in fact the most certain path toward realising a genuine global revolution.
>
> (Ikeda, 1999, p. 295)

By helping Carlos I felt enabled to put my suffering in perspective and to find determination to resolve my problems not just for me, but for Carlos and for the wider society including Sally's family. I felt myself oscillating being excited at the tangible possibility of a change in society based on individual transformations of this kind and being fearful that my hopes would again be dashed.

Rosenfeld, a psychoanalyst, writes about the resistance that his patients face when they start to engage with him during therapy. The stakes are high because, in order for us to change and move forward, the status quo — how we habitually operate — has to stand-down or be overthrown. Rosenfeld describes the predictable resistance as similar to an internal Mafia filling us with fear and warning us away from change:

> The main aim seems to be to prevent the weakening of the organisation and to control the members of the gang so that they will not desert the destructive organisation and join the positive parts of the self ...
>
> (Rosenfeld, 2002, p. 111)

Resistance manifests in many forms. Referring to a patient, Rosenfeld explains:

> He would then admit he would like to improve, but soon he would feel his mind drifting away from the consulting room. He would become so detached and sleepy that he could scarcely keep awake.
>
> (Rosenfeld, 2002, p. 110)

As I sat with Carlos we reflected on this idea that he would unconsciously resist his own efforts to change and that he would also face increased negativity from the people around him, including drug dealers, who had a vested interest in him staying as he was. It was clear to Carlos that he would need a previously unimaginable level of determination.

> Evil demons will take possession of others and through them curse, revile and heap shame on us. But we reverently trusting in the Buddha will put on the armour of perseverance. In order to preach this sutra we will bear these difficult

things. We care nothing of our bodies or lives but are anxious only for the unsurpassed way.

(Shakyamuni, 1993b, p. 194)

Carlos was surprised that I would encourage him to undertake a practice that would make his life more difficult. But he agreed that up until now his efforts to avoid difficulties through drug taking had had the reverse effect and had been putting his life in real danger.

Psychodynamically, our intent is never simply to create more pain for ourselves, even if this is often an unintended outcome. The most maladaptive beliefs and behaviours have some adaptive intent, misguided and pathogenic though they may be.

(Engler, 2003, p. 53)

Chanting and striving

Buddhist writings, such as those in the Lotus Sutra, make clear that pain and suffering are inherent factors of life not to be avoided by retreating but transformed through altering the relationship we have with them, a point highlighted by Polly Young-Eisendrath:

Much ... anguish is rooted in our desire to have things go our way and the resultant feelings of humiliation and despair when they do not.

(Young-Eisendrath, 2003, p. 301)

History makes clear that religion and prayer do not and have not provided an external magical solution to the world's problems. According to psychoanalyst Ronald Britton, spirituality and religion are restricted to promoting a false sense of reality, what he refers to as an 'as if' belief (1998, p. 59). For me it is the opposite; faith helps people avoid accepting a limited view of themselves and of their situation. If there are to be solutions to the excesses of injustice, inequality, environmental destruction and war they will come through the efforts of individuals. As Daisaku Ikeda explains:

The challenges before us may be difficult but inasmuch as we ourselves have created them, it is clear that we also have the capability to resolve them.

(Ikeda, 1999, p. 288)

The practice of regular chanting helps create a reflective space for me to develop a more honest relationship with myself as well as to muster the energy needed for the goals that I see as important. Nichiren Daishonin described the Gohonzon, which chanting is directed towards as, The Object of Devotion for Observing the Mind (p. 354, *Writings of Nichiren Daishonin*). Concentrating on the Gohonzon creates space for an intimacy as well as a distance through reflection. Britton has emphasised this

need for the interaction of our self-perception or beliefs with an inner objectivity which he calls taking a third position and which '... provides us with the capacity for ... observing ourselves while being ourselves' (Britton, 1998, p. 42).

Maintaining the belief that things will get better is an act of faith and is a precondition of things actually getting better. However, even with that knowledge on board my experience tells me that faith in this sense is one of the hardest, if not the hardest, task to achieve. One of the main obstacles is the reoccurrence of problems in our lives and the resulting frustration that causes. In his book *Where We Have Hope*, about the ongoing struggle for democracy in Zimbabwe, journalist Andrew Meldrum describes asking his activist friend John Makumbe if he feels there is light at the end of the tunnel? John answers:

> Sure there is light at the end of the tunnel. The only problem is that Mugabe keeps building more tunnel.
>
> (Quoted by Meldrum, 2004, p. 265)

Focusing on attitude rather than outcomes grounds us in the present and helps foster perseverance. Nichiren Daishonin backs up this point:

> And even when they strike me I feel no pain, for I have been prepared for their blows from the very beginning.
>
> (Daishonin, 1999b, p. 728)

This does not mean that outcomes are not important. Only that the happiness that usually follows success is similar, in its fragility, to the unhappiness that usually follows failure and that both should be underpinned by a determination to move forward regardless of whether we experience victory after victory or defeat after defeat. The focus then moves to the present moment and to how we are managing our feelings:

> Freedom isn't the absence of all restrictions. It means possessing unshakeable conviction in the face of any obstacle. This is true freedom.
>
> (Ikeda, 1999, p. 145)

The funeral

The morning of Sally's funeral I chanted with Carlos at his flat and we were both emotional and our voices particularly crackly, each of us having to stop and recover briefly before continuing. Carlos explained we were chanting in the room where he would take crack and it was as if he were fighting the demons that would come and tempt him to take it later tonight. I was equally trying to hold an optimistic vision for myself within the random unjust life I saw around me.

I arrived at Sally's funeral to a huge community turnout in an uplifting Baptist Church. Sally's daughter — the children's mother — had forgotten her written speech but apologised and spoke movingly. The emotion of the songs resonated and I

was overcome with tears as were many people there as well as the other professionals involved. As I looked around I reflected on why I was there. Such a huge turnout, such a show of support and love for a wonderful woman. 'Why were social services involved again?' After the service the family was hospitable and I was introduced to other members of the family. I could not sense the usual division between service users and professionals. Instead there was commonality. It felt special and something that everyone present, Sally included, was contributing to. I thought of my father and could feel myself grieving him, something I had barely done consciously since his death so long ago.

I was the only professional involved to go to the burial. But I knew I had to. I happened to catch sight of the children's young uncle who had seen Sally trying jovially to convert me to Christianity outside her new house the last time I saw her alive. She was happy that day and had reminded me that the Supervision part of the Residence Order was up and that getting the house ready for them would be the last work I would undertake with the family. She was wrong about that.

The uncle now invited me along with his young friends into a big flash car, with DVD screens on the back seat, to go to the burial. I was glad for the lift but as I sat on the leather seats my fantasy was that these guys were drug dealers and I felt angry given that drugs were a cause for the children's separation from their mother and for all the heartache Sally suffered, not to mention for Carlos' near death. I had no idea what the uncle or his friends really did for a living but my mood persisted until we began talking. I responded to the uncle's abstract reference to religion and explained I was a Buddhist. We all spoke and they blamed a range of sources for the 'problems in the community'. I explained the Buddhist take on responsibility — how each individual needs to recognise their own role in any problem and do what they can to change things. It was perhaps the most spontaneous conversation I have had with a group of near strangers but was soon to find myself despairing that our discussion had been meaningless.

Digging deep

It was a hot summer's day and around the grave hundreds of people stood, many in elegant clothes. I myself had a new pair of shoes on, so elegant my mother thought they were dancing shoes. Even as I stood so full of emotions I was still conscious that I would get thick earth on my shoes if I got too near to the grave. The diggers started shovelling earth on top of Sally's coffin and a few people sang songs. But why, despite the huge crowd, was only a handful of people, mostly elderly men, being left to do such a hard job on such a sweltering afternoon? I could understand why the eldest son was not getting involved with the digging. He was too upset and stood back. But why didn't the guys from the car want to help? It struck me that this was why Sally had died — not enough people were there to help her. I felt myself despairing again.

I shook my head and contemplated leaving. This time I reminded myself of my own words in the car to the young men about responsibility. I took off my jacket, stepped forward and joined the handful of people to shovel earth into the grave. As I sweated and dug I looked at the fresh clods of earth on my shoes. I started to feel

better — even glad to be alive. I was doing everything I could. I thought of Sally, and then my thoughts turned to my father ... 'Dad this lump of earth is for you'.

References

Bobrow, J. (2003) 'Moments of truth — truths of moment', *Psychoanalysis and Buddhism*. Wisdom Publications.

Britton, R. (1998) 'Subjectivity, objectivity and triangular space', *Belief and Imagination, Explorations in Psychoanalysis*, Routledge, London & New York.

Cree, V. E. (1996) 'Why do men care', in *Working with Men*, eds K. Cavanagh & V. E. Cree, Routledge, London & New York.

Daishonin, N. (1999a) 'On attaining Buddhahood in this lifetime', in *The Writings of Nichiren Daishonin*, editor-translator The Gosho Translation Committee, Soka Gakkai.

Daishonin, N. (1999b) 'On repaying debts of gratitude', in *The Writings of Nichiren Daishonin*, editor-translator The Gosho Translation Committee, Soka Gakkai.

Daishonin, N. (1999c) 'The object of devotion for observing the mind established in the fifth five-hundred-year period after the thus come one's passing', in *The Writings of Nichiren Daishonin*, editor-translator The Gosho Translation Committee, Soka Gakkai.

Daishonin, N. (2004) 'The emergence of the treasure tower', in *The Record of the Orally Transmitted Teachings*, Soka Gakkai.

Doel, M. (2002) 'Task-centred work', in *Social Work Themes, Issues and Debates*, eds R. Adams, L. Dominelli & M. Payne, 2nd edn, Macmillan Press Ltd, Basingstoke.

Engler, J. (2003) 'Being somebody and being nobody: a re-examination of the understanding of self in psychoanalysis and Buddhism', *Psychoanalysis and Buddhism*, Wisdom Publications.

Freud, S. (1914) 'On narcissism: an introduction', SE 14: 98, *Standard Edition of the Complete Works of Sigmund Freud*, ed. J. Strachey, Hogarth Press, London.

Ikeda, D. (1999) *Faith into Action, Thoughts on Selected Topics by Daisaku Ikeda*, World Tribune Press.

Izod, J. (2001) '*2001: A Space Odyssey*: a classical reading', in *Jung and Film, Post-Jungian Takes on the Moving Image*, eds C. Hauke & I. Alister, Brunner-Routledge.

Jones, C. (2002) 'Social work and society', in *Social Work Themes, Issues and Debates*, eds R. Adams, L. Dominelli & M. Payne, 2nd edn, Macmillan Press Ltd, Basingstoke.

Lishman, J. (2002) 'Personal and professional development', in *Social Work Themes, Issues and Debates*, eds R. Adams, L. Dominelli & M. Payne, 2nd edn, Macmillan Press Ltd, Basingstoke.

Meldrum, A. (2004) *Where We Have Hope, A Memoir of Zimbabwe*, John Murray (Publishers).

Rochford, G. (1991) 'Theory, concepts, feelings and practice: the contemplation of bereavement within a social work course', in *Handbook of Theory to Practice Teachers in Social Work*, ed. J. Lishman, Jessica Kingsley, London.

Rosenfeld, H. (2002) 'Destructive narcissism and the death instinct', *Impasse and Interpretation*, Brunner Routledge, The New Library of Psychoanalysis, p. 1.

Rubin, J. B. (2003) 'A well lived life: psychoanalytic and Buddhist contributions', *Psychoanalysis and Buddhism*, Wisdom Publications.

Shakyamuni (1993a) 'Expedient means', in *The Lotus Sutra*, trans. Burton Watson, translated from *Miao-fa Lion-hua ching*, Columbia University Press.

Shakyamuni (1993b) 'Encouraging devotion', in *The Lotus Sutra*, trans. Burton Watson, translated from *Miao-fa Lion-hua ching*, Columbia University Press.

Shakyamuni (1993c) 'The life span of the thus come one', in *The Lotus Sutra*, trans. Burton Watson, translated from *Miao-fa Lion-hua ching*, Columbia University Press.

Young-Eisendrath, P. (2003) 'Transference and transformation', *Psychoanalysis and Buddhism*, Wisdom Publications.

Index